'Survivor' amuses S. African viewers

JOHANNESBURG — The first series of the U.S. television show "Survivor" to be set in Africa, featuring American competitors trying to outlast each other, left its South African audience in stitches this week.

"Can the image of the American tourist get worse than this bunch of screechers?" asked Robert Kirby, TV critic for the weekly Mail & Guardian.

The
American Effect

Global Perspectives on the ▮ United States, **1990–2003**

Sergei Bugaev Afrika
Makoto Aida
Chantal Akerman
Siemon Allen
Gilles Barbier
Stephanie Black
The Builders Association
 and motiroti
Gerard Byrne
Anita W. Chang
Patricia Clark,
 Meira Marrero Díaz,
 and José Angel Toirac
Arno Coenen

The
Global Perspectives on the ██ United States, **1990–2003**

American Effect

Gail Dolgin and
 Vicente Franco
Alfredo Esquillo, Jr.
Fiona Foley
Andrea Geyer
Veli Granö
Yongsuk Kang
Bodys Isek Kingelez
Pawel Kruk
Andreja Kulunčić
Jannicke Låker
Ane Lan
Cristóbal Lehyt
Mark Lewis
Amina Mansour
Maria Marshall
Bjørn Melhus
Zoran Naskovski
Olu Oguibe
Marlo Poras
Muhammad Imran
 Qureshi
Sandeep Ray
Andrea Robbins and
 Max Becher
Miguel Angel Rojas
Sherine Salama
Ousmane Sow
Heiner Stadler
JT Orinne Takagi and
 Hye Jung Park
Hisashi Tenmyouya
Zhou Tiehai
Saira Wasim
Danwen Xing
Miwa Yanagi
YOUNG-HAE CHANG
 HEAVY INDUSTRIES

Lawrence Rinder

Tariq Ali
Ian Buruma
Caryl Phillips
Elena Poniatowska
Sean Rocha
Nawal El Saadawi
Edward Said
Luc Sante
Pramoedya Ananta Toer
Aleksandar Zograf

Whitney Museum of American Art, New York
Distributed by Harry N. Abrams, Inc., New York

This book was published on the occasion of the exhibition *The American Effect: Global Perspectives on the United States 1990–2003* at the Whitney Museum of American Art, New York, July 3–October 12, 2003.

The American Effect has been made possible by support from Ronald L. Bailey, The Mat Charitable Trust, The Rockefeller Foundation, Jeanne and Michael Klein, AFAA/"Programme Afrique en créations," The Cultural Services of the French Embassy, and the National Committee of the Whitney Museum of American Art.

A⁻AA

programme**afriqueencréations**

WHITNEY

front cover, from the top, details from:
Zoran Naskovski
still from Death in Dallas, 2000
Sergei Bugaev Afrika
Dream Machine, 2002
Saira Wasim
Friendship After 11 September 1, *from the series* "Bush," 2002
Bjørn Melhus
still from America Sells, 1990
Andrea Geyer
Interim, 2002

back cover, from the top, details from:
Arno Coenen
still from The Last Road Trip, 2000
Mark Lewis
still from Jay's Garden, Malibu, 2001
Danwen Xing
Untitled, *from the series* "disCONNEXION," 2002
Yongsuk Kang
Untitled, *from the series* "Maehyang-ri," 1999

pages 1 and 216
Siemon Allen, Newspapers, 2002–03 *(details)*

©2003 Whitney Museum of American Art
945 Madison Avenue at 75th Street
New York, New York 10021
www.whitney.org

Library of Congress Cataloging-in-Publication Data

The American Effect : global perspectives on the United States, 1990–2003 / essays by Tariq Ali ... [et al.] ; foreword Maxwell L. Anderson ; introduction by Lawrence Rinder.
 p. cm.
 ISBN 0-87427-134-7
 1. Civilization, Modern--American influences. 2. United States--In art. I. Ali, Tariq. II. Whitney Museum of American Art.
 CB430.A49 2003
 700'.9'049--dc21 2003009394

Book design by:
Martin Venezky/Appetite Engineers
Printed in Canada

Distributed by
Harry N. Abrams, Inc.
100 Fifth Avenue
New York, New York 10011
www.abramsbooks.com

Abrams is a subsidiary of

LA MARTINIÈRE
G R O U P E

The
Global Perspectives on the ■ United States, **1990–2003**

American Effect

Table of Contents

Artist Index

Italics indicate
illustrations

Foreword

Maxwell L. Anderson

ALICE PRATT BROWN DIRECTOR
WHITNEY MUSEUM OF AMERICAN ART

Art is perhaps the most revealing window into the human condition. At a time of great anxiety, it therefore seems only natural to examine what art can reveal about a nation. America is in such a state as of this writing, because, for the first time since the Cuban Missile Crisis, there is a prevailing fear that circumstances beyond our control jeopardize our way of life.

The Whitney Museum of American Art exists to survey the art made in this country, but from time to time since our founding, we have examined the work of non-American artists in search of greater insight, starting with European modernists in the 1930s. We have also made forays into the political realm, sending an exhibition to Moscow at the height of the Cold War, in part to promote American values in the heart of our greatest adversary in history. Through the 1990s exhibition series "Views from Abroad," we mixed American and non-American works to learn more about what is distinctive about the art of this country.

We are today in a time when artists around the world feel compelled to respond to America's unprecedented global reach. We would do well to gain insight, by examining this art, into how we are perceived as a nation by the world at large. These artists are passionate voyeurs of our way of life, and the purpose of this exhibition is to learn from what they see in us. Lawrence Rinder spent several months visiting studios around the world, on almost every continent, in search of revealing works of art touching in some way on American identity. The result is an anthology of images about America—its values, policies, and effects—that will provoke a discussion about how we are seen abroad, and, to be sure, how we see ourselves. How those who question our policies and values perceive us is the most urgent question we face as a nation in a search for security, and in this exhibition we look to artists to teach us something about ourselves that we cannot learn from isolated introspection.

I would like to thank Leonard A. Lauder, Robert J. Hurst, and the rest of the Whitney Board of Trustees for their openness to this endeavor. The Whitney staff did a magnificent job in producing this challenging exhibition. I want to thank especially the curatorial staff who contributed so much to this exhibition: Tina Kukielski, curatorial assistant, contemporary art, and Kirstin Bach, exhibition coordinator. As with all Whitney exhibitions, numerous departments lent their skills, expertise, and hard work to make this exhibition a success. I would like to thank the following individuals and their department members: Christy Putnam, associate director for exhibitions and collections management;

FOREWORD

Holly Davey, audio-visual coordinator; Donald MacLean, facilities manager; Debbie Rowe, manager of information technology; and Mark Steigelman, manager, design and construction; Suzanne Quigley, head registrar; Joelle LaFerrara, assistant registrar, collections loans; Joshua Rosenblatt, head preparator; and all of the capable art handlers and technicians; Raina Lampkins-Fielder, associate director, Helena Rubinstein Chair of Education; Lynne Rutkin, deputy director for external affairs; Amy Roth, manager of foundation and government relations; Mary Haus, former director of communications; and Stephen Soba, acting director of communications.

The Publications and New Media Department, formerly under the direction of Garrett White, was responsible for producing this exceptional catalogue. I want to thank Rachel de W. Wixom, head of publications and new media, for her invaluable work on this project. Martin Venezky of Appetite Engineers designed the book with exquisite sensitivity to the subject and the works of art. Our design manager, Makiko Ushiba, and Anita Duquette, manager of rights and reproduction, also contributed to the success of the exhibition. Deidre Stein Greben's editing of this book has been both sensitive and incisive.

Significant support for this exhibition has been provided by Ronald L. Bailey, The Mat Charitable Trust, The Rockefeller Foundation, Jeanne and Michael Klein, AFAA/ "Programme Afrique en créations," The Cultural Services of the French Embassy, and the National Committee of the Whitney Museum of American Art.

We are especially indebted to the artists who participated in the exhibition. It is an honor to present their work in a context that does so much to illuminate the place of America in the world. Thanks also to the lenders for generously allowing us to borrow their works: Asano Laboratories, Inc.; Kim Atienza; Koli Banik; Shelagh Cluett; Contemporary African Art Collection—The Pigozzi Collection; Kathryn Fleck; JGS, Inc.; Martin Z. Margulies; Musée d'Art Moderne Grand-Duc Jean; Anita and Hamad Nasar; Linda Pace; Ryutaro Takahashi; and William and Ruth True.

In closing, I would like to thank Lawrence Rinder for undertaking a demanding global odyssey. He has capably assembled powerful works of art in service of an important inquiry.

Veli Granö, *still from* A Strange Message from Another Star, 1998

The American Effect

Lawrence Rinder
APRIL 17, 2003

Since the end of the Cold War, America has come to hold sway over a global empire.[1] Other nations have aspired to or nearly achieved such hegemony, including ancient Greece and Rome, Ottoman Turkey, Victorian Great Britain, and both Imperial and Soviet Russia. Yet no country has attained such widespread influence and control over so many aspects of life worldwide.

Militarily, America's global reach is unprecedented. Even before September 11, 2001, an average of 60,000 U.S. troops were deployed at any given time in approximately 100 countries around the world.[2] There is little chance, however, that the United States would tolerate another nation having a prolonged military presence on its own soil. Since the end of the Cold War, America has become more and more explicit about its right to act unilaterally, and even preemptively, to maintain its security and economic interests through military action. The recent invasion of Iraq in the absence of United Nations support exemplifies this emerging doctrine.

Economically, as well as militarily, America is the undisputed world leader. The United States has by far the largest gross domestic product of any nation on earth.[3] America's

economic muscle, combined with proportionately strong voting privileges in financial bodies such as the International Monetary Fund (IMF) and the World Bank, gives it de facto control over global capital flows. Since their inception in the aftermath of World War II, the IMF and the World Bank have become the prime architects of a new system of international commerce and finance, which, operating according to so-called neo-liberal economic principles, encourages the elimination of tariffs, the opening of markets, and the deregulation of trade and investment. These principles have greatly benefited America's industry and agriculture, thereby strengthening its economic might. America's cultural influence is also unsurpassed, transforming increasingly remote corners of the world into frontiers for the marketing of American music, food, film, and sports.

It should come as no surprise, then, that today so many artists around the world are drawn to America as a theme for their work. "The American Effect" explores a selection of these works by artists in thirty countries in Asia, Africa, Europe, Australia, and South and North America. Reflected here are some of the direct consequences of America's ubiquitous military presence, de facto economic control, and pervasive cultural influence. Also found in these artworks are effects more psychological in nature, reflecting America's role as a powerful figure in the world's imagination. In this age of American Empire, the image of the United States has taken on almost mythic dimensions, symbolizing, consciously or unconsciously, deeply held personal fantasies and fears. "The American Effect" is about the way these two phenomena, America's real

and imagined effects, intertwine to create a fertile source of themes and images for artists around the world.

"The American Effect" encompasses works made since 1990, the year that marked the end of the Cold War and the rise of America as the sole global superpower. With the fall of the Berlin Wall and the disintegration of the Soviet Union, the United States found itself standing alone in an extraordinary vacuum of power, a vacuum that it hastened to fill. Every nation looks out for its own interests, yet historically such interests have been kept in balance by the need to maintain friendly relations with other countries and form common alliances. Since the end of the Cold War, however, America's exceptional power has enabled it to act in an increasingly unilateral fashion. This unconstrained self-interest is reflected in a pattern of international treaties and agreements the United States has abrogated or refused to ratify, including the Treaty of Rome calling for the founding of an international criminal court, the Basel Convention on the Control of Transboundary Shipments of Hazardous Wastes, the Anti-Ballistic Missile Treaty, and the Kyoto Protocol for Global-Warming Prevention.

The most significant post–Cold War transformation is the emergence of the doctrine of American global military dominance promulgated for over a decade by political figures such as Dick Cheney, Paul Wolfowitz, and Colin Powell but not fully realized until after the Bush victory in the 2000 election. In a speech at West Point in June 2002, Bush said America must forestall the rise of another superpower by maintaining "military strengths beyond challenge" and articulated the new policy of preemption by saying, "We must take the battle to the enemy,

disrupt his plans and confront the worst threats before they emerge."[4] With the recent invasion of Iraq, this doctrine has evolved beyond mere ideology into an overt expression of unilateralist military strategy.

In 2002 the Pew Global Attitudes Project surveyed 38,000 individuals in forty-four countries concerning their opinions of the United States. Conducted well in advance of the widely unpopular war against Iraq, the results of this survey already confirmed that world views of America had lurched toward the negative, even among some of its staunchest allies and the recipients of copious amounts of its foreign aid. Some American pundits responded to this data by suggesting that such negativity is inevitable when you are the "biggest, richest, and strongest kid on the block."[5] According to this perspective, no matter how positive the contribution of the United States to global freedom, democracy, and prosperity, the simple fact of its success will lead a certain proportion of the world population to resent or even hate America. Others believe that not all of the recent policies adopted by the United States have had their intended effects and that we may well have squandered an enormous reservoir of goodwill by opting for global dominance over worldwide cooperation. "In general," the Pew report reads, "respondents to the global survey are more critical of U.S. policies than they are of U.S. values. More specifically, there is a strong sense among most of the countries surveyed that U.S. policies serve to increase the formidable gap between rich and poor countries."[6] Even among our allies in the developed world such as Germany, France, and Canada, "roughly 70 percent say U.S. policies serve to widen the global economic

Danwen Xing, Untitled, *from the series "disCONNEXION,"* 2003

divide."[7] Interestingly, the study notes, "antipathy toward the U.S. is shaped more by what it *does* in the international arena than by what it *stands for* politically and economically. In particular, the U.S.'s perceived unilateral approach to international problems and the U.S. war on terror play large roles in shaping opinion toward the U.S."[8] Another somewhat paradoxical finding of the study is that "even those who are attracted to many aspects of American society, including its democratic ideas and free market traditions, object to the export of American ideas and customs."[9]

What we are calling here "the American effect" refers not only to the material, cultural, and political consequences of America's policies and activities abroad, but also America's influence on a psychic, even subconscious level. The works in this exhibition explore the ways in which the idea of America has come to be seen increasingly from abroad as an almost mythic power. Its presence in the world can be measured, on the one hand, by the impact of the newest Hollywood movies or sports heroes, the volume of hazardous waste sent from its shores to foreign countries, or by the emulation of, or antagonism toward, its constitutionally guaranteed liberties. But it can also be measured by exploring images that represent a state of mind in which America appears to have the power of an archetype. "Archetypes are typical modes of apprehension," explained C.G. Jung, "and whenever we meet with uniform and regularly recurring modes of apprehension, we are dealing with an archetype, no matter whether its mythological character is recognized or not."[10] By invoking the notion of the archetype and positioning an aspect of this exhibition in the domain of the psychological, I do not mean to denigrate as fantasy the astute observa-

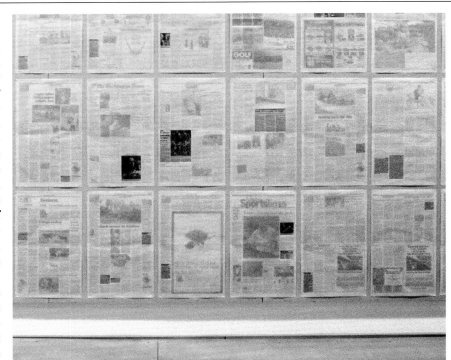

ABOVE AND RIGHT: **Siemon Allen**, Newspapers, 2001–02 *(installation view at Fusebox, Washington, D.C.)*

tions many of these artists bring to their very real subjects. Phenomena can be both real and symbolic, and indeed this is the special, complex condition that defines "the American effect." Thanks to its extraordinary power, America's actions are more than simple deeds; in the realm of the imagination, they embody the limits of possibility, whether perceived as good or evil. This is a powerful position to occupy, but also a vulnerable one. As the global hegemon, America bears the weight of humanity's hopes, but it must also bear the brunt of resentment and, some of these artists suggest, assume responsibility for humanity's shattered dreams.

In fact, America has fascinated the world for centuries, though initially not for its ubiquity and hegemonic power but for its perceived newness, uniqueness, and future promise. In his seminal study of American

character and society published in 1782, French author J. Hector St. John de Crèvecoeur, writing in the guise of a successful American farmer, asserted:

In Italy, all the objects of contemplation, all the reveries of the traveler, must have a reference to ancient generations and to very distant periods, clouded with the mist of ages. Here, on the contrary, everything is modern, peaceful, and benign. Here we have no war to desolate our fields; religion does not oppress the cultivators; we are strangers to those feudal institutions which have enslaved so many. . . . Here everything would inspire the reflecting traveler with the most philanthropic ideas; his imagination, instead of submitting to the painful and useless retrospect of revolutions, desolations, and plagues, would, on the contrary, wisely spring forward to the anticipated fields of future cultivation and improvement, to the future extent of those generations which are to replenish and embellish this boundless continent. . . . Here he might contemplate the very beginnings and outlines of human society, which can be traced nowhere now but in this part of the world."[11]

CALL NOW!
Redskins
Club
Level
Season
Tickets!

SPORTS

...agnussen, Panoz Win Rubber Match

Elimination Game
Els Loses Lead, Survives Four-Man Playoff, Wins on Fifth Extra Hole

More Than a Little, Doubt About It

LETTERS TO THE EDITOR

WORLD NEWS

China and Taiwan Back Away From New Confrontation

After 186 Years, Human Rites

Zimbabwe Ends Altered Corn Dispute

...pen Championship No Easy Task

Warehouse Sale!
Saturday, August 10 from 9 to 4pm
Sunday, August 11 from 12 to 4pm

Hatfill's Lawyer...

THE AMERICAN EFFECT

Muhammad Imran Qureshi, To Be or Not to Be, 2002

THE AMERICAN EFFECT

Crèvecoeur was among the first to voice the notion that America, however different from the rest of the world, was not so much an exception to the global norm as an adumbration of a global future. "Here individuals of all nations are melted into a new race of men," he wrote, "whose labours and posterity will one day cause great changes in the world."[12] Today the term *Americanization* is understood everywhere.

In the immediate aftermath of the attacks on the World Trade Center and Pentagon, the front-page headline of the leading French newspaper *Le Monde* read, "We Are All Americans"—a remarkable declaration in a country that, more than most, has actively resisted the importation of American language, customs, and commodities. Yet this pledge of fraternity has evaporated in the face of multiple currents of difference and disagreement. Indeed, it would be a grave mistake to imagine that the whole world is now American or that it even wants to be. It could be said that it is precisely the fault lines between American ubiquity and the alternative visions of the non-American imagination that has made today's world as unstable as it is. President George W. Bush's assertion "Either you are with us or you are with the terrorists" appears to have been one of the factors that triggered the decline of the United States in global public esteem. The perception that America wants things its way or no way at all has created an environment that challenges the sympathies of even its closest allies.

Even so, it is evident in a number of works in this exhibition how the prevalence of American culture abroad has instilled in foreign artists a reservoir of symbols, stylistic effects, and outright sympathy that renders their work as familiar as if it was made by an American native. Even among those abroad who oppose United States policies, there can be a sense of belonging to an essentially American world. Meanwhile, other artists in this exhibition explore fractures that exist in American society itself, palpable tensions created by differences of identity—of ethnicity, ideology, and class—that continue to make some feel like they belong and others like they do not.

The artists selected for "The American Effect" include some who have never been to this country, but simply imagine it from afar or, in a number of cases, witness its material impact on their daily lives, no matter how geographically distant they may be. Other artists have traveled to America, encountered directly daily life in its cities, towns, and countryside, and measured these experiences against their expectations. Still others are immigrants, who, despite their status as legal aliens or even new American citizens, believe that they bring to bear upon their art the point of view of an outsider.

Some of these artistic visions may be disturbing or infuriating. There are images of violence against the United States, images that speak of tremendous resentment, hostility, and desire for revenge. At a time when Americans are feeling especially vulnerable to threats of terrorism and our military forces have been engaged in overseas combat, it may seem imprudent to exhibit such works. The point of this exhibition, however, is neither to enflame passions nor to denigrate America. On the contrary, this exhibition should prove by example the vitality of American society and culture and the unique strength that derives from an openness to difference. Artists play a crucial role as barometers of feeling, expressing currents of thought and emotion that course through soci-ety at both conscious and unconscious levels. Sometimes, difficult images are precisely what are needed to remind us of our vulnerabilities and shock us into greater awareness of the realities of the world around us. While some viewers will be surprised by the extent of hostility represented in this exhibition, others will find the works generally more sympathetic than they expected. In fact, there is a considerable amount of positive commentary here, and many of these artists still draw on a powerfully utopian image of the United States.

Ironically, despite the pervasive global reach of the United States, many of its citizens know exceedingly little about the rest of the world, let alone about what the rest of the world thinks of them. This is not a recent phenomenon: historically, Americans have been relatively disconnected from global concerns. Isolated by oceans on either side and endowed with the resources to be virtually self-sufficient, America has for centuries turned its attention inward. In his 1831 classic, *Democracy in America*, Alexis de Tocqueville wrote that the majority of Americans "[live] in a state of perpetual self-adoration; only strangers or experience may be able to bring certain truths to the Americans' attention."[13] Yet experience of others is precisely what we Americans are lacking. Remarkably, only 14 percent of Americans today hold passports.[14] Lacking direct experience and subject to the filtering power of the media, many Americans have found themselves caught off guard by global reactions to America's recent policy decisions. The September 11 attacks were the first indication to many here of the intensity of anti-American feeling in certain quarters of the world. Similarly, many Americans were astonished by the widespread antipathy around the globe to United

States intervention in Iraq. To some, it may have even seemed that American values were at odds with those of the entire world. However, as the recent Pew survey indicates, when America is disliked, it is generally for its policies, not for its values. From afar, such nuances can be easily lost. Perhaps, as de Tocqueville suggested, we should take the time, especially now, to pay attention to strangers.

As it has for hundreds of years, the United States continues to signify for many the possibility of happiness, success, and freedom. Japanese artist Miwa Yanagi's riveting photograph, *Yuka*, is part of a series called "My Grandmothers," for which the artist asked young Japanese women to describe how they imagined their ideal old age. In this image we see a mature woman, teeth gleaming and hair flying as she rides ecstatically in the sidecar of a motorcycle driven by a handsome young man across the Golden Gate Bridge. Here, the fantasy of American exuberance and unlimited opportunity is expressed with unabashed idealism. Even more fantastical is Congolese artist Bodys Isek Kingelez's impression of Lower Manhattan in the year 3021. In this sculptural model, the corporate towers of New York's financial center have been transformed into a Las Vegas–like wonderland replete with flamboyant color and gaudy decoration. Completed after September 11, 2001, Kingelez's work suggests a strong faith in the American capacity for recovery and regeneration.

For Polish artist Pawel Kruk, impersonating the basketball star Michael Jordan is a way to gain access to what he perceives as an emblematically American aspiration to perfection. His single-channel video, *Larger Than Life*, is a faux interview with Jordan, in

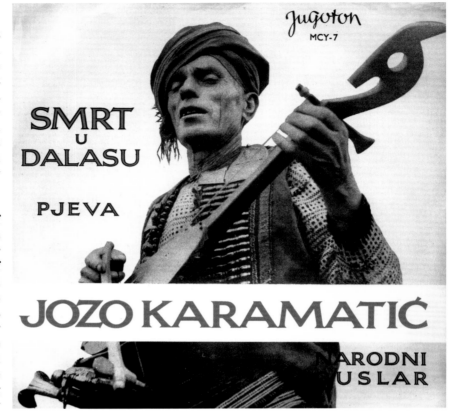

ABOVE: **Zoran Naskovski**, *album cover from* Death in Dallas, 2000
RIGHT: **Andrea Robbins and Max Becher**, Blonde, *from the series "German Indians,"* 1997–98

which Kruk himself plays the role of the basketball superstar, using lines borrowed from Jordan's 1993 autobiography *Rare Air: Michael on Michael.* "I don't remember the fall of communism," says Kruk, "but the day of the first televised NBA game in Poland is a day that changed my life. For me, Michael Jordan is the embodiment of the American possibility of achievement."[15] Impersonation and simulation are also at the core of Andrea Robbins's and Max Becher's photographic series titled "German Indians," which documents the phenomenon of a German—especially East German—fascination with the culture, fashion, and history of Native Americans. Inspired by the turn-of-the-century German ethnographer Karl May, numerous hobby clubs, where members gather for powwows and strive for authenticity in their emulation of American Indians, have formed across Germany. In another series of photographs, "Wall Street in Cuba," Robbins and Becher show the decaying buildings of the old financial district of prerevolutionary Havana in which monumental Beaux-Arts and neoclassical banks mirror the power and prestige of their American models.

Throughout the world, one of the most potent symbols of America as a utopian ideal is still the image of John F. Kennedy. Zoran Naskovski's installation, *Death in Dallas,* is inspired by a Herzegovinian epic ballad that was written in homage to Kennedy shortly after his assassination. The decasyllabic verse is sung by Jozo Karamatić, who accompanies himself on an ancient Balkan stringed instrument known as a *gusle.* The ballad is remarkable for its detail: we even

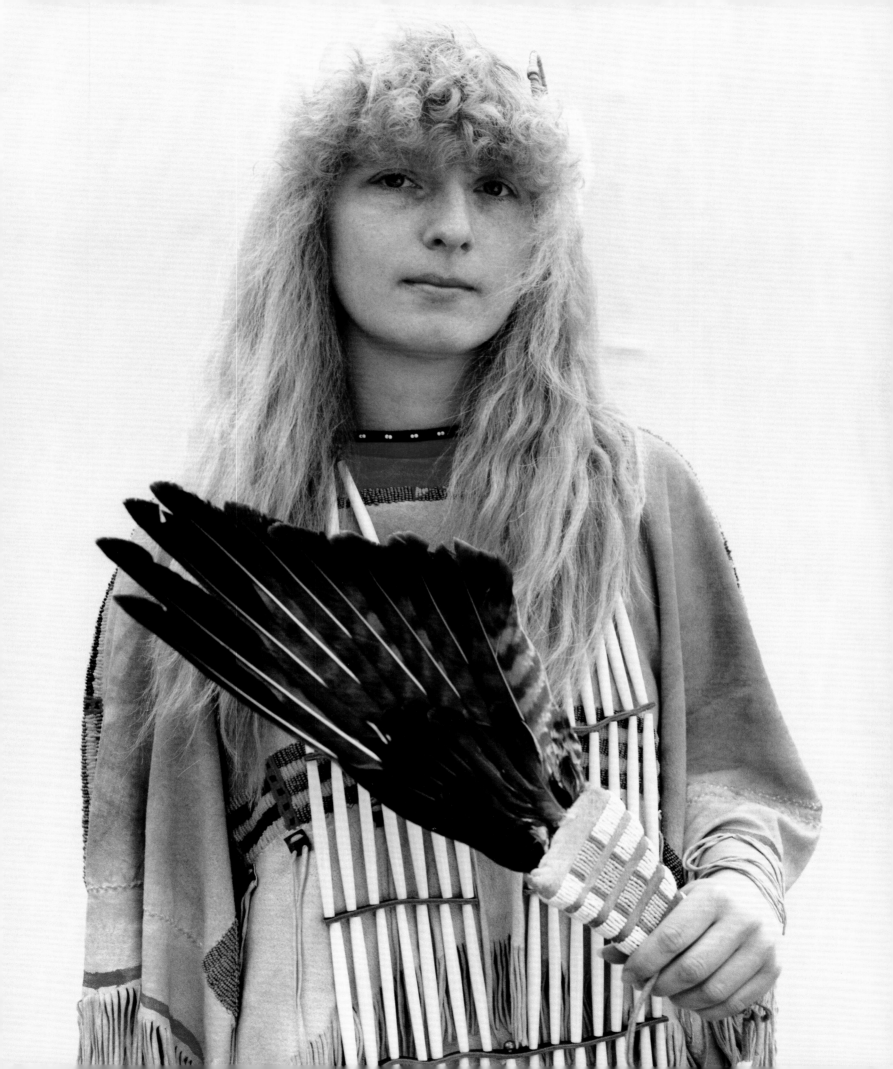

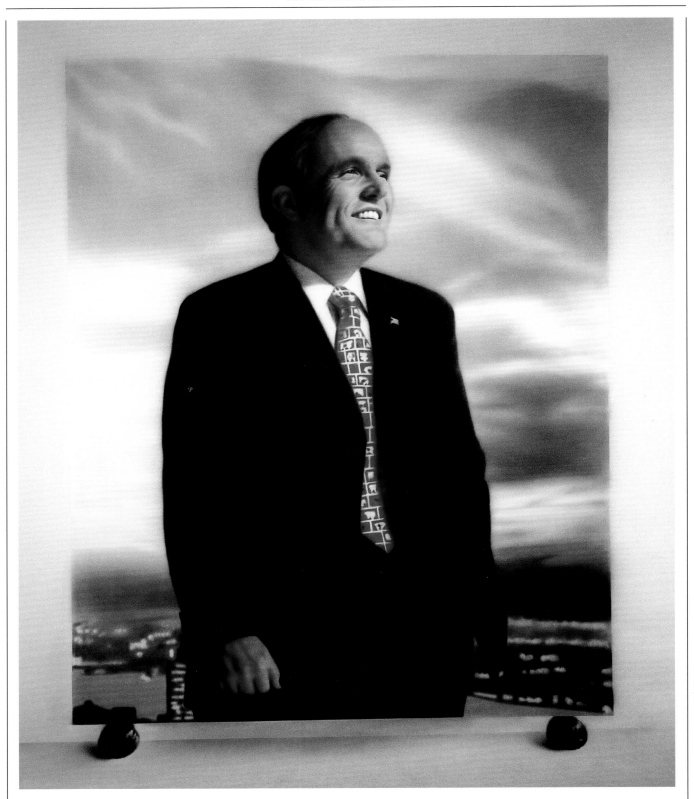

Zhou Tiehai, LIBERTAS, DEI TE SERVENT!, 2002

learn, for example, the name of the attending nurse at the hospital where Kennedy's body was taken. The singer's vocal style is visceral, a coarse, throaty wail that seems to have been carried across the centuries from some primordial funeral rite. Accompanying the soundtrack is a video projection in which Naskovski has combined footage of Kennedy and his family in happier days with shocking imagery of the assassination itself.[16] Kennedy also figures in a work by Russian artist Sergei Bugaev, who goes by the name Afrika. Drawing on his training as a psychotherapist to explore the ways in which the influence of America has entered into the global subconscious, Afrika created what he calls "dream machines." The works are composed of old Russian folk objects, such as spinning wheels, wooden sleds, and keepsake chests, which he assembled around sheets of titanium covered with kitsch American political souvenirs, including carpets emblazoned with images of John F. Kennedy or Martin Luther King, Jr. Afrika encouraged various friends and acquaintances to sleep on these "beds," and when they awoke, he took notes on their dreams, seeking evidence of the psychic intersection of Russian and American identities.

Some expressions regarding America's accomplishments come leavened with healthy doses of irony and skepticism. British artist Maria Marshall's video includes a soundtrack of her seven-year-old son reciting an excerpt from a speech President Bill Clinton delivered on November 13, 1993, in Memphis, Tennessee, extolling the virtues of work and discipline in maintaining an orderly American family. However, the image on the video loop consists of Marshall's two little boys wantonly unwrapping a large roomful of presents. In this work, Marshall captures the peculiarly American clash of Puritan rigor and consumerist excess. German artist Bjørn Melhus's feature-length video, *Far Far Away*, uses the almost universally recognizable imagery, characters, and narrative of *The Wizard of Oz* to explore the powerful feelings of inferiority and aspiration that underlie his personal perspective on America. The dialogue of the film is composed entirely of snippets edited from the soundtrack, from its original English as well as its German version. Melhus has reworked the story to allow for one German and one American Dorothy, both played by Melhus himself. German Dorothy dreams of going to Oz (America) to be reunited with her American doppelganger. Their meeting is endlessly frustrated by the fact that German Dorothy can never seem to escape from her dowdy Bavarian apartment, while the cosmopolitan American Dorothy flashes from coast to coast, appearing on talk shows and ultimately fracturing into a sheer, evanescent telepresence. Irish artist Gerard Byrne's installation, *why it's time for Imperial, again*, includes a video dramatization of a dialogue between Frank Sinatra and Chrysler Corporation chairman Lee Iacocca that was originally published in 1980 as an advertisement in *National Geographic* magazine. Their conversation consists of a friendly debate on the merits and timeliness of the newly improved version of one of the car manufacturer's leading models. As such, it serves as a kind of time capsule of American taste and consumer-oriented marketing strategy. However, by setting their dialogue in the midst of a run-down industrial district, Byrne comments on the inevitable obsolescence of even this highly touted new product.

French artist Gilles Barbier humorously captures the aging of America's beloved comic-book superheroes—archetypes of power and invincibility. In his life-size tableau, *Nursing Home*, a group of them—including The Incredible Hulk, Catwoman, and Superman—relax in the lounge of a nursing home, looking as they would had they aged normally from the date of their first comic-book appearance. Mr. Fantastic's elastic limbs have lost their ability to retract and sprawl limply across the table and floor, while Captain America reclines on a gurney attached to an IV. Chinese artist Zhou Tiehai takes on another American superhero, the mayor of New York City during the September 11 attacks, Rudolph Giuliani. His portrait of the mayor, *LIBERTAS, DEI TE SERVENT!*, is based on *Time* magazine's person-of-the-year cover illustration for 2001, but also draws on the "great leader" archetype familiar to the genre of socialist realism. In this large-scale painting, Tiehai substitutes for the more typical figure of Stalin, Lenin, or Mao the American mayor who since September 11 has become world-renowned. Tiehai, however, unexpectedly adds two balls of elephant dung beneath the canvas, a thinly veiled reference to Giuliani's censure of artist Chris Ofili's contribution to the Brooklyn Museum's "Sensation" exhibition in 1999.

America can be seen as simultaneously inspiring dreams of salvation while conjuring aching feelings of disappointment. In his highly idiosyncratic video, *Amerika*, Norwegian artist Ane Lan, dressed as a woman in Middle Eastern attire, reclines in an Orientalist setting while singing: "Amerika, Amerika, where are you now? Who are your deep wound? Who are your face? What have you done with our ability? Who shall I call upon if you are not there? Where are your heart that beats? [*sic*]" A similar sense of disappointment in the promise of American justice and freedom infuses Finnish artist Veli Granö's documentary film, *A Strange Message from Another Star*. It concerns Paavo

THE AMERICAN EFFECT

ABOVE AND RIGHT: **The Builders Association and moti**roti, *stills from* How to Neuter the Mother Tongue, 2003, *excerpt from* ALLADEEN

Rahkonen, whose father immigrated to America from Finland to escape the bloody chaos of the Finnish civil war. From an early age, Rahkonen was obsessed with creating and using rocket fuel and eventually became the designer of a type of fuel used to power the space shuttle. However, disillusioned by America's use of atomic weaponry against Japan and convinced that the United States government is hiding information from its populace, Rahkonen moves to the outback of Utah and devotes himself to developing a rocket and fuel that can propel him to safety on another planet. Norwegian artist Jannicke Låker's video *No. 17,* meanwhile, presents a powerful interplay between the opposing forces of attraction and repulsion in an encounter she has with a young American in Oslo. In this disturbing and even sadistic work, Låker appears to lure the innocent young American tourist into her apartment, where, while continually filming, she convinces him to strip, show off his muscles, and dance. In a final act of humiliation, she throws the hapless fellow out of her apartment, tossing his shoes into the hallway after him. Despite its harrowing approach, Låker's *No. 17* symbolically represents a widespread fantasy of challenging America's perceived omnipresence and naivete. The format of the video, the artist explains, is derived from the Jerry Springer–style television talk show: "To explore people's privacy, to make embarrassing situations, to give people sitting at home on their sofas a tickling, thrilling feeling—it was made," says Låker, "as naked, private and embarrassing as possible."[17]

America's image abroad is heavily influenced by the fact that American industry and capital now extend throughout the world. Indeed, Americans sometimes export their free-market ethos with almost missionary zeal. Artist Bjørn Melhus was walking in East Berlin on the day of the unification of the German monetary system following the fall of the Berlin Wall when he came across a troupe of American teens performing an enthusiastic and lyrical paean to American culture. He videotaped their song-and-dance number and edited it into a searing expression of American economic rapacity titled *America Sells.* Another work examining the effects of America's demand for a global free-market economy is *Life and Debt* by Stephanie Black. This documentary, based on Jamaica Kincaid's book *A Small Place,* explores the devastating impact of World Bank and IMF lending policies on Jamaican agriculture and industry. In the 1980s and 1990s, in a pattern that has been repeated throughout the world, Jamaica slid into a debilitating spiral of debt and dependency that

SHARU JOSE
Trainer/Supervisor

eviscerated the local economy and undermined social stability.

America's vast wealth and productivity creates enormous amounts of waste, waste that is often disposed of overseas. Danwen Xing, a Chinese artist, has made a series of large-scale photographs, titled "disCONNEXION," depicting the so-called e-waste that is shipped from America and dumped in Guangdong province on the south coast of China to be sorted and "recycled" by local laborers. The volume of e-waste shipped to China in 2002 alone was estimated to include over 10.2 million computers, as well as additional millions of computer keyboards, printers, monitors, and other peripheral devices.[18] Drawn by the prospect of work, laborers from China's impoverished West migrate to these areas, where they become specialized in sorting and recycling various computer parts and materials and inhabit communities known by their specialty, i.e.,

HP Laser Jet Town and HP Ink Jet Town. A recent article in *Barrons* magazine describes Chinese women "roasting circuit boards over charcoal fires to melt out the solder for its lead, using nitric acid to free small amounts of gold from electrical contacts, and dumping leftover sludge into local rivers, swamps, and agricultural irrigation canals."[19] Xing's photographs of these sorted piles of e-waste are strangely beautiful testimonies to the normally invisible consequences of America's environmental and export policies. America exports not only its physical waste but also its more menial jobs abroad. One remarkable example of this is the phenomenon of call centers that have sprung up in the Indian city of Bangalore to provide phone operators to American and British service industries. The Builders Association, a U.S.–based theater company, and **moti**roti, a London-based artist collective, have recently co-pro-

duced a video on this topic in conjunction with their recent theater work, *ALLADEEN*. In the video, a call-center trainer explains the procedures by which young Indian employees are inculcated in American culture and speech patterns so that they can pass as Americans to their telephone interlocutors. After undergoing an instructional process known as "neutering the mother tongue," they are given American names and are told never to reveal their true identities or location.

Some artists take on the role of a witness, documenting in an almost anthropological way America's land and people. Olu Oguibe, a Nigerian artist who has lived in the United States for nearly a decade, created a series of annotated drawings depicting the American populace as seen by an imaginary nineteenth-century British traveler. In this guise, Oguibe comments simultaneously on how America has been an object of fascination and

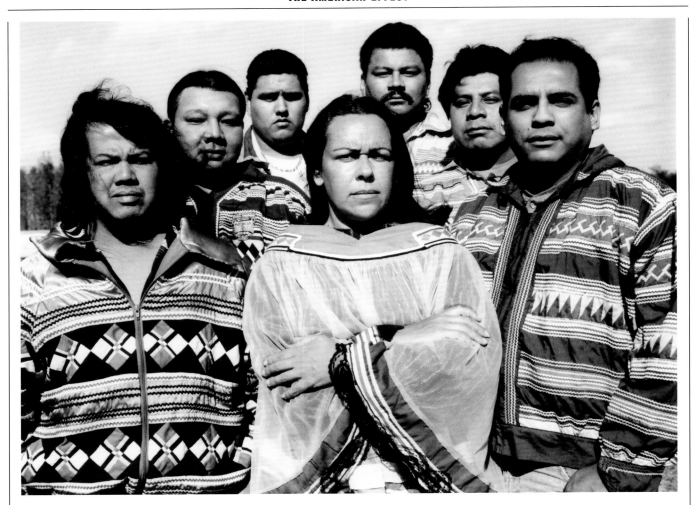

on how it has often perpetuated stereotypes of race, class, and social groups inherited from Europe. Canadian-born artist Mark Lewis's soundless film, *Jay's Garden, Malibu,* presents a tour around a Malibu garden designed by the leading Los Angeles landscape architect Jay Griffith. Using that quintessentially American medium, 35-mm film, Lewis shot with a steadycam, which allowed for a seductively smooth cinematic flow through the pastoral scene. With scantily clothed adult film actors—selected by Lewis from among the leading porn stars of Los Angeles—wandering in and out of the camera's view, the sense of voyeurism in the work is unmistakable. "You could, I suppose, see the film as a mapping of the porn utopia [*sic*] (the idea

of porn is more or less premised, one presumes, on the idea that pleasure can and will erupt at any moment and with anybody) onto an American utopic landscape."[20] A renegade, countercultural attitude widely identified with the American West is captured as well in *Dakota,* by YOUNG-HAE CHANG HEAVY INDUSTRIES, a South Korean collaborative duo made up of Young-hae Chang and Marc Voge. The great American road trip and antiheroic characters familiar to such classic narratives as *On the Road, Thelma and Louise,* and *Natural Born Killers* are evoked in this hard-driving, Internet-based work. Using strobelike flashes of text accompanied by a frenetic Art Blakey drum solo, *Dakota* gives a peek into the lives of a

pack of dissolute American teens only to reveal itself as a flight of pure fantasy, imagined from inside the confines of a traditional Korean home on the other side of the Pacific Ocean. *The Last Road Trip,* by Dutch artist Arno Coenen, is a journey through an intensely urbanized American landscape. Digitally manufactured and apocalyptic in tone, *The Last Road Trip* takes the viewer on a fast-paced psychedelic trip through a dystopian vision of Southern California, encompassing glimpses of fast food, suicide, police surveillance, pornography, fiscal mayhem, and religious sloganeering.

Other artists dig deeper into American history to focus on episodes that proved crucial in shaping America's identity, often in ways that suggest

THE AMERICAN EFFECT

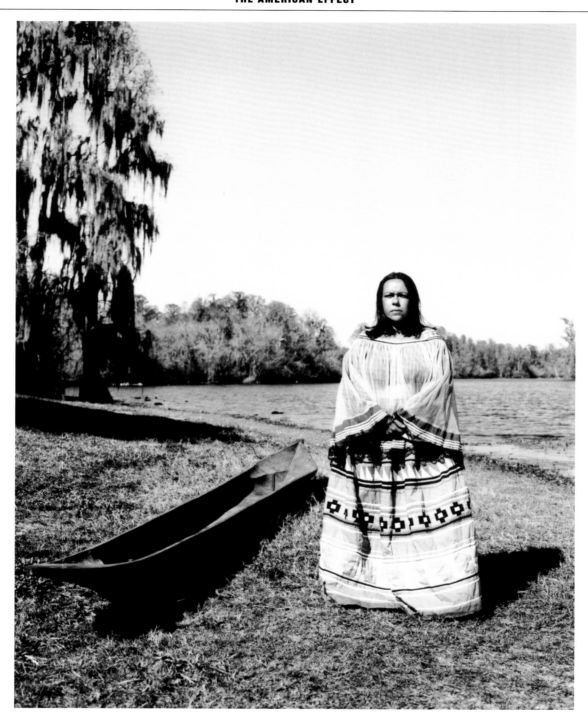

ABOVE: **Fiona Foley**, Wild Times Call 6, 2001
LEFT: **Fiona Foley**, Wild Times Call 2, 2001

parallels with their own country's past. Egyptian artist Amina Mansour's sculpture consists of a partially gilded wooden vitrine containing a floral bouquet made of cotton. Attached to the front of the vitrine is a small porcelain plaque with a hand-painted image of an American antebellum mansion. For Mansour, the investigation of national identity is fraught with fantasy and inextricably linked to issues of class and gender. In this deceptively simple, richly poetic work, Mansour—who was born in Alabama and resides in Alexandria—draws an implicit link between America's pre–Civil War era Deep South and prerevolutionary Egypt, both cultures in which the ruling classes amassed great wealth through cotton cultivation. A certain feminine complicity in the oppressive social structures that made such wealth possible is evoked by the genteel floral arrangement and by the manicured woman's hands upon which the vitrine stands. Fiona Foley, an Australian artist of the Badtjala people, similarly grounds her work in an earlier era to express her own complex relationship with American society and culture. In her series of photographs titled "Wild Times Call," she mimics the tone and composition of the faux documentary studies of Native Americans by the early-twentieth-century photographer Edward Curtis. In one image, Foley appears as a Seminole Indian, dressed in traditional garb and posed in the natural landscape of Southern Florida, the Seminole's ancestral home. In another image, Foley, still in Seminole dress, appears with a group of Seminole men. Presented in a straightforward pose, they confront the viewer with their contemporaneity and solidarity. Senegalese sculptor Ousmane Sow reinterprets America's campaign against its own indigenous people with a tableau of life-size figures crafted of wire, mud, and cloth depicting the

defeat of Lieutenant Colonel George Armstrong Custer and the Seventh Cavalry at the Battle of the Little Big Horn. Sow, who had a long career as a physical therapist before he became a professional artist at the age of fifty, renders his figures not so much with external as internal anatomical precision. Their forms are based on muscle, skeletal, and organ structure as opposed to the more conventional surface-oriented modeling of the body. Sow's unique approach endows each of his figures, whether soldier or Indian, with an equally fragile and tender feeling of human vulnerability.

America's extensive military involvements over the past hundred years have left a trail of resentment and even fantasies of revenge. In *A Picture of an Air Raid on New York City,* Japanese artist Makoto Aida turns the tables on America's devastating bombing of Japanese cities in World War II. In this striking image, a squadron of Japanese fighter planes, forming the infinity sign, flies above a horrific scene of contemporary midtown Manhattan in flames, recalling both the traditional Japanese style of *Senbazuru* ("a thousand paper cranes") and the genre of hell scenes known as *Jigokuezu.* This work is based on Muromachi-era (1338–1573) folding screens, though here cheap paint is substituted for the customary gold leaf and holographic paper for mother-of-pearl inlay. "I am not in favor of attacking America," says Aida, "but this is an image that came into my mind."[21] The piece is part of the "War Pictures Returns" series, which is comprised of eleven works concerning World War II–era violence, including atrocities committed by Japan during its occupation of Eastern Asia. In *MaMcKinley,* Filipino artist Alfredo Esquillo, Jr., portrays President William McKinley, who led the United States during the bloody three-year war in which America

asserted control over the Philippines (1899-1901). McKinley, who said that his aims were to "uplift and civilize and Christianize" the Filipinos, is represented as a dowdy Victorian matron protectively holding a young Filipino child.[22] However, *MaMcKinley's* hands look like nothing so much as rapacious, reptilian claws. American author Mark Twain, writing at the time of the Philippines War, commented, "We have pacified some thousands of the islanders and buried them; destroyed their fields; burned their villages . . . subjugated the remaining ten millions by Benevolent Assimilation, which is the pious new name of the musket. . . . And so, by these Providences of God—and the phrase is the government's, not mine—we are a World Power."[23]

America's military is more pervasive than ever before, and its effects are profound and immeasurable. Yongsuk Kang draws attention to the cumulative effect of fifty years of American test bombing in South Korea at the Kooni Firing Range on Nong Island near the village of Maehyang. Rarely reported in the United States media, these bombings have resulted in numerous deaths and injuries among the nearby villagers. For Kang, it is important to maintain a sense of objectivity about this highly charged subject. "Many war photographers approach their subjects in a sentimental way," he writes. "My photos of Maehyang village are not true war photos, but photos of military exercises. However, although America is our ally, its military exercises are like a real invasion, a real war. My photos try to take an objective, unsentimental look at this invasion at once emotional and real, and the tragedy of modern Korean history."[24]

Among the other consequences of the American military presence in Korea are the so-called camp towns,

Yongsuk Kang, Untitled, *from the series "Maehyang-ri,"* 1999

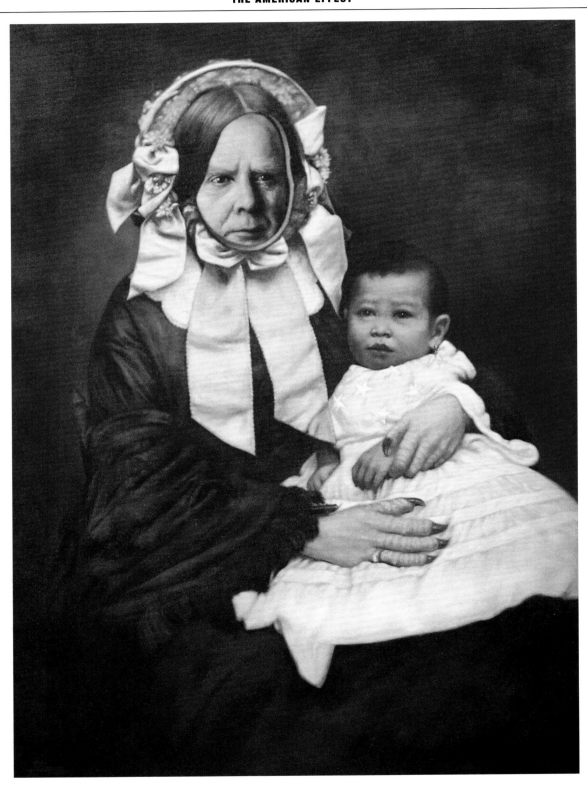

ABOVE: **Alfredo Esquillo, Jr.**, MaMcKinley, 2001
RIGHT: **Miguel Angel Rojas**, Bratatata, 2001 *(detail)*

THE AMERICAN EFFECT

THE AMERICAN EFFECT

sprawling complexes devoted to prostitution that exist on the periphery of some 100 American military bases spread throughout the country. In their documentary film, *The Women Outside,* JT Orinne Takagi and Hye Jung Park relate the story of several women whose lives have been transformed by their involvement in this shadow economy, an economy officially decried by both the Korean and American governments but unofficially tolerated and even actively sustained. For his "Legendary Warriors" series, Japanese artist Hisashi Tenmyouya created paintings reminiscent of the *musha-e* ("warrior picture") prints of nineteenth-century artists such as Utagawa Kuniyoshi and Tsukioka Yoshitoshi. A self-taught artist with an early career as a graffiti tagger, Tenmyouya mixes contemporary and traditional designs and motifs. Several works from the "Legendary Warrior" series address American military activities throughout the world. Some deal with real historical events while others, such as *Tattoo Man's Battle,* are more symbolic. In this work, Tenmyouya represents a David and Goliath struggle between Japan, depicted as a mounted warrior with a glowing sword, and the United States, shown as a monstrous figure spewing fire from his several leering mouths. In *Bush vs. Bin Laden,* Tenmyouya shows a grisly image of President Bush literally tearing Bin Laden to shreds against a backdrop of the burning World Trade Center. A text written directly on the picture reads: "It is a rule that you punch the other back if he punches you first. That is the start of the war named 'revenge,' although we all know that a number of people will be killed. . . . No one can afford to sing John Lennon's 'Imagine' easily at this moment. . . . Everyone knows that peace would be

best . . . but who could possibly achieve peace on earth as long as there are differences in wealth and ideology." Another work in the series, *Black Ships, Atomic Bombs and the Greenville,* represents various challenges that the Japanese have faced from America. "Black Ships" refers to the four black warships commanded by Commodore Matthew Perry that sailed into Tokyo harbor in 1853 and forced Japan to open to the world. Having never seen steamships before, some Japanese thought they were giant dragons puffing smoke, represented here by the artist as the mushroom cloud of the nuclear bombs dropped on Hiroshima and Nagasaki in 1945. The periscope on the ship refers to the more recent incident in which the Japanese fishing vessel *Ehime-Maru* was sunk by an American submarine, the U.S.S. *Greenville,* in the Pacific Ocean near Hawaii. For Colombian artist Miguel Angel Rojas, too, the American effect consists of tremendous and conflicting pressures on his country: on the one hand, the overwhelming American demand for Colombian drugs—a market that sustains the finances of the rival left- and right-wing insurgencies— and on the other, the American-assisted militarization of drug interdiction. With works made of tiny bits of American dollar bills and coca leaves, Rojas creates images that speak of the subtle infiltration of these opposing forces into the very fabric of Colombian society.

The delicate balance between America the Protector and America the Oppressor is captured in works by two Pakistani artists, Saira Wasim and Muhammad Imran Qureshi. In *History till 11 September,* Wasim reinterpets Raphael's painting *The School of Athens* as a Mughal-style miniature to create an image of contemporary

American imperial power. Here, President George W. Bush, swathed in an American flag, is welcomed by the host of scholars. However, rather than contemplating the nature of the universe, we see that these academics are busy designing missiles. Behind Bush, Pakistani president Pervez Musharraf, disguised as a tiger, salutes the American president. In *Friendship After 11 September 1,* Bush and Musharraf embrace beneath a kind of ceremonial pergola while beneath them parade Pakistani mullahs (disguised as sad clowns) and an array of familiar American icons, such as Ronald McDonald and the Statue of Liberty. *Friendship After 11 September 2* draws on French neoclassical painting in its portrayal of Bush as victorious Roman emperor. In *The Kiss,* Wasim shows Musharraf happily working on a computer while American and British cherubs blow kisses and hover adoringly by his side to express their appreciation for his support of the war against terrorism. Also working in the traditional miniature format, Qureshi uses abstract imagery to refer to recent American military actions and attitudes. In his painting *Take It or Leave It,* he shows boxlike forms, one decorated with camouflage and another with finely drawn leaves, that symbolize, respectively, the bombs and the boxes of food that the American airforce simultaneously dropped on Afghan villages. Another work, *To Be or Not to Be,* shows simple targets overlaid on shrublike patterns of leaves indicating, in the artist's words, "no matter whether for good or for bad, everyone today is a target of America. And the result is always the same . . . Destruction!!!"[25] Heiner Stadler's film, *Eat, Sleep, No Women,* also concerns the American-led war in Afghanistan. The film takes place on

Hisashi Tenmyouya, Tattoo Man's Battle, 1996, *preliminary sketch for the series "Legendary Warriors,"* 2000–02

ABOVE: **Saira Wasim**, History till 11 September, *from the series "Bush,"* 2002
RIGHT: **Saira Wasim**, Friendship After 11 September 2, *from the series "Bush,"* 2002

Sherine Salama, *still from* A Wedding in Ramallah, 2002
PAGES 38–39: **Heiner Stadler**, *still from* Eat, Sleep, No Women, 2002

October 7, 2001, when the first strike was made against the Taliban regime. Weaving together documentary and fictional narrative, Stadler creates a compelling portrait of the global reverberations of America's actions on a single fateful day: a billboard painter in Rawalpindi worries that the date set for his wedding may be delayed due to anti-American attacks on a local movie theater; near the Amazon, two miners' spirits soar when the price of gold shoots up; and an Egyptian pop star contemplates canceling his upcoming American tour.

Several artists examine America by studying its mass media. In their three-channel video, *The Golden Age*, Cubans José Angel Toirac and Meira Marrero Díaz in collaboration with American Patricia Clark present a selection of Cuban and American news coverage of the Elían Gonzalez incident. "During the video,"

they write, "the trauma of this particular child is developed, and one sees in the situation a climax of historical political tensions between Cuba, the United States, and the extreme right-wing Cuban-American community in Miami."[26] The piece is organized to echo the structure of the influential 1889 children's book *La Edad de Oro (The Golden Age)* by José Marti, the celebrated writer and leader of the Cuban independence movement. The philosophical basis of Marti's thought was humanist," note the artists, "and was permeated with the ideals of the French Revolution. Our work is designed spatially on three monitors to reference Francis Ford Coppola's version of Abel Gance's *Napolean*, as well as the tricolor flags of France, the United States, and Cuba."[27] The final section of the video reconnects the Gonzalez incident to events of the recent past, such as the American-

sponsored invasion at the Bay of Pigs and the Cuban Missile Crisis. Siemon Allen similarly reflects on the American news media and its relation to his home country, South Africa. To create his installation, *Newspapers*, Allen collected every issue of the *Washington Post* and the *Washington Times* published since September 2001. He then highlighted every mention of South Africa, whether in articles on AIDS or reports on cricket scores. By assembling these pages in a grid on the gallery wall, Allen invites the viewer to compare the coverage of his country in two major American newspapers—one liberal, one conservative—and to reflect on the ways that American media outlets filter our perception of the world. In *Arrest*, Chilean Cristóbal Lehyt puts his own spin on various images recently appearing in the American media, including a Haz-Mat team cleaning after an anthrax attack,

THE AMERICAN EFFECT

Anita W. Chang, *still from* She Wants to Talk to You, 2001

a swearing-in before Congress, and Oklahoma City bomber Timothy McVeigh. On a long shelf beneath drawings of these images made directly on a gallery wall, Lehyt has placed captions relating his own perspective on the same people and events. Slide projectors, discretely placed under the shelf, show an image of the viewing platform at Ground Zero next to a surreptitiously taken photo of a Chilean military school. This juxtaposition underscores the fact that the World Trade Center attack of 2001 and the American-backed overthrow of the democratically elected Chilean president Salvador Allende in 1973 both took place on September 11. By pointing to this coincidence, Leyht asks the viewer to compare America's role in each tragedy and to critically question America's heroic self-image.

In *Distributive Justice: America*, Croatian artist Andreja Kulunčić sidesteps the mass media to establish a mechanism for the direct surveying of opinions about America. The Internet-based work enables the public to register and compare their views of America in terms of the notion of "distributive justice." This concept, borrowed from the fields of philosophy and economics, concerns the ways in which societies form a consensus on the just distribution of wealth. As part of a long-term project devoted to this issue, Kulunčić's latest work focuses on this question as it applies specifically to the United States.

The American Effect comprises several works, including a number of documentary videos, which explore the experiences of refugees and immigrants, examining their reasons for moving to the United States and comparing their expectations to their experiences on arrival. Andrea Geyer created *Interim* to "reflect on the logic and implications of the set of essential rules and customs supposedly practiced in the United States."[28] Geyer based her work, in part, on contemporary handbooks for immigrants to America and guides for students learning English as a second language. *Interim* combines text and images, in the form of an eighty-page newspaper, to create a multilayered expression of the complex negotiation immigrants have between individual and collective experience in the dense urban environment of New York City. Sandeep Ray's documentary video, *Leaving Bakul Bagan*, concerns a young Indian woman preparing for a long-awaited flight to America whose departure is delayed by the outbreak of internecine violence on the streets of her native city and the imposition of a curfew. While she waits for things to settle down so she can travel safely to the airport, her brother seizes the opportunity to excoriate her thoughtless embrace of all things American and her lack of awareness of America's

problematic role in global politics. *A Wedding in Ramallah,* by Sherine Salama, is the story of a young Palestinian woman whose arranged marriage to a Palestinian man living in the United States sets in motion an excruciatingly long wait for emigration papers. After years of anticipation, the woman's idealized view of life in America is undermined when she finds herself stranded in a small apartment in Cleveland with nothing to do but watch television, vacuum, and sleep. Belgian artist Chantal Akerman's film, *From the Other Side,* explores the complex web of desire and animosity that defines the U.S.–Mexican border. Combining lingering, atmospheric shots of this stark desert region and heart-wrenching interviews with Mexican migrants, border officials, and wary Americans, Akerman weaves together a humanistic portrait of an area torn apart by inexorable global forces.

Marlo Poras's alternately endearing and unsettling film, *Mai's America,* follows a high-school exchange student from Hanoi who is spending her senior year in a small town in Mississippi. Mai's experience is a love-hate affair, combining the discovery of liberties she has never known with exposure to shocking intolerance and endemic social malaise. Gail Dolgin's and Vicente Franco's film, *Daughter from Danang,* on the other hand, concerns one of the thousands of Vietnamese children airlifted out of Vietnam at the end of the war who returns to discover her family in the provincial city of Danang. Having grown up in rural Kentucky, the film's protagonist encounters vast chasms of cultural difference and expectation that send her, and the members of her extended biological family, into uncharted and almost unbearable emotional terrain. In a work that highlights the relatively empowered position of women in America, Anita W. Chang's

TOP: **JT Orinne Takagi and Hye Jung Park**, *still from* The Women Outside, 1995
BOTTOM: **Marlo Poras**, *production still from* Mai's America, 2002

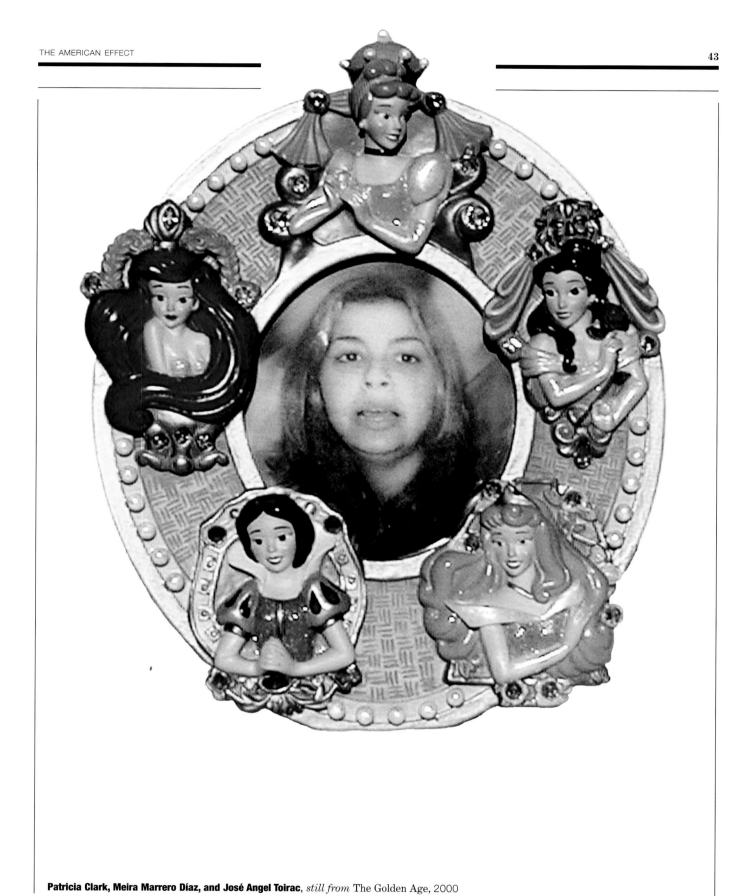

Patricia Clark, Meira Marrero Díaz, and José Angel Toirac, *still from* The Golden Age, 2000

film, *She Wants to Talk to You*, juxtaposes the observations of three thirteen-year-old girls living in Nepal with five older Nepali women who have come to America to enjoy more liberated lives.

In selecting the works for this exhibition, I did not consider their messages alone, but sought pieces that balanced compelling content with commensurately engaging formal or conceptual qualities. I looked for works endowed with subtlety, depth, and originality of expression. While I made an effort to explore many nations and cultures, traveling to nearly twenty countries in Asia, Latin America, and Europe (the impending war with Iraq compelled me to cancel a trip to the Middle East), I did not attempt to balance every viewpoint or represent the diversity of opinion within each nation or region. Given the limited scope of this endeavor, it would not have been possible to represent all perspectives.

This is less a global survey than it is a selected exploration of works of art by forty-seven international artists and three collaborative groups. Unlike the Pew Foundation's recent survey, this exhibition has no scientific status, no aspirations to be objective or comprehensive. Nevertheless, I believe that through these works we can begin to gain an impression of "the American effect," of the ways in which America is seen and experienced throughout the world.

Notes

1 It should be acknowledged that the terms *America* and *American* are jointly claimed by the citizens of the United States of America and by the inhabitants of the whole Western Hemisphere. For some Latin Americans, Mexicans, and Canadians, the fact that we citizens of the United States take for granted that "America" refers uniquely to us is ample evidence of our arrogant and hegemonic tendencies.

2 William M. Arkin, "Response to Terror; Military Memo; U.S. Air Bases Forge Double-Edged Sword; Deployment: Presence in Nine Countries Ringing Afghanistan Enhances Capability but also Fuels Islamic Extremism," *The Los Angeles Times*, January 6, 2002, p. A1.

3 With a Gross Domestic Product (GDP) in 2002 of $9.837 billion, America's economy was more than double that of its closest competitor, Japan, with a GDP of $4.842 billion. [source: *Pocket World in Figures: 2003 Edition*, (London: *The Economist* in association with Profile Books Ltd., 2002), 24.]

4 David Armstrong, "Dick Cheney's Song of America: Drafting a Plan for Global Dominance," *Harper's Magazine*, Vol. 305, no. 1829 (October 2002), 81.

5 Jim Hoagland, quoted in transcript of "America's Image" in *Online NewsHour* (December 5, 2002), 5.

6 The Pew Global Attitudes Project (2002), 61.

7 Ibid.

8 Ibid., 69.

9 Ibid., 63.

10 C.G. Jung, *The Portable Jung*, ed. Joseph Campbell (New York: Penguin Books, 1988), 56.

11 J. Hector St. John de Crèvecoeur, *Letters from An American Farmer and Sketches of Eighteenth-Century America* (New York: Penguin Books, 1986), 42–43.

12 Ibid., 70.

13 Alexis de Tocqueville, *Democracy in America*, trans. George Lawrence, ed. J.P. Mayer (New York: HarperCollins Publishers, Inc., 2000), 256.

14 Mark Hertsgaard, *The Eagle's Shadow: Why America Fascinates and Infuriates the World* (New York: Farrar, Straus, and Giroux, 2002), 10.

15 Pawel Kruk, interview with the author, August 10, 2002.

16 Since the March 12, 2003, assassination of Serbian prime minister Zoran Djindjic, Naskovski's piece has acquired another tragic dimension of unintended meaning.

17 Jannicke Låker, email to the author, January 7, 2003.

18 The Basel Action Network and Silicon Valley Toxics Coalition, "Exporting Harm: The High-Tech Trashing of Asia" (February 25, 2002), 14.

19 Thomas G. Donlan, "Wages of Waste: A Lesson in Environmental Economics," *Barrons*, 82, no. 9 (March 2002), 38.

20 Mark Lewis, email to the author, April 4, 2003.

21 Makoto Aida, interview with the author, July 2002.

22 William McKinley, quoted in Howard Zinn, *A People's History of the United States* (New York: Harper & Row Publishers, 1980), 306.

23 Mark Twain, quoted in Howard Zinn, *A People's History of the United States* (New York: Harper & Row Publishers, 1980), 309.

24 Yongsuk Kang, artist statement, *Korean Contemporary Art's Shifting Center: Wandering Bodies on a Shaky Earth* (Seoul, South Korea: The Korean Culture and Arts Foundation, 2000), 19.

25 Muhammad Imran Qureshi, email to the author, December 17, 2002.

26 Patricia Clark, Meira Marrero Díaz, and José Angel Toirac, unpublished artists' statement, July 10, 2000.

27 Ibid.

28 Andrea Geyer, unpublished artist's statement, undated.

RIGHT AND PAGES 46–47: **Bodys Isek Kingelez**, New Manhattan City 3021, 2002

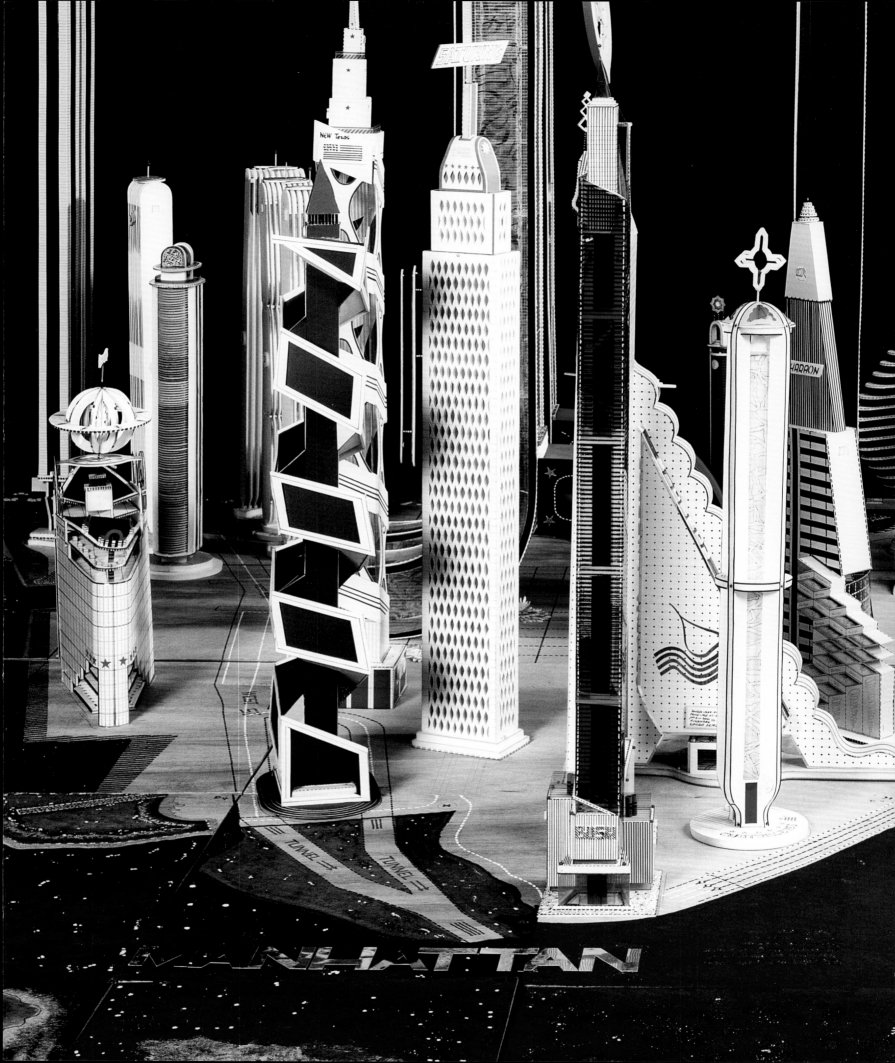

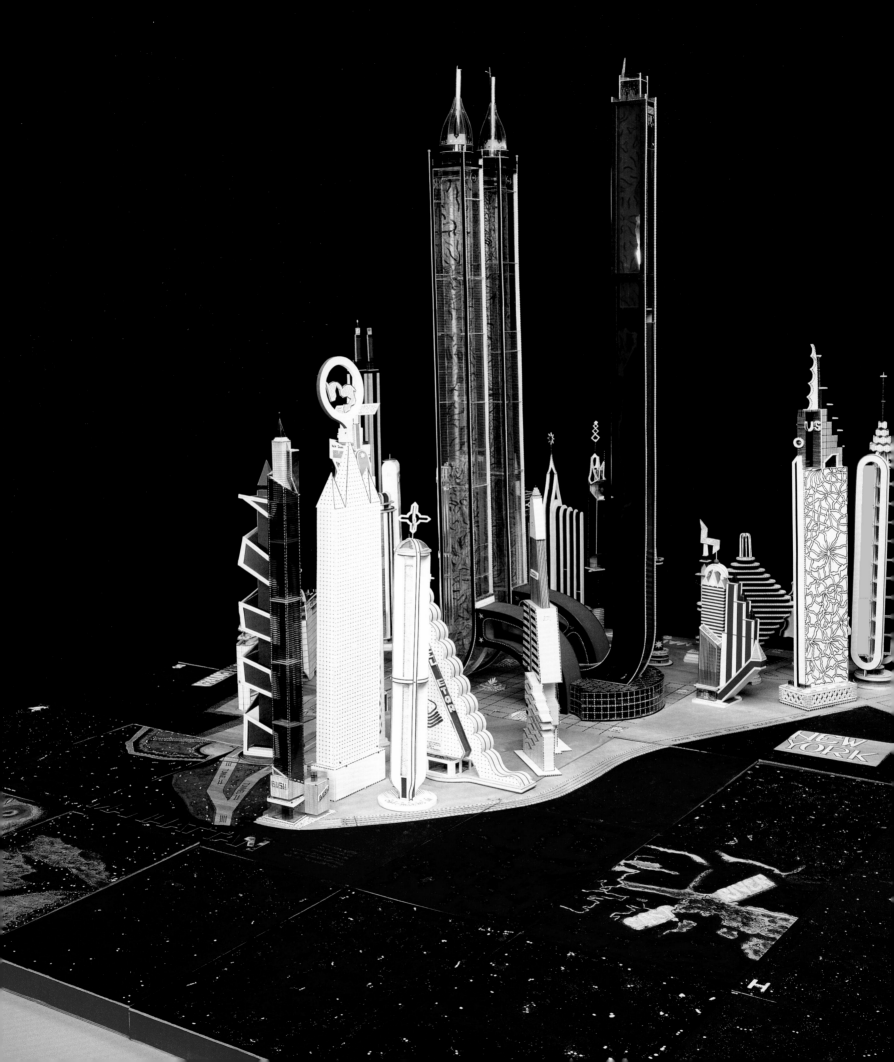

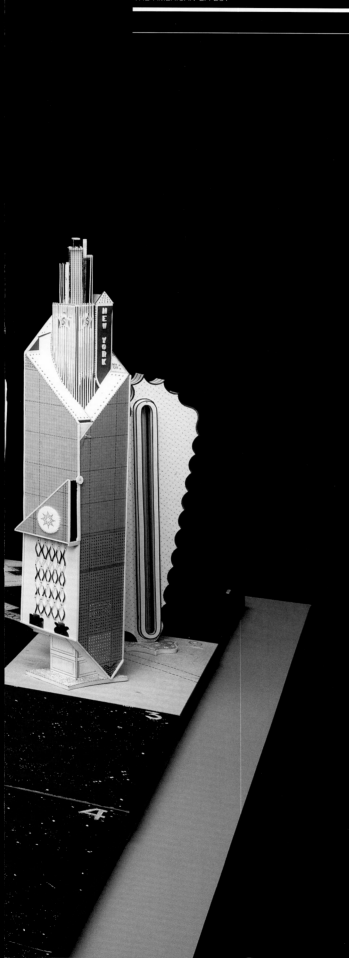

Freedom

Pramoedya Ananta Toer

OCTOBER 24, 2002

Not until the summer of 1999, when I was seventy-four years of age, was I given the opportunity to visit the United States. There were reasons for this delay. In the 1950s, during the first part of my adult life, Joseph McCarthy and people of his ilk held sway in the United States, making it virtually impossible for a person like myself—a firebrand and a leftist, I'm sure I would have been called—to set eyes on Liberty's raised torch.

In the middle phase of my adult life, from 1965 until 1979, I was a political prisoner in a penal colony established by a man whose company McCarthy would surely have enjoyed: General and then president Suharto, who, after taking political control of the country, oversaw the detention and killing of up to one million Indonesian citizens who were—or were purported to be—leftists or members of the Indonesian Communist Party. Though I was released from Buru Island Penal Colony in 1979, from that year until 1998, when Suharto finally relinquished his power, I remained a prisoner in my own land, first under house arrest and then under city arrest. There may have been no bars around my home, no armed guards at my gates, but Suharto and his minions did all they could to keep my mind immobile and my voice from being heard. Every book I published during Suharto's "New Order," the euphemistic sobriquet for his thirty-year militaristic regime, was banned. Activist students who took up my cause were jailed. Proprietors of bookstores where my books were sold were threatened.

And so it was not until this, the final stage of my adult life, that I found the chance to breathe American air and to seek confirmation or, possibly, refutation of my personal views about the United States and that country's role in the international dissemination of freedom and democracy.

The interminable plane ride from Jakarta to Newark, where I first landed, had put my nerves on edge, but when I first stepped foot on American soil, I felt, I must admit, an almost tangible sense of victory rush through me. I was now in the land of the free. I had finally disentangled myself from Suharto's grasp! I had experienced and yet somehow survived the many forms of oppression visited upon me by that man and his militaristic regime.

Looking around me as I traveled that day into Manhattan—first at the mazelike highways, then at the New York skyline dominated by the World Trade Center buildings, those towers of might, and finally at the melange of humanity on the city's

FREEDOM

streets—it registered frequently in my mind that I was in the land of Thomas Paine, one of the modern world's most revered thinkers. This American had helped to shape American thought, and through his heirs, the American people had (or were said to have) disseminated his concepts of freedom, democracy, and humanitarianism throughout the world. But had they? Even when thinking these thoughts, I was uncomfortably aware of the fact that while freedom and courage make complementary soul mates, democracy and power do not always walk hand in hand.

 Let me explain. Somewhere long ago, I read that in the United States there are only two criteria for being a good citizen: paying one's taxes and committing no crime. As long as citizens do not break these two cardinal rules, they are guaranteed freedom of association and freedom of expression, regardless of their religious or political beliefs. During my stay in the United States, a two-month sojourn that took me both to large cities and smaller burgs, this notion appeared to be justified. On the streets of New York and in the farm towns of Wisconsin, the forthrightness of the American people I met, and their almost too urgent need to express their opinions and beliefs, impressed me greatly. By the time I left the United States, I understood why this country or, more accurately, the American people have often been labeled "champions of democracy." In the United States, democratic principles are indeed honored and upheld; they are part of the warp and woof of American society. Americans are, in their own homes and towns, a truly free and democratic people.

 But labels can be misleading. From the beginning of my career as a writer in the early 1950s through my intellectual travels in the years and decades that followed, I was given numerous labels: "socialist," "leftist," "communist," "anti-American," and so on. Regardless of their accuracy, which, frankly, has little if any relevance at this point in time, I know very well why they had been bestowed upon me. It was not because I was a leftist, a communist, or whatever; it was because I spoke out against double standards in

FREEDOM

ABOVE AND LEFT: **Patricia Clark, Meira Marrero Díaz, and José Angel Toirac**, *stills from* The Golden Age, 2000

FREEDOM

Zoran Naskovski, *still from* Death in Dallas, 2000

the application of democratic princi-
ples, whether by the United States
or by my own country. As I saw it
then and as I see it now, democracy is
not the right of the powerful only.
Democracy is, as America's forefathers
proclaimed, the right of the disenfran-
chised, too. But when the Cold War
was raging, such principles, it seemed,
could be ignored.

Outside the United States—
especially in Third World countries,
such as Indonesia, which enjoy both
abundant natural resources and a
geographically strategic position—it
appears to many that the American
government views power (and not
courage or justice!) as one of the pil-
lars of democracy. It also appears that
American interests all too easily blur
the standards of democracy as they are
applied elsewhere. In Indonesia, and
perhaps in other countries as well, I
have surmised that there is a general
view, particularly among people like
myself who have suffered the loss of
their civil rights, that democracy is
something reserved for Americans only.

My personal opinion—and on
this point, I would like to be proved
wrong—is that the United States
believes that Indonesia will only be a
true democracy if and when it accepts
as its own the American paradigm of
economic and militaristic interests. In
the 1950s, during the Cold War, officials
of the American government let then-
president of Indonesia Sukarno and
other world leaders know that if they
were not with them, they were against
them. If they were not anticommunist,
then they must be communist and,
therefore, a target for toppling.

Sukarno opposed capitalism
and imperialism; he mobilized the
Asian-African freedom movement and
was the first world leader to oppose
the war in Vietnam. As a result, he was
viewed in the West and, more particu-
larly, in the corridors of Washington as

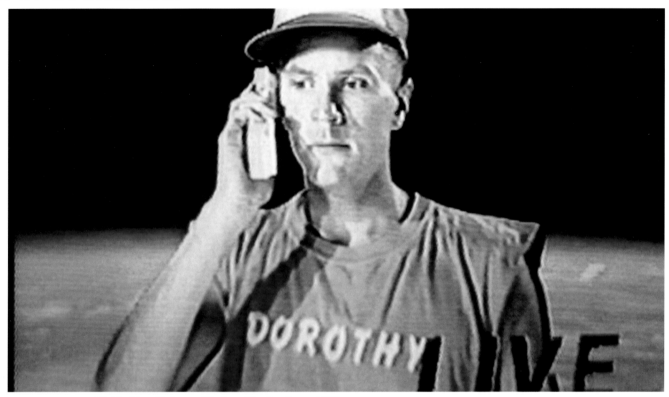

ABOVE, AND PAGES 53–55: **Bjørn Melhus**, *stills from* Far Far Away, 1995

an anti-Western political agitator. Sukarno's fault was that he did not want the country whose independence he had proclaimed to become a nation of beggars, dependent upon Western largesse and investment. He wanted democracy, but of a form that was suitable for Indonesia.

It is no secret, as recently released CIA documents reveal, that the American government backed Sukarno's overthrow and helped to put in place as head of state a man who had no respect for democracy but who understood well the value of economic and military aid. In the years that followed, Suharto and his cronies enriched themselves and their families while putting the country further and further in debt, a debt that now amounts to US$140 billion, or $700 for each and every of the approximately 200 million citizens of Indonesia. While this was happening and while Suharto was suppressing all opposition to his

development policies, what was the United States, Indonesia's main benefactor, doing? Applauding itself that the Cold War in Indonesia had been won and that democracy was now in place. But where was freedom? Where was democracy? What was in place was power. Even when Indonesia invaded East Timor in 1976, the American government patted Suharto on the back and, with a wink and a shrug, mumbled politely that this and other so-called excesses were minor stumbling blocks on the way to the creation of an economically developed and democratic Indonesian nation.

Now let us advance to the present time, when a different American president and a different American government are saying that if you don't support the American war on terrorism than you must be a terrorist nation yourself. I fear that the United States is making the same mistake that it made during the Cold

War: not only measuring a country's value by its level of support for American economic interests, but weighing that country's need for democratic reform against the country's embrace of American political goals.

Months ago I saw on CNN a broadcast commemorating the anniversary of the September 11 attacks on the United States. At the former site of the World Trade Center towers, two symbolic pictures emerged, one for Indonesia, the other for the United States.

In 1998, when Suharto's militaristic regime ended, Indonesia was left with a veritable mountain of debris from the New Order's destruction of the country's democratic pillars. Today, Indonesian political reformers are trying to rebuild a democratic system but haven't, it seems, either the power or the will to clear away all the New Order rubble and are, therefore, mistakenly attempting to

FREEDOM

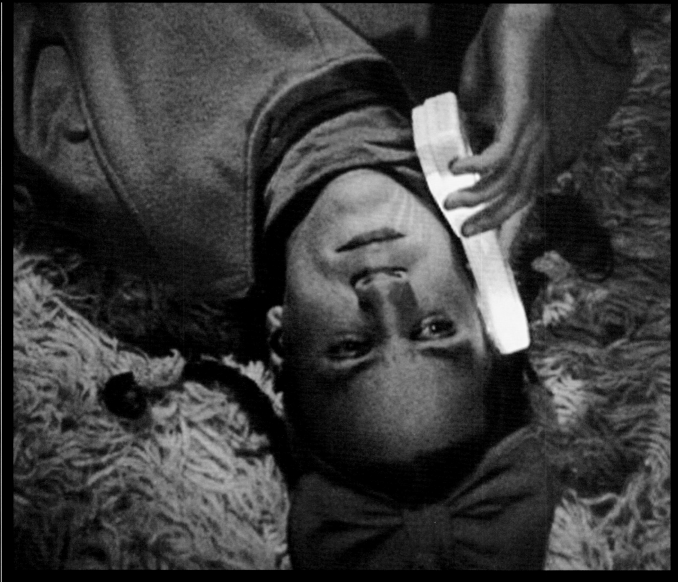

build a democracy on less than solid ground.

Now let us look at New York. There, after only one year, the rubble that once had been the soaring towers of the Trade Center has been cleared. Rebirth and redevelopment can now begin. But, meanwhile, in retaliation for the attacks on the United States, President George W. Bush is calling not for justice, but for further destruction.

It is time for the American people to think again of Thomas Paine and the country's guiding principles,

The United States must not let calls for vengeance avert the nation from what its true mission should be: the propagation of liberty and democracy throughout the world.

Replace those towers of might with beacons of freedom.

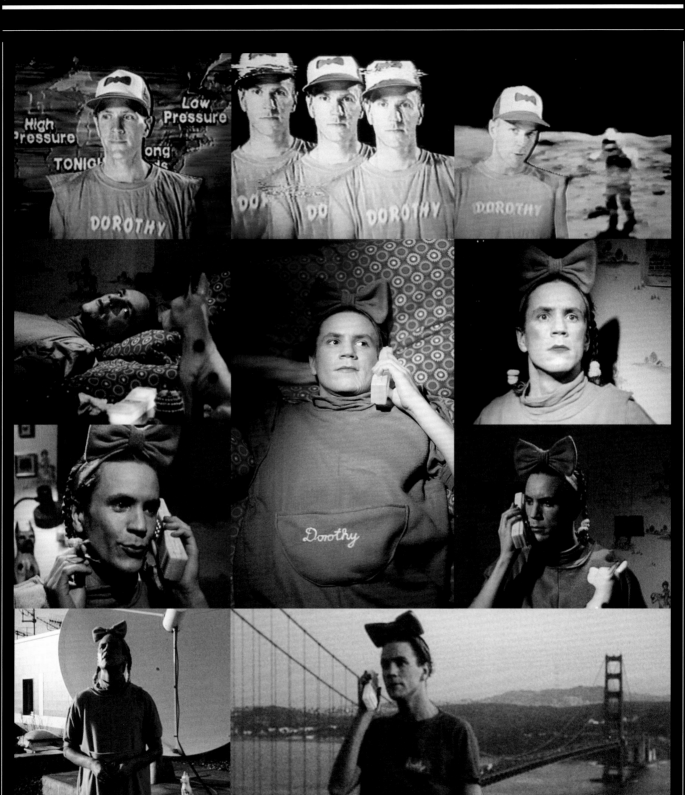

YUKA

For the longest time I used to think, when I get old, I wanna relax in a tub of natural hot springs.
And so, after turning 70, I moved to Yufuin* and chilled out for a few years as planned.
But after staring at the same paradise day in and day out, I started realizing how I wanted
to get outta this little Eden and bounce somewhere far far away.
Obsessed with this thought, I hopped on a plane headed to LA without telling any of my family.
Thinking back, I must've died once in Yufuin, and come back to this world from the dead.

After taking lots of little trips, solo,
I met my current lover (a spoiled rich kid I hear)
All of a sudden, I ended up being taken across the US in search for 'black gold'—on another
one of his ridiculous dreams.
Indeed, I've had to turn down his marriage proposals, but he's obviously not giving up.
I haven't seen my kids or my grandkids back in Japan for such a long time.
My grandkids, even if we met, we probably wouldn't recognize each other.
When I talked to my grandkids over the phone recently, I told them I've been reincarnated,
and the one in elementary school cried asking if I was dead.

My tooth? A souvenir from landing the jackpot last year in Vegas.
Anyway, that boy keeps cracking me up with his non-stop jokes.
He says my big laugh brings good fortune.

(*) Yufuin is a famous hot springs resort in Kyushu, the southernmost main island of Japan.
 It is known for its remarkably beautiful scenery situated around a natural basin.

Miwa Yanagi, Yuka, 2000, *from the series "My Grandmothers,"* 2000–

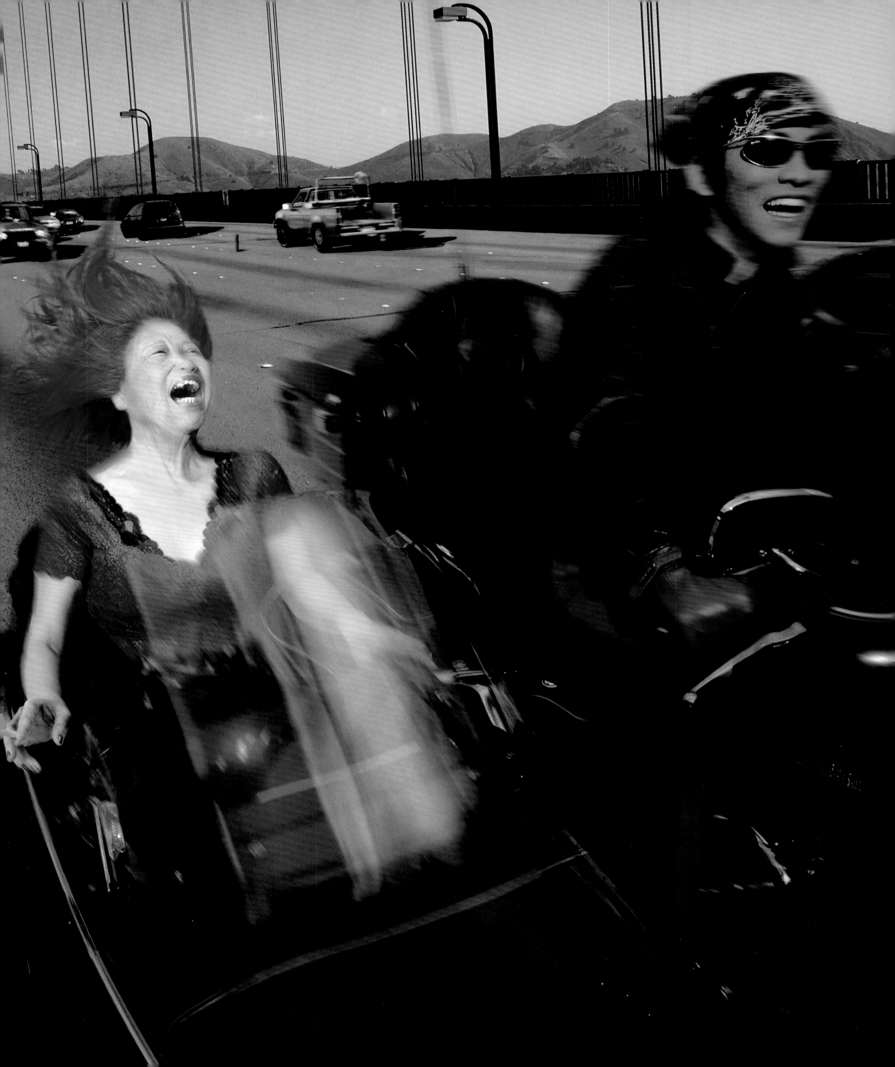

Stephanie Black, *still from* Life and Debt, 2001

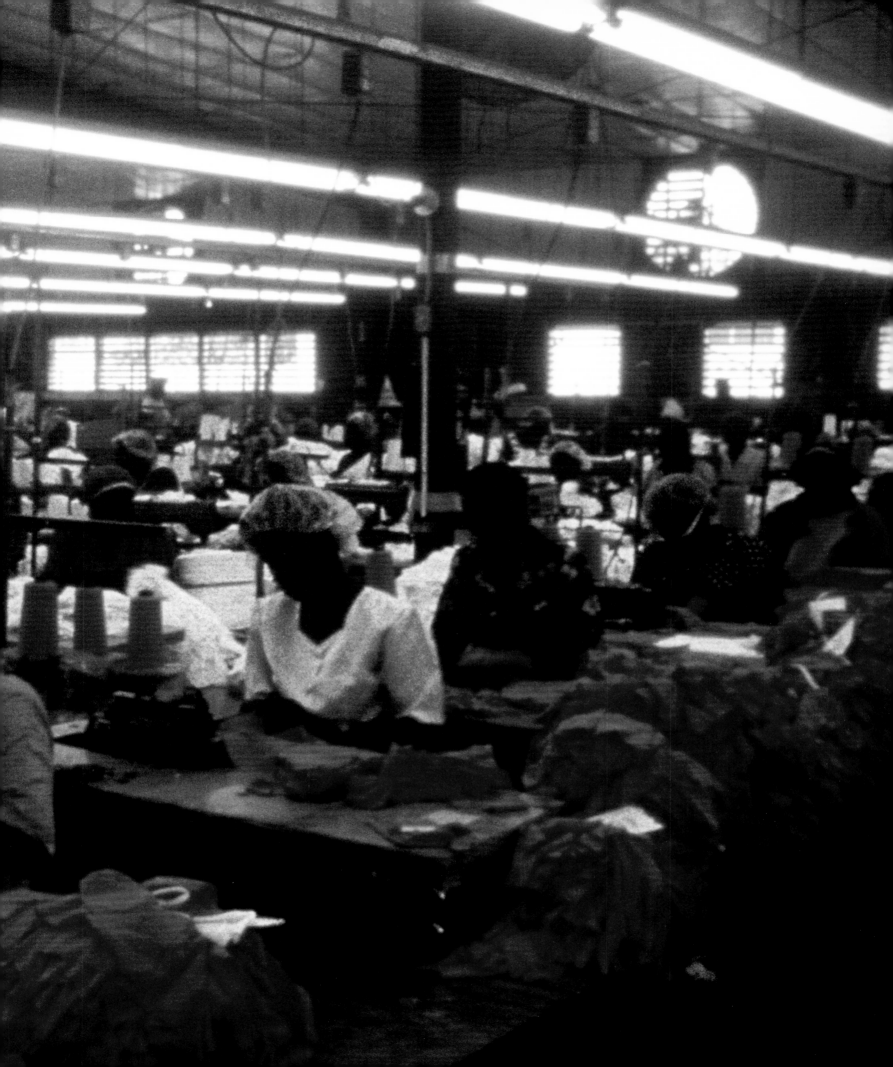

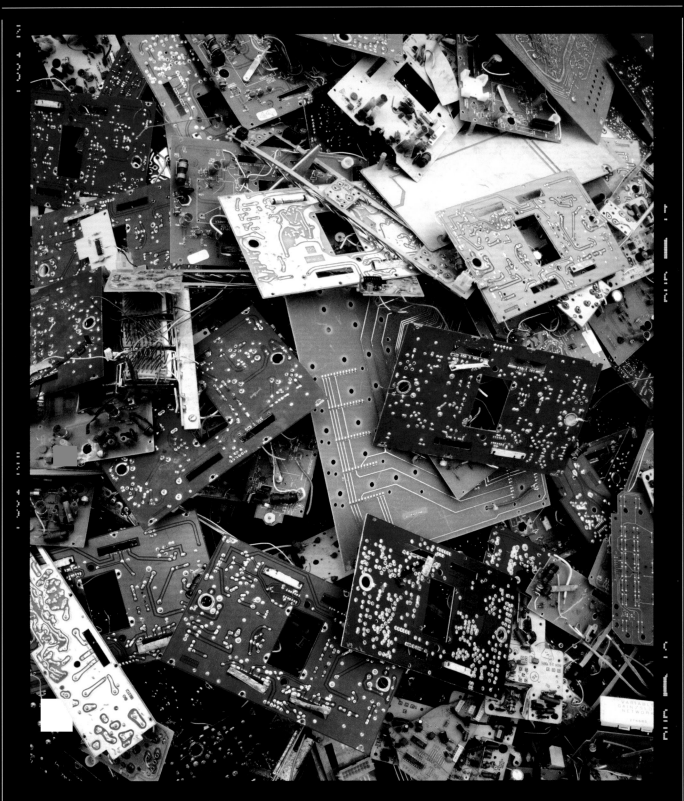

Danwen Xing, Untitled, *from the series "disCONNEXION,"* 2003

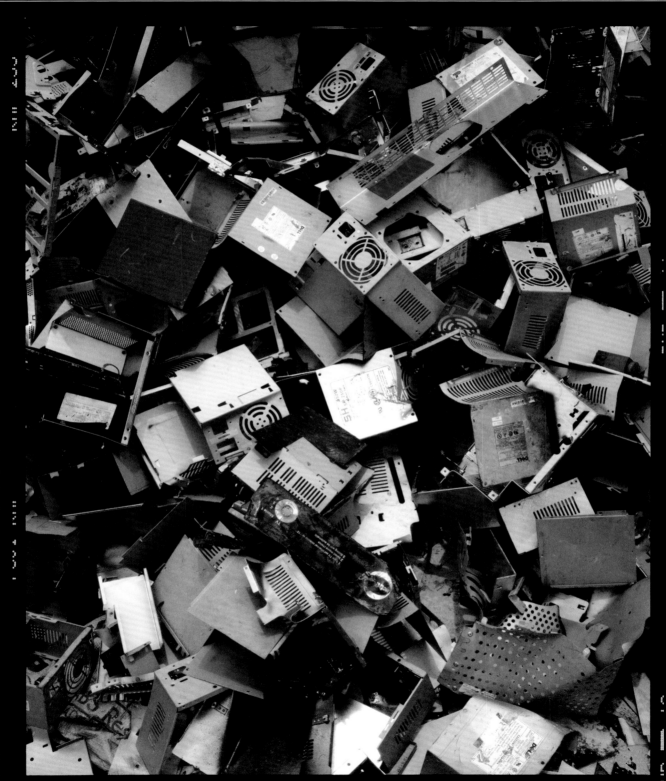

Danwen Xing, Untitled, *from the series "disCONNEXION,"* 2003

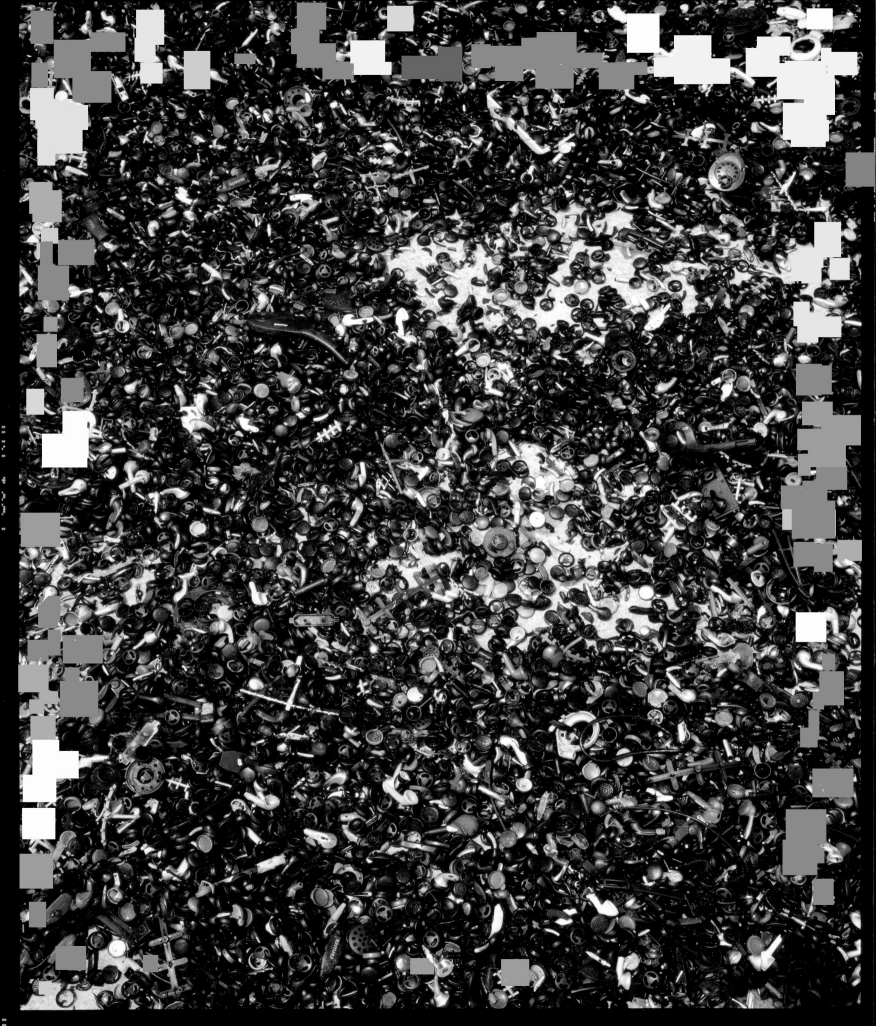

ABUNDANCE

ABOVE: **Danwen Xing**, Untitled, *from the series "disCONNEXION,"* 2003 *(detail)*
LEFT: **Danwen Xing**, Untitled, *from the series "disCONNEXION,"* 2003

Abundance

Luc Sante

DECEMBER 17, 2002

Of all the nations of the earth, the United States unquestionably has the most stuff. This is glaringly apparent to visitors arriving from the Third World, and less so, in this time of globalization, to those from other Western countries. When my family and I came to America from Belgium for the first time, in 1959, we were coming from a Europe still straitened by the demands of postwar reconstruction, also a Europe whose mercantile economy was still based on need rather than on impulse or lark or envy or dazzle.

So it was that when my parents first walked into an American supermarket they were overwhelmed, struck with vertigo. To them it was bizarre and funny to be confronted with twenty-seven different brands of soap powder, and five or six different sizes or grades of each brand of soap powder, and thirty or forty boxes of each size or grade of each brand of soap powder. They laughed and, I think, were a little frightened by the experience. At home there were at most two or three brands of anything and groceries were still sold in small neighborhood *épiceries* that only stocked one brand of each product on its shelves. Europe now has supermarkets of its own aplenty, and it has shopping malls, though far fewer than there are in America, and it even has highway strips of close-out outlets and the like, although not in profusion. The gap has been bridged, to an extent. A consumer in Madrid or Copenhagen can face the same apparently limitless variety of jeans as his or her counterpart in Houston or Miami.

Even so, no country in the world multiplies this mass every few miles along its major roadways. America's preeminence in this domain is not simply a matter of marketing philosophy, or of prosperity, but has much more to do, I think, with its attitudes toward the land itself. The promise of America was of a vast and underpopulated land overflowing with resources whose extent could barely be comprehended, let alone exhausted. The westward progress of the pioneers was a relentless march in search of the main chance—the happy valley where the farmer could not just subsist but prosper, and not just prosper but become king. In the Old World a farm was, at best, a self-sustaining device, capable of earning a good living for its

ABUNDANCE

Gerard Byrne, *photograph from* why it's time for Imperial, again, 1998–2000

dependents, ideally from generation to generation. In America such an ideal was just not good enough. The requirements for a successful farm began with its potential for earning a consistent return, but the wish of its proprietors was that it would expand and increase continually, the wish being something like one of those Texas ranches that took days to traverse on horseback. On the way to this ideal, a farm family might settle, provisionally, numerous times, and if it exhausted the land it could just throw it away— especially if it were benefiting from government claims—and move on. The principle seldom worked out this way in practice. Many farmers eked out a meager existence on rocky or parched or chemically imbalanced plots. But the myth is what mattered, and the fact that it had materialized for somebody somewhere.

But the resources were un- deniable. There were those buffalo herds so enormous that they might take a week to traverse your field of vision, and earth so fertile in places that a European delicacy such as the peach could choke Georgia like a com- mon weed before it was mastered and cultivated. The promise of America was of a land of Goshen, whose abun- dance could be squandered and violated and still keep coming. The existence of limits did not go unnoticed or unrecorded. The hemlock forests of the Catskill Mountains were exhaust- ed by the tanning industry early in the nineteenth century, for example. But such disappointments were written off and quickly forgotten as the popular imagination rushed to the next avenue of wealth. This denial of reality per- sists even today, of course, when there are no unexplored places, no resources unaccounted for, no bottomless horns of plenty left in the land. The United States is still huge, still big enough that mistakes can be overlooked, problems

parked behind the barn and forgotten, waste dumped in the hollow and left to rot unseen. The public policy of the nation is still shaped by the notion that money can be found, as it were, in the street. The threat of scarcity is treated as an obscene and foreign idea and to entertain it approaches treason.

It is not surprising, then, that for reasons other than the simple con- solidation and maximization of wealth, a hundred dry-goods stores would be melted down to form a Woolworth's, and a dozen Woolworth's liquefied to make a WalMart. It is not surprising that people, even single people, visit Costco and emerge bearing ten-pound jars of mayonnaise that will be no more than a tenth consumed before the expiration date. It is not surprising that many Americans buy a new car each year even though the old one is barely dented, that the only thing you can do with used computer equipment is to throw it away, that pawn shops,

ABUNDANCE

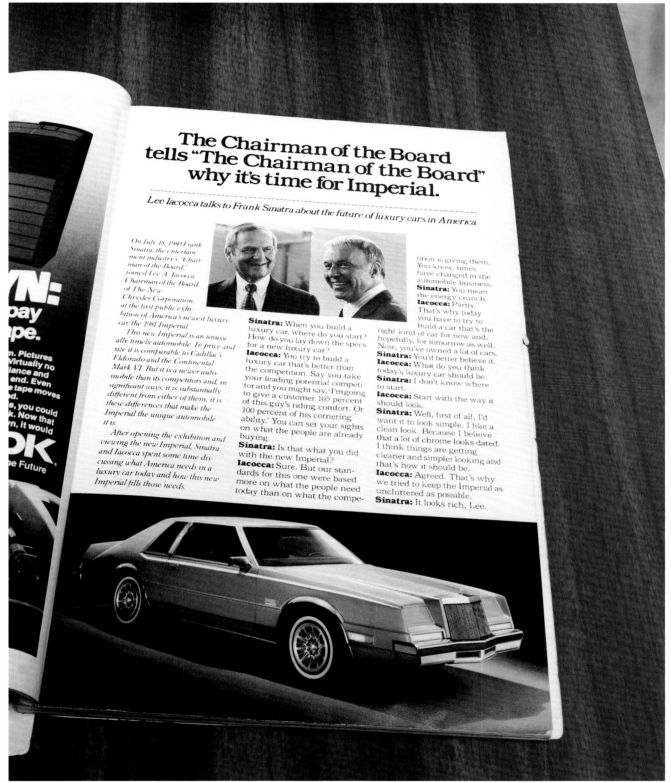

ABOVE, AND PAGES 66–67: **Gerard Byrne**, *photographs from* why it's time for Imperial, again, 1998–2000

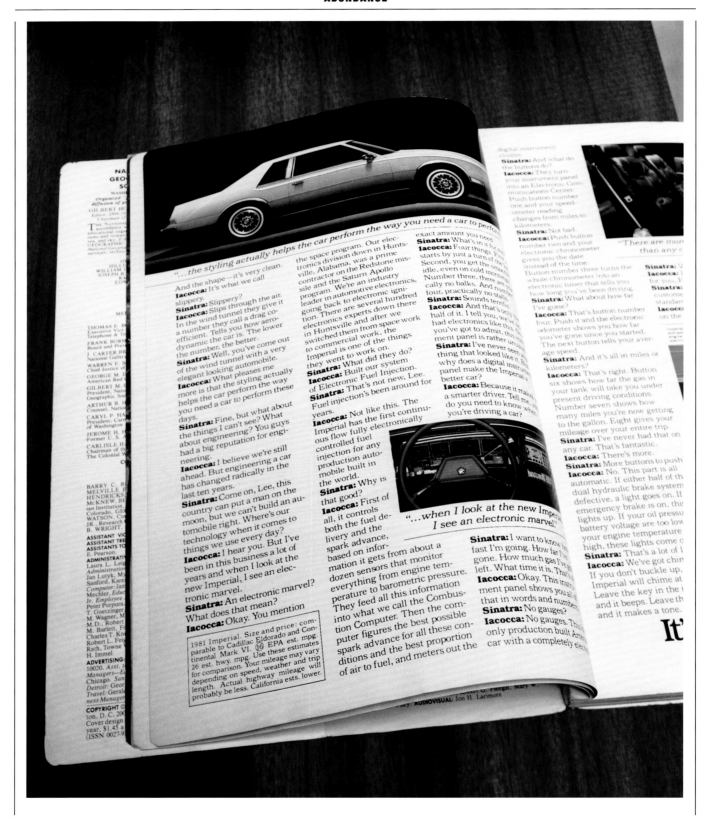

"...the styling actually helps the car perform the way you need a car to perform...

And the shape—it's very clean, slippery.

Iacocca: It's what we call slippery.

Sinatra: Slippery?

Iacocca: Slips through the air. In the wind tunnel they give it a number they call a drag co-efficient. Tells you how aero-dynamic the car is. The lower the number, the better.

Sinatra: Well, you've come out of the wind tunnel with a very elegant looking automobile.

Iacocca: What pleases me more is that the styling actually helps the car perform the way you need a car to perform these days.

Sinatra: Fine, but what about the things I can't see? What about engineering? You guys had a big reputation for engi-neering.

Iacocca: I believe we're still ahead. But engineering a car has changed radically in the last ten years.

Sinatra: Come on, Lee, this country can put a man on the moon, but we can't build an au-tomobile right. Where's our technology when it comes to things we use every day?

Iacocca: I hear you. But I've been in this business a lot of years and when I look at the new Imperial, I see an elec-tronic marvel.

Sinatra: An electronic marvel? What does that mean?

Iacocca: Okay. You mention

the space program. Our elec-tronics division down in Hunts-ville, Alabama, was a prime contractor on the Redstone mis-sile and the Saturn Apollo program. We're an industry leader in automotive electronics, going back to electronic igni-tion. There are several hundred electronics experts down there in Huntsville and after we switched them from space work to commercial work, the Imperial is one of the things they went to work on.

Sinatra: What did they do?

Iacocca: Built our system of Electronic Fuel Injection.

Sinatra: That's not new, Lee. Fuel injection's been around for years.

Iacocca: Not like this. The Imperial has the first continu-ous flow fully electronically controlled fuel injection for any production auto-mobile built in the world.

Sinatra: Why is that good?

Iacocca: First of all, it controls both the fuel de-livery and the spark advance, based on infor-mation it gets from about a dozen sensors that monitor everything from engine tem-perature to barometric pressure. They feed all this information into what we call the Combus-tion Computer. Then the com-puter figures the best possible spark advance for all these con-ditions and the best proportion of air to fuel, and meters out the

exact amount you need

Sinatra: What's in it for me?

Iacocca: Four things. First starts by just a turn of the Second, you get the smooth idle, even on cold morning Number three, there are pra cally no balks. And number four, practically no stalls.

Sinatra: Sounds terrific.

Iacocca: And that's only half of it. I tell you, we've had electronics like this. you've got to admit, this ins ment panel is rather uniq

Sinatra: I've never seen a thing that looked like it. B why does a digital instrum panel make the Imperial a better car?

Iacocca: Because it make a smarter driver. Tell me do you need to know when you're driving a car?

"...when I look at the new Imperi I see an electronic marvel."

Sinatra: I want to know fast I'm going. How far I' gone. How much gas I've left. What time it is. That

Iacocca: Okay. This inst ment panel shows you all that in words and number

Sinatra: No gauges?

Iacocca: No gauges. Tha only production built Ameri car with a completely electr

digital instrument cluster.

Sinatra: And what do the buttons do?

Iacocca: They turn your instrument panel into an Electronic Com-munications Center. Push button number one and your speed-ometer reading changes from miles to kilometers.

Sinatra: Not bad.

Iacocca: Push button number two and your electronic chronometer gives you the date instead of the time. Button number three turns the whole chronometer into an electronic timer that tells you how long you've been driving.

Sinatra: What about how far I've gone?

Iacocca: That's button number four. Push it and the electronic odometer shows you how far you've gone since you started. The next button tells your aver-age speed.

Sinatra: And it's all in miles or kilometers?

Iacocca: That's right. Button six shows how far the gas in your tank will take you under present driving conditions. Number seven shows how many miles you're now getting to the gallon. Eight gives your mileage over your entire trip.

Sinatra: I've never had that on any car. That's fantastic.

Iacocca: There's more.

Sinatra: More buttons to push?

Iacocca: No. This part is all automatic. If either half of th dual hydraulic brake system defective, a light goes on. If emergency brake is on, thi lights up. If your oil pressu battery voltage are too low your engine temperature high, these lights come o

Sinatra: That's a lot of l

Iacocca: We've got chim If you don't buckle up, Imperial will chime at Leave the key in the and it beeps. Leave th and it makes a tone.

"There are mor than any c

Sinatra: V

Iacocca: for you, F

Sinatra: custome standard

Iacocca: on th

It'

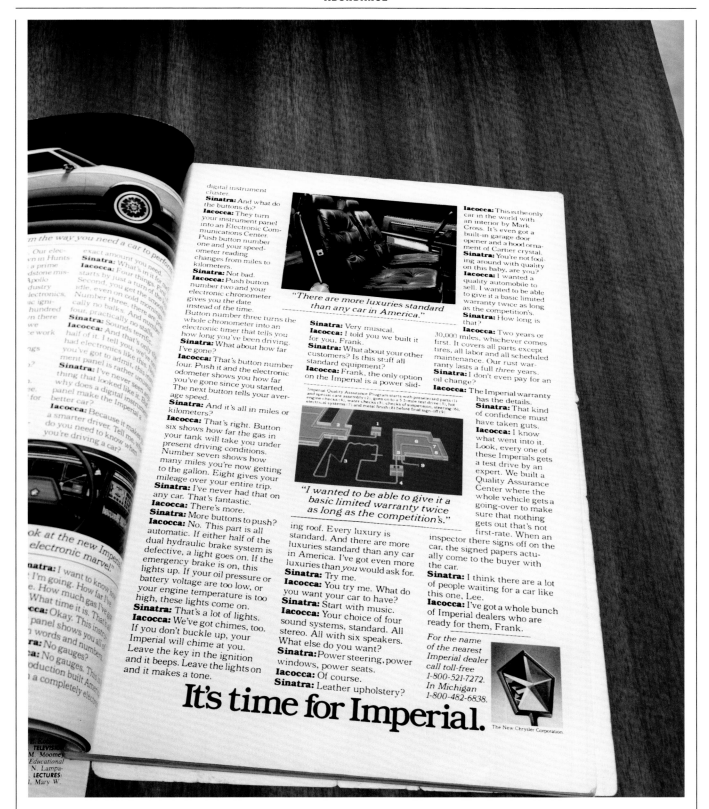

ABUNDANCE

which a generation ago still traded in kitchenware and suits of clothes, now only deal in jewelry, firearms, and musical instruments. In Jonathan Demme's 1989 film *Married to the Mob,* when the disgruntled housewife, played by Michelle Pfeiffer, becomes disgusted with her life, she simply donates her house and all its contents to Goodwill—what else could be done with it? In reality—as I found out when I had to dispose of my parents' belongings after they died—even charities are exceedingly discriminating, since now only the utterly destitute can be persuaded to accept secondhand objects. Despite the well-publicized efforts of certain charities, restaurants and markets daily dispose of unimaginable quantities of food that is still fresh. New York City has lately cut back drastically on its recycling program because recycling is too expensive. Reuse is simply not an option—it does not feed into the mainstream economy, for one thing, and for another, it implies scarcity.

The home to which Americans of all classes aspire these days is a vast, sprawling thing, at least half again as big as its split-level predecessors of a generation or two back. It has a two-story atrium, a cathedral-ceilinged living room, at least three dining areas (breakfast nook, casual-lunch terrace, and formal dining room) cheek by jowl, a master bedroom that is effectively an entire apartment, and a finished basement the size of a small gymnasium. It is also made of ticky-tack. The inhabitants need a great deal of room for their stuff—and it is understood that if you have not already acquired the stuff before moving into the house, it will naturally proliferate according to the principles of some Parkinson's Law of objects—and a great deal of room for

Gerard Byrne, *stills from* why it's time for Imperial, again, 1998–2000

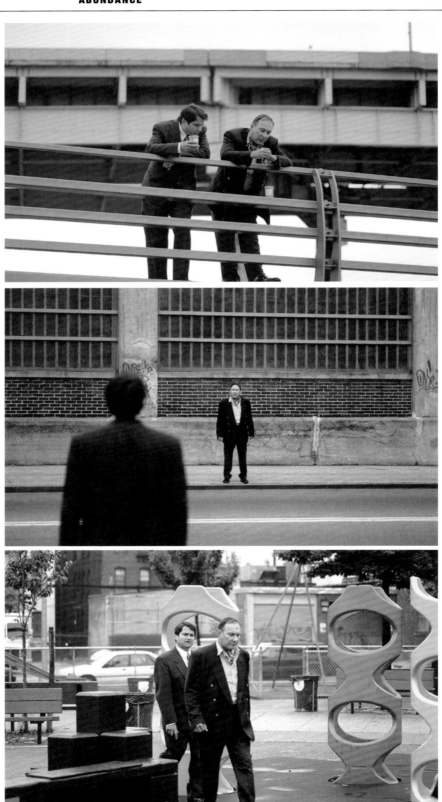

ABUNDANCE

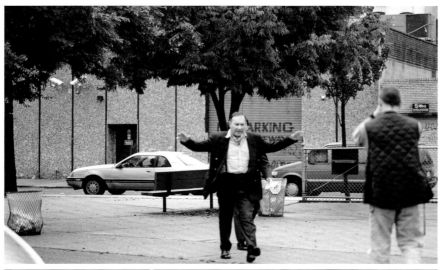

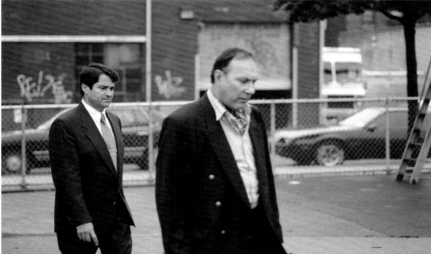

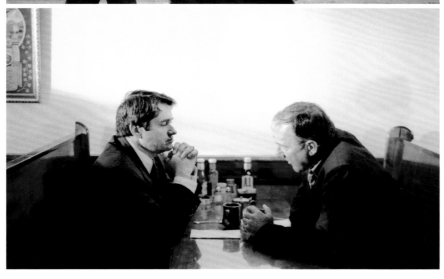

themselves, especially if they fit the desired body profile for men nowadays, which is XXXL. The house is made of gypsum and Tyvek and possibly carpet sweepings atop a pine frame, because to construct such a thing of brick or stone or hardwood would be unimaginably expensive, but also because the house is not meant to last. Twenty or thirty years from now, the new purchaser of the plot will naturally want to tear it down anyway, so as to upgrade. The technologies of the future will make their own demands on structure, and then the mountains of stuff assembled by the next generation will make the house appear proportionately stingy. After all, how many monuments of modernist architecture have fallen in Southern California in recent years so that the new people could build suitably Brobdinagian temples to their own superiority? Storybook wolves would be delighted by America, where a big house made of straw is infinitely more desirable than a small house made of brick.

What is striking about all these trends is that the American cult of abundance has only increased as the abundance of the land itself has diminished. When limitless forests of timber still crowded the North, people contrived to make furniture last for decades, possibly generations. When the oil fields of Texas and Oklahoma were still barely tapped, people drove cautious distances in relatively modest cars—and not only because the technology was itself still modest. When most people physically exerted themselves every day at work, at home they consumed much less fat, and not just because it was proportionately more expensive.

The United States possesses an excellent Constitution and Bill of Rights, and it also has an unwritten shadow constitution implicit in its mores and conventions, the first article

ABUNDANCE

TOP, BOTTOM, AND PAGES 71–73: **Maria Marshall**, *stills and text from* President Bill Clinton, Memphis, November 13, 1993, 2000

. . . until people who are willing have work.
Work organizes life. It gives structure and discipline to life.
It gives meaning and self-esteem to people who are parents.
It gives the role model to children. We have to make a partnership.
Who will be there to give structure, role modeling,
discipline, love and hope to these children? . . .
until people who are willing have work.
Work organizes life. It gives structure and discipline to life.
It gives meaning and self-esteem to people who are parents.
It gives the role model to children.
We cannot repair the American community and restore the American family
until we have the structure, the values, the discipline and the reward
that work gives us. We have to make a partnership.
Who will be there to give structure, role modeling,
discipline, love and hope to these children?

ABUNDANCE

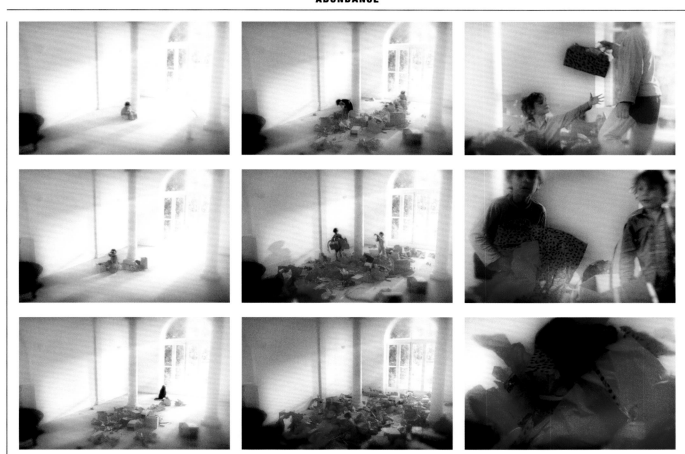

of which is: "You will take your desires for reality"—as long as they are material desires, of course. America is the land of wishful thinking, one in which people vote not according to their interests, but according to their imagined and wished-for interests, the interests of the class to which they aspire. Americans spend far in excess of their incomes, not because they think that some previously unsuspected source of funds will magically appear, but because they are spending as much money as they think they should by rights have, as much as their spiritual familiars, the celebrities, are regularly observed spending.

So America is the undisputed world capital of stuff. Ten-acre stores encumber the landscape at regular intervals, filled with many more goods than can be reasonably expected to sell, since the appearance of abundance is

paramount. The goods that are not sold will pass to jobbers who will dispose of some at close-out outlets, although many more will find themselves in landfills. The goods that are sold will likewise make their way to the landfills, if not tomorrow, then next month or next year. The kitchen appliance that languishes unused will eventually be noticed and thrown away, while the one that does find employment will either soon break or be supplanted by a model with more features, many of them imaginary (consider the proliferation of speeds in every succeeding generation of blender, speeds that bear individual names but are otherwise indistinguishable from one another).

In a decade, how many of the objects for sale on that shop floor will still exist? How many of the stores themselves will still exist? How many

of the neighborhoods to which the purchased goods were brought home in triumph will still exist? How long can this cycle—which begins to look like a conjurer's trick—continue? And just how dependent is America upon the existence of this cycle? Are there perhaps qualities inherent in the nation that have been eclipsed by the overwhelming size of the machinery of acquisition and disposal? Much depends on the answers to these questions.

ABOVE: **Mark Lewis**, Jay's Garden, Malibu, 2001 *(installation views at Kunsthalle Bern)*
PAGES 74–75: **Mark Lewis**, *production still from* Jay's Garden, Malibu, 2001

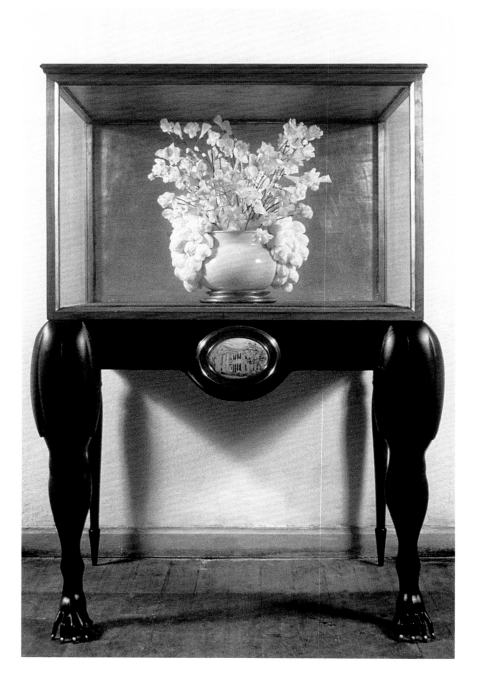

Amina Mansour, Vitrine 1 Chapter 1–5, 1998–99

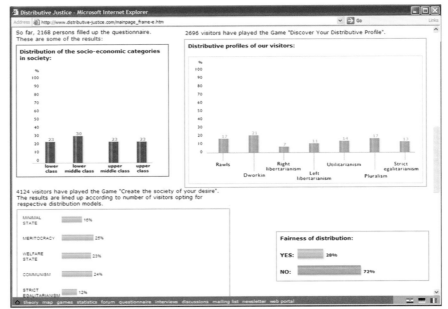

ABOVE: **Andreja Kulunčić**, *questionnaire from*
Distributive Justice, 2002

RIGHT: **Andreja Kulunčić**, *screenshot from*
Distributive Justice, 2002

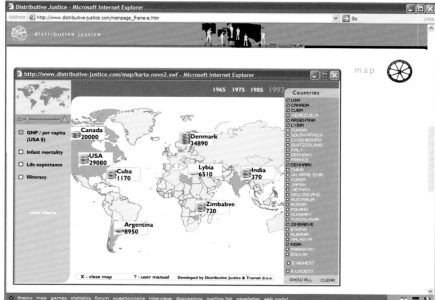

ABOVE: **Andreja Kulunčić**, Distributive Justice, 2002 *(installation views at Documenta 11, Kassel, Germany)*

LEFT: **Andreja Kulunčić**, *screenshot from* Distributive Justice, 2002

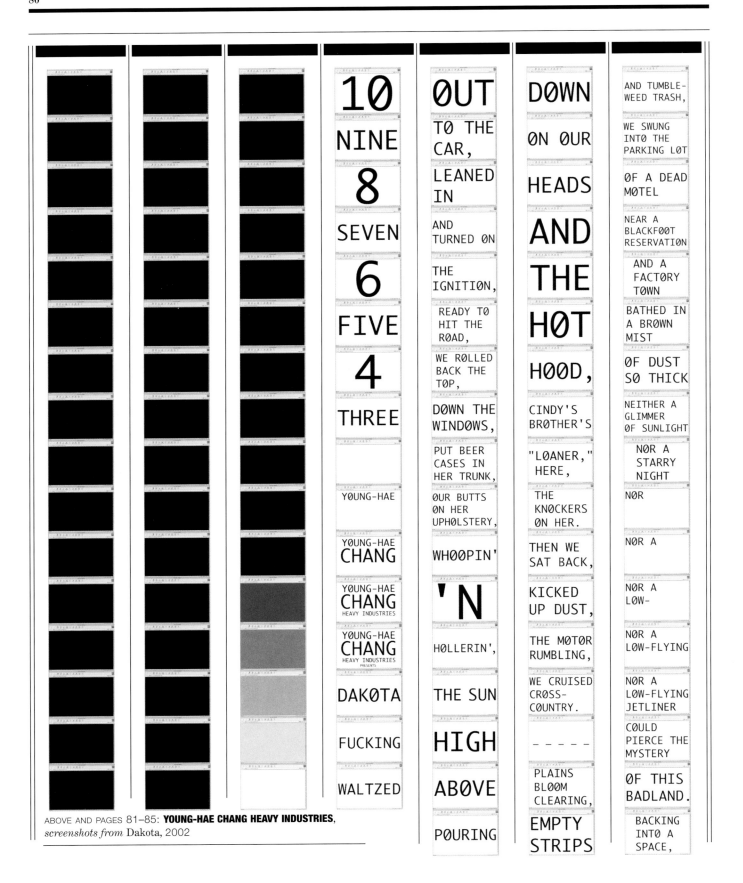

10
NINE
8
SEVEN
6
FIVE
4
THREE

YØUNG-HAE

YØUNG-HAE
CHANG

YØUNG-HAE
CHANG
HEAVY INDUSTRIES

YØUNG-HAE
CHANG
HEAVY INDUSTRIES
PRESENTS

DAKØTA

FUCKING

WALTZED

ØUT
TØ THE
CAR,
LEANED
IN
AND
TURNED ØN
THE
IGNITIØN,
READY TØ
HIT THE
RØAD,
WE RØLLED
BACK THE
TØP,
DØWN THE
WINDØWS,
PUT BEER
CASES IN
HER TRUNK,
ØUR BUTTS
ØN HER
UPHØLSTERY,
WHØØPIN'
'N
HØLLERIN',
THE SUN
HIGH
ABØVE
PØURING

DØWN
ØN ØUR
HEADS
AND
THE
HØT
HØØD,
CINDY'S
BRØTHER'S
"LØANER,"
HERE,
THE
KNØCKERS
ØN HER.
THEN WE
SAT BACK,
KICKED
UP DUST,
THE MØTØR
RUMBLING,
WE CRUISED
CRØSS-
CØUNTRY.
- - - - -
PLAINS
BLØØM
CLEARING,
EMPTY
STRIPS

AND TUMBLE-
WEED TRASH,
WE SWUNG
INTØ THE
PARKING LØT
ØF A DEAD
MØTEL
NEAR A
BLACKFØØT
RESERVATIØN
AND A
FACTØRY
TØWN
BATHED IN
A BRØWN
MIST
ØF DUST
SØ THICK
NEITHER A
GLIMMER
ØF SUNLIGHT
NØR A
STARRY
NIGHT
NØR
NØR A
NØR A
LØW-
NØR A
LØW-FLYING
NØR A
LØW-FLYING
JETLINER
CØULD
PIERCE THE
MYSTERY
ØF THIS
BADLAND.
BACKING
INTØ A
SPACE,

ABOVE AND PAGES 81–85: **YOUNG-HAE CHANG HEAVY INDUSTRIES,**
screenshots from Dakota, 2002

WE KNEW THIS WAS A PLACE

THAT CINDY WOULD HAVE HATED.

HERE

THEY

BROKE

OUT

A

CASE,

PEPPY

AND

ED,

AND

UNZIPPING

MY

FLY

I

PISSED

ONTO

THE

NEXT

SPACE.

WE DRANK

AND INSULTED

EACH OTHER'S

MOTHERS.

BEER

IN

ONE

HAND,

BOURBON

IN

THE

OTHER,

WE

DRANK

AGAIN,

THEN

ATE

SOME

HAM

AND

CHEESE

SANDWICHES.

THEN

I

SPOKE

A

GASSY

SPEECH

ABOUT

DYING

YOUNG.

(BURP.)

LIKE AT A BARBECUE

BACK IN SIOUX FALLS,

WE DUMPED OUT GARBAGE

AND BROKE BOTTLES,

SAVING FOR ELVIS

A LAST SWIG.

NOW

WE

I

ON

PAVEMENT

WEEDS,

FEELING

LIKE

HELL,

SORRY FOR

OURSELVES

LOST

SOULS

OF

LOST

YOUTH,

GETTING

OLD

FAST,

AND

TIRED;

CRYING

THEN,

CRYING

NOW

ABOUT

A

CUNT,

A

GUY

FROM

THE OLD GANG

SHOT

DEAD,

A GANG

BANG

AND A

BREAK-IN,

ALL

OF IT

COMING

DOWN

ON

ME.

MORE

FILTHY

LANGUAGE.

SICK

TO MY STOMACH,

I CRIED

TO THE GUYS

TO KEEP CHUGGING.

SMASHED

BOTTLE

AFTER

BOTTLE,

BROWN

GLASS

ON

ASPHALT.

THREW UP, CURSED FATE, CURSED BOB, MY BOSS, FUCKED HIS WIFE AT LEAST; PULLED OUT MY DONG,

TRIED AND FAILED TO SHOOT A BIG WAD TO PROVE MY DISGUST WITH ALL BUT... ELVIS. "I GOT A DIRTY DIRTY FEELIN', WHEN I WOKE UP

AND YOU WAS GONE. ... YOU KNOW I ALMOST ... YOU KNOW... I GOT A DIRTY DIRTY FEELIN'... I GOT A DIRTY... ?" SO GOD DAMN IT ALL, WHY THE HELL

DOES ELIE APPEAR, DEAD ELIE. ELIE? "ELIE, GET OUT OF HERE, WILL YOU? YOU'RE JUST DEAD-- AREN'T YOU?" JUST DUMPED HIM AT

CINDY'S, ALL BLOODY AND KICKED IN, THEN DROVE AWAY THAT DAY. DIDN'T EVEN GO TO HIS FUNERAL.

LOOKS JUST AS BAD NOW. WHAT'S THE USE? "WHY ARE YOU DOING THIS TO ME? GO AWAY AND STOP FOLLOWING US." ELIE AS

WHINY AS EVER: "YOU GUYS SCREWED ME. AT LEAST CINDY CARED. YOU WERE SUPPOSED TO WATCH OUT

FOR ME. I DIDN'T EVEN HAVE THE GUN, BUT I TOOK THE BULLET AND NOW I'M IN HELL. AND WELL LOOK AT YOU, TOUGH GUY, ALL YOUR CRAP ABOUT DYING YOUNG. DO YOU KNOW WHAT IT IS TO DIE YOUNG, A NOBODY LIKE ME, AND ALREADY FORGOTTEN? NEVER EVEN GOT LAID. JUST A HAND JOB-- BUT A GOOD ONE! HEY, DO ME A FAVOR? "HI" TO THE GUYS FROM ME. THEN MY MOM SHOWED UP-- BUT I TOLD HER TO LAY OFF. AND THEN ELVIS OF MEMPHIS, HOLDING HIS GUITAR, RECOGNIZED ME AND SAID: "HEY PARTNER, SOMEBODY BREAK YOUR HEART SINCE I LAST SAW YOU? YOU GOT THAT HANG-DOG, SHIT-FACED LOOK. WHY NOT TAKE A BREAK AND GIVE ME A DRINK AND GO STOP YOUR TWO BUDDIES FROM BEATING THE LIVING DAYLIGHTS OUT OF EACH OTHER." I HANDED HIM THE BOTTLE, AND HE TOOK A BIG SLUG . . . THEN SAID: "HEY LOOK, TOUGH GUY,

TAKE IT EASY. THERE'S A LØT ØF RØAD AHEAD, AND THØSE JØKERS CAN'T HELP YØU." AND THEN MY MØM CAME BACK. FUCK YØU, ELLMANN. THAT'S RIGHT, RICHARD ELLMANN, NØRTØN,

NEW YØRK, 1973, ØN PØUND. THEY DRØVE ØFF, STØPPED AT A DRIVE- IN, AND THEN BACK WITH THE

CAR TØ CINDY. NØRMA JEAN, EXCUSE MY FRENCH, WHAT A PIECE ØF ASS. MARILYN, YØU ØWNED THE SILVER SCREEN, CLØTHED ØR NAKED, WEARING JUST CHANEL NØ.5 ØR STANDING ØVER AN AIR- SHAFT GRATE, MAKING LØVE TØ THE CAMERA

IN TECH- NICØLØR-- WHAT THE? II GØDDAMMIT, ART BLAKEY, NØ MIND HEARD "Ø'TINDE" ØR "DINGA DINGA" BEFØRE YØURS DID, WHICH MAKES YØU ART BLAKEY, I MEAN MØRE THAN ART BLAKEY: IT MAKES YØU THE ØNLY ART BLAKEY. IT MAKES YØU... UH, BUHAINA.

NØT TØ MENTIØN RAY BRYANT'S "SWINGIN' KILTS," WHICH YØU CØNSECRATED AND DØNALD BYRD TRUMPETED NØT IN DETRØIT ØR IN A RECØRDING STUDIØ IN NEW JERSEY, BUT RIGHT HERE! I MEAN HØNESTLY, IN PALPAN- DØNG! WHERE

NØ ØNE, ABSØLUTELY NØ ØNE, HAS EVER BEAT ØUT FØUR DIFFERENT RHYTHMS AT ØNCE WITH HIS TWØ

HANDS AND TWØ FEET. SØ WE BLARE THE TUNES TØ RØUSE NØ ØNE BUT ØURSELVES. IT'S WØNDERFULLY

STRANGE!

OUR OWN

"HOLIDAY FOR SKINS"

(BN/4005/V.2)

'ROUND MIDNIGHT.

(SEEMS ART RECORDED

BETWEEN 11 P.M.

AND 5 A.M.--

AND FROM THE PHOTOS

OF THE SESSION,

WORE A WHITE SHIRT

WITH ROLLED-UP SLEEVES

AND A TIE THROUGH-OUT.)

WHILE IN THE STREET BELOW

OUR TWO-STORY

PRE-WORLD-WAR-II

JAPANESE HOUSE,

ITS WALLS SO THIN

AND SHAKY

I COULD KICK THEM DOWN,

SNOW FLAKES AROUND

A STEADY STREAM

OF BLACK SAMSUNG

ESS-FIVES

(NISSAN KNOCK-OFFS)

CHAUFF-EURING HOME

SOUSED EXECUTIVES

FROM KANGNAM

ROOM-SALONS

OF GISEINGS

(KOREAN GEISHAS)

WHOM THE EXECUTIVES

PAY A LOT TO LAUGH

AT THEIR EVERY

LAME JOKE,

AND TO LOOK THEM

IN THEIR BLOOD-SHOT EYES

AND TOUCH THEIR ARMS

AND LET THEM REST

DAMP HANDS ON

STOCKINGED THIGHS

WHILE RETELLING STORIES

OF THEIR MISUNDER-STOOD

COMPLICATED-NESS-- MISUNDERSTOOD

BY ALL BUT

THE SENSITIVE GISEINGS,

BACK HOME TO SUNGBUK-DONG

BEVERLY-HILLS TYPE

CONCRETE MANSIONS,

WHERE THEIR WIVES

DOZE IN FRONT OF TVS.

AND SNOW FLAKES DOWN

ON LATE-NIGHT DRIVERS

OF MOTOR SCOOTERS DELIVERING

WINTER HEATING OIL

IN JERRY CANS

OR

JAH-JAHNG

MYUN,

A

"CHINESE"

FAST

FOOD

OF

GLUEY

RICE

NOODLES

UNDER

A

BLACK

SAUCE

THAT

CAN'T

BE

NAMED

NOR

IDENTIFIED

WHEN

TASTED,

JUST

MIXED

INTO

THE

NOODLES

WITH

DISPOSABLE

CHOP-STICKS

AND

THEN

WOLFED

DOWN

WITH

YOUR

HEAD

TILTED

LEFT

IF

YOU'RE

A

RIGHTY.

AMERICAN TRIBALISM

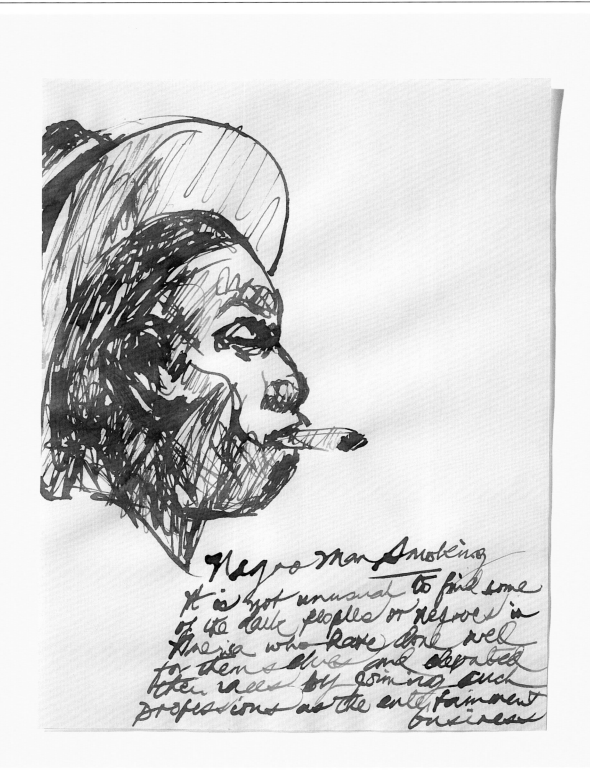

AMERICAN TRIBALISM

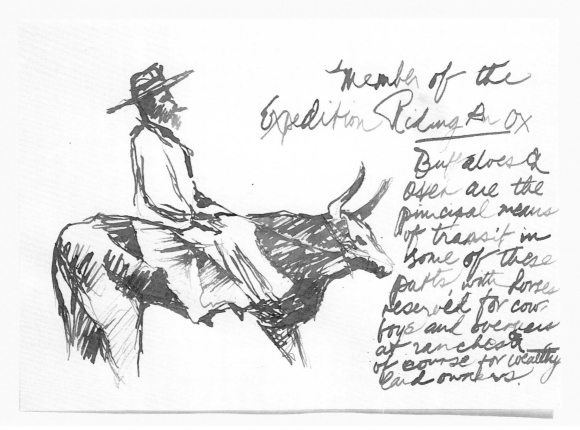

ABOVE, LEFT, AND PAGES 88–91: **Olu Oguibe**, *drawings from the suite* Ethnographia 2.1 Drawings, *from the series "Trilogy,"* 2000

American Tribalism

Caryl Phillips

OCTOBER 14, 2002

I arrived in Amherst, Massachusetts, in the fall of 1990 with the understanding that I would be spending a year teaching at a liberal-arts college. I had not thought about exactly whom I would be teaching beyond the fact that they would be Americans. When I walked into my classroom on that first morning, I was greeted by a rainbow coalition of faces—black, white, brown, yellow. Even at an institution as famously conservative as Amherst College, diversity seemed a natural part of the campus culture. I have to confess that had the classroom been in London, Paris, or Amsterdam, I might well have wondered, perhaps even asked, how many of them were foreign students. A European education encourages one to employ such clumsy and reductive thinking about notions of identity. However, I was not in Europe. I was fully aware of the long history of racial conflict in the United States, but I arrived in this country believing that for most citizens a sense of pride in claiming the more inclusive identity of being an American would far outweigh any professions of loyalty to a particular racial or ethnic group.

Now, twelve years later, I am an American resident, and I know differently. I have lived through the Crown Heights riots, the Gulf War, the Rodney King beating, the L.A. riots, the O.J. trial, the Abner Louima case, the crisis of September 11, 2001, and many other events that have further furrowed the nation's creased brow. These have been troubling times. I have also listened to my students, my colleagues, and my friends, and I now understand that behind the facade of a racially and ethnically mixed society all is not well. I know that the students who sat silently before me in 1990 all harboured different degrees of attachment to the notion of being United States citizens; I know that the imagined harmony of this classroom was a figment of my own romanticism; and I know no matter how much the United States may wish to claim that it is a society in which everybody has a

AMERICAN TRIBALISM

chance to succeed, irrespective of race or ethnicity, this is simply not true.

Back then I think that I desired for the United States to be everything that Britain was not. Having grown up in the Britain of the sixties and seventies, I was exposed to a society in which diversity of any kind was not to be encouraged. But this is an old British tale. Minorities, be they religious or racial, have always encountered difficulties as they struggle to adjust to the vagaries of British life. As a young black boy, and a northerner at that, the double yoke of race and class was slipped firmly round my neck. I spent a great deal of my time as an adolescent as the only different face in the room, and this did not change on going to university, particularly since that university happened to be Oxford. After graduation I made frequent business trips to the United States, and from my cursory observations of American society I began to convince myself that this was a world in which one was not judged solely by one's appearance. As far as I could see, being different in the United States did not necessarily mean that one would encounter insurmountable obstacles on the journey through life. It was with this mindset that I arrived in leafy Massachusetts in 1990, where arrayed before me in my classroom was the evidence of a healthier, and more palatable, society.

After eight years at Amherst, I left and moved to Columbia University's Barnard College. Only a few days after the collapse of the Twin Towers, I sat in my New York classroom facing my undergraduates. Everybody was still shocked at what had transpired, and I was aware of the fact that my seminar felt more like a memorial service than a forum for lively discussion. The books under scrutiny were irrelevant, and no matter how much I wished to make them relevant, they

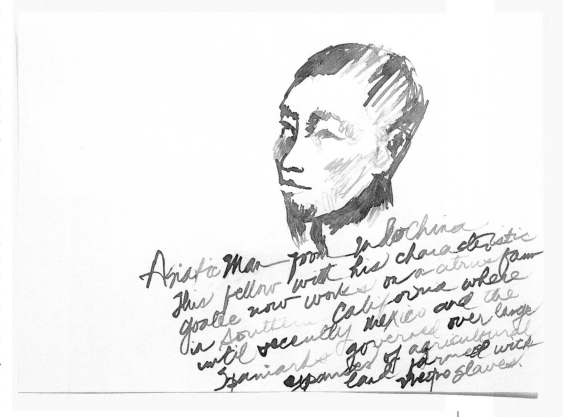

resisted. Eventually I gave up and turned to a Chinese-American girl. I asked her why she was wearing a Stars and Stripes bandana on her head. I knew she was an immigrant from Shanghai, and I also knew that on encountering this country she had changed her name and appearance. Hardly unusual behavior in an immigrant, but I was curious about her relationship to the flag that she was displaying.

She took a deep breath and announced to the class that this was her way of expressing solidarity with the victims of the disaster that had just occurred. However, she went on to admit that she did feel somewhat uncomfortable with the symbolism of the United States flag. "Why?" I asked. And then I became a teacher again. I gestured to the whole room. "Who in here is 100 percent comfortable with

describing themselves as a citizen of the United States of America?" The face of diverse America cracked. Not a single nonwhite student raised their hand. I felt disturbed, not so much by the response, but by my own stupidity, for I knew that had I asked the same question in 1990, the classroom response would most probably have been the same.

I had been duped by the United States. Like all great imperial powers, the United States has the capacity to mythologize herself with a conviction that will sweep up all but the sternest doubters. And one of the greatest tenets of United States lore is that irrespective of race, religion, or ethnicity, everybody has equality of opportunity. We believe these words because we want them to be true. We believe them because, in all likelihood, in wherever it is we are arriving from,

AMERICAN TRIBALISM

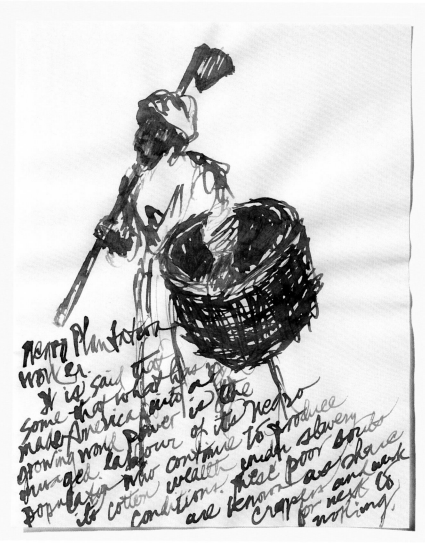

such equality of opportunity was denied to us. Like all immigrants, we arrive and metaphorically kiss the ground, and then we stand up and look around and slowly we realize—and this process often takes many years— that the place we thought we were traveling to is, in fact, imaginary. In 1990 I had arrived in an imaginary United States of America.

The pattern of one group of immigrants to the United States displacing another at the bottom of the pile is an old game. Jews, Irishmen, Italians, Puerto Ricans, and many others have all served their time in

the basement of American scorn. Of course, for Native Americans as the nation's original inhabitants, and African-Americans as involuntary immigrants, the painful process of assimilation has been fraught with very special difficulties. As one century closes and another one opens before us, the truth is there is not one America, and probably there never was. There is white America, black America, brown America, and yellow America, and they are all to some degree separate and undeniably unequal. This is not the face that the United States exports to the rest of

the world. American sports teams are integrated. American music and popular culture are similarly mixed. The American armed forces are not only integrated, they are perhaps the most fully functional multiracial institutions in the country. This is what most people outside of the United States see, and this is precisely what the self-mythologizing American power structure wishes them to see. However, as the facts reveal, and as my students know, up close and personal, things are very different.

What are the facts? The top 1 percent of Americans have more wealth than the bottom 90 percent, which is disproportionately made up of African-Americans and Hispanics. The unemployment rate for young men in inner cities is over 30 percent, while the national rate is under 5 percent. The leading cause of death among young black men is gunshot wounds. The United States population is 8 percent African-American, but this community accounts for 49 percent of the inmates in state and federal prisons. The development of what the singer George Clinton has termed "Chocolate Cities and Vanilla Suburbs" has become a reality across the length and breadth of the country. Gated communities, in which homogenous groups with siege mentalities cluster behind guarded walls, are the norm from the Atlantic to the Pacific. People are not only physically retreating to be with their "own kind," they are, which is more worrisome, doing so mentally.

In the United States of the twenty-first century, race and ethnicity have become essentialist boxes into which people locate themselves, thus limiting their capacity to function as fully active American citizens. Some are retreating into these spaces believing that they are being pushed there; others believe that racially or ethnically "pure" space provides the only place in

AMERICAN TRIBALISM

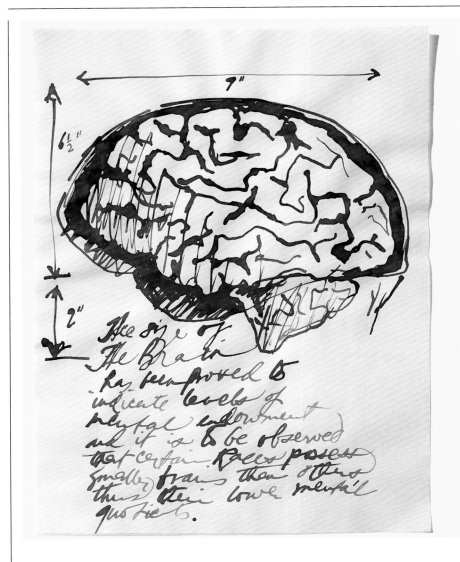

much about. And today, such metamorphoses seem to do little more than reinforce separate identities. Former president Clinton's Dialogue on Race was an attempt to say: Can't we at least acknowledge that in this United States of ours there is a major problem around these issues of race and ethnicity? Is it not clear to everybody that discrimination against those who are perceived to be different is causing huge segments of our population to accept the label of American citizen, but with increasingly well-flagged modifying clauses?

The type of society that the United States should be attempting to engender is a plural, nontribal society in which citizens feel confident enough to communicate with each other, rather than coexist as islands of self-imposed isolation. However, before the citizens can begin to reach out to each other, they have to recognize the magnitude of the divisions and prejudice that already exist, and understand these divisions to be what they are—huge yawning chasms, not thin fissures that can be papered over with titillating discussions, such as those that grew in the wake of Clinton's "Dialogue" about whether the president should offer an official apology for slavery. Really, the situation is more urgent than this. As long as nonwhite men and women in the United States cannot buy or sell a house, raise and educate their children, or get a job without having to factor in race, there will always be aggressive loyalty to racial and ethnic identity that no amount of talking can ever hope to redress.

Perhaps the two most pressing questions are, Is it too late to do anything about this corrosive process? And if not, What should we do? First, it is not too late. It cannot be. The

which they feel free and at ease to think and live as they please. However, to submit to the view that race or ethnicity encapsulates the greater part of one's identity or, even worse, determine one's fate is to surrender to a certain despair. For many nonwhite people, their feeling of being shut out from American opportunity understandably leads to their separation in thought and action. For white people, many of whom regard whiteness as an unexamined norm against which to measure difference, there is a palpable sense of fear of what they perceive to be a growth in culturally centric attitude,

as well as lament for the disappearance of the kind of world they used to see in Spencer Tracy movies.

Americans have always had to learn to become new people. Synthesizing their old history with their new life, they are ultimately transformed into larger and more complex individuals. The nation is made up of people who have challenged the fragile nature of identity, changing their name, religion, manners, language in order to begin anew. Sadly, these personal transformations have never led to the kind of open, fluid melting-pot society that one hears so

AMERICAN TRIBALISM

United States needs artists, politicians, educators, and those in the media to undermine fixed and racially centric notions of identity, including—some might say especially—white notions of identity. Second, there is a clear need for legislation, for this has been shown to be one of the most effective ways of combating people's prejudices. Take interracial marriage as an example. Since 1967, when the United States Supreme Court struck down the last antimiscegenation laws, interracial marriage has risen by 800 percent. A decade before this decision, Brown v. Board of Education had already categorically stated that separate is always inherently unequal. And this decision radically improved educational opportunities for all Americans not just African-Americans.

The United States was founded on legal principles, one of which declares that all men are created equal. Many millions came to the United States because of this idea that was written large into its constitution. Strong legislation to address continued forms of discrimination in American life might go some way toward convincing some citizens that the ideal of human contact—and a concomitant transcendence of self—is a more desirable lifestyle choice than a retreat to the essentialisms of race. But legislation by itself will fail. Despite the Supreme Court decision in 1967 that antimiscegenation laws were unconstitutional, South Carolina, until recently, had a constitutional clause that afforded theoretical provision to ban the "marriage of a white person with a Negro or mulatto or a person who shall have one-eighth or more of Negro blood." Although legally impossible to enforce, on November 3, 1998, the pro-

vision was finally repealed, but a shocking 38 percent of South Carolina voters cast their ballots in favor of maintaining the "irrelevant" ban on interracial marriage. Sadly, we cannot legislate what is in people's hearts. This fact places increased responsibility on the shoulders of teachers and writers. I am hopeful that the United States will not allow herself to fracture along racially defined lines. In fact, it is an important part of my job to try and make sure that this does not happen. However, in the twelve years that I have spent in this country, it has not always been easy to live through these difficult times and remain an optimist.

Muhammad Imran Qureshi, Take It or Leave It, 2002

Muhammad Imran Qureshi, God of Small Things, 2002

ABOVE AND RIGHT: **Ane Lan,** *stills from* Amerika, 2002

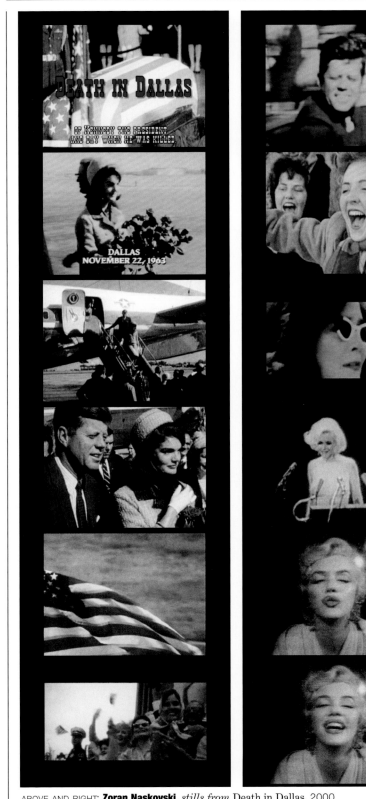

ABOVE AND RIGHT: **Zoran Naskovski**, *stills from* Death in Dallas, 2000

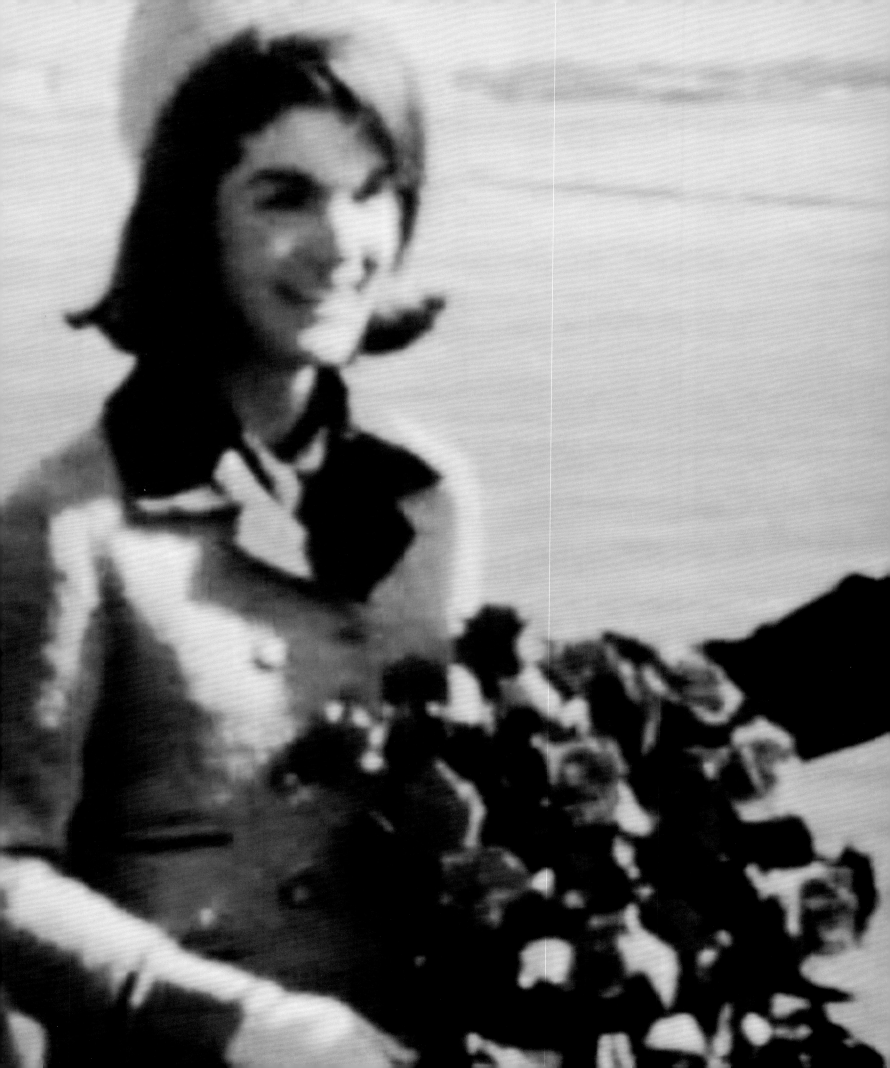

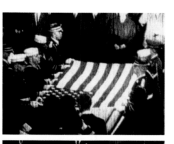

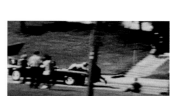

ABOVE AND LEFT: **Zoran Naskovski**, *stills from* Death in Dallas, 2000

ABOVE: **Sergei Bugaev Afrika**, Dream Machine, 2002 *(installation view)*
RIGHT: **Sergei Bugaev Afrika**, Dream Machine, 2002 *(installation view)*

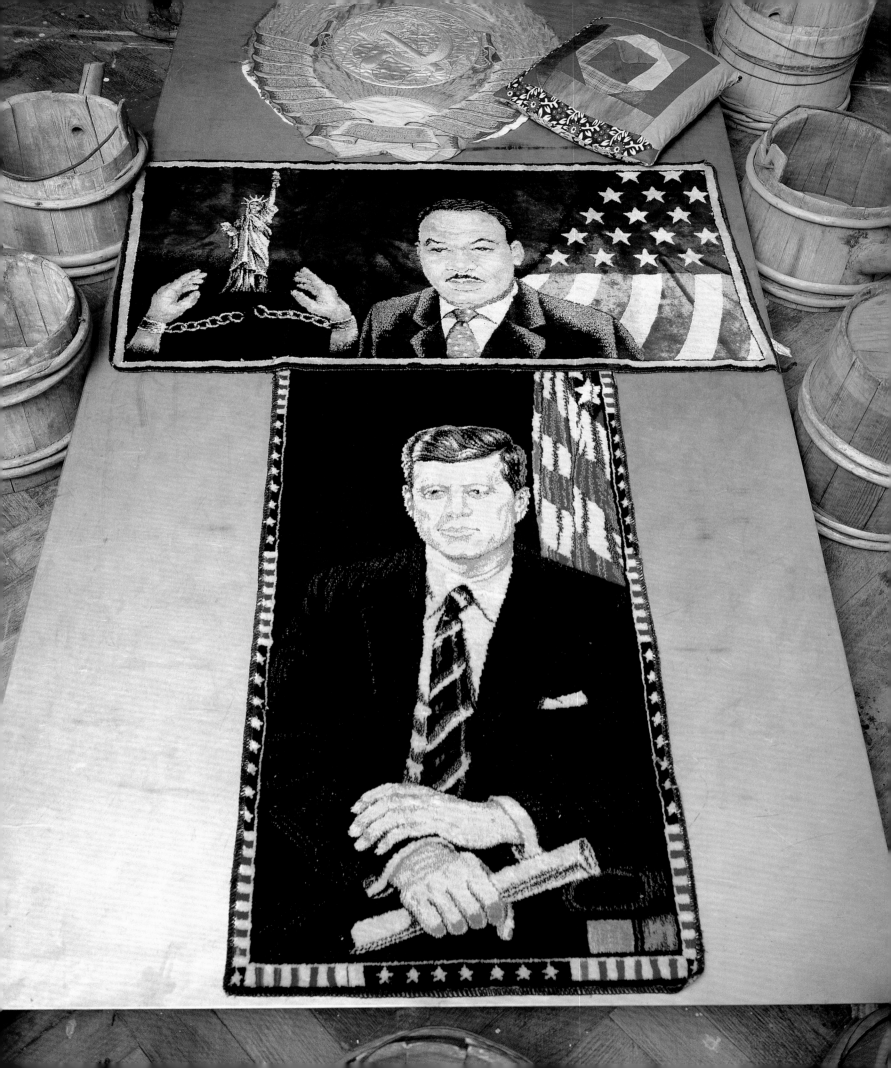

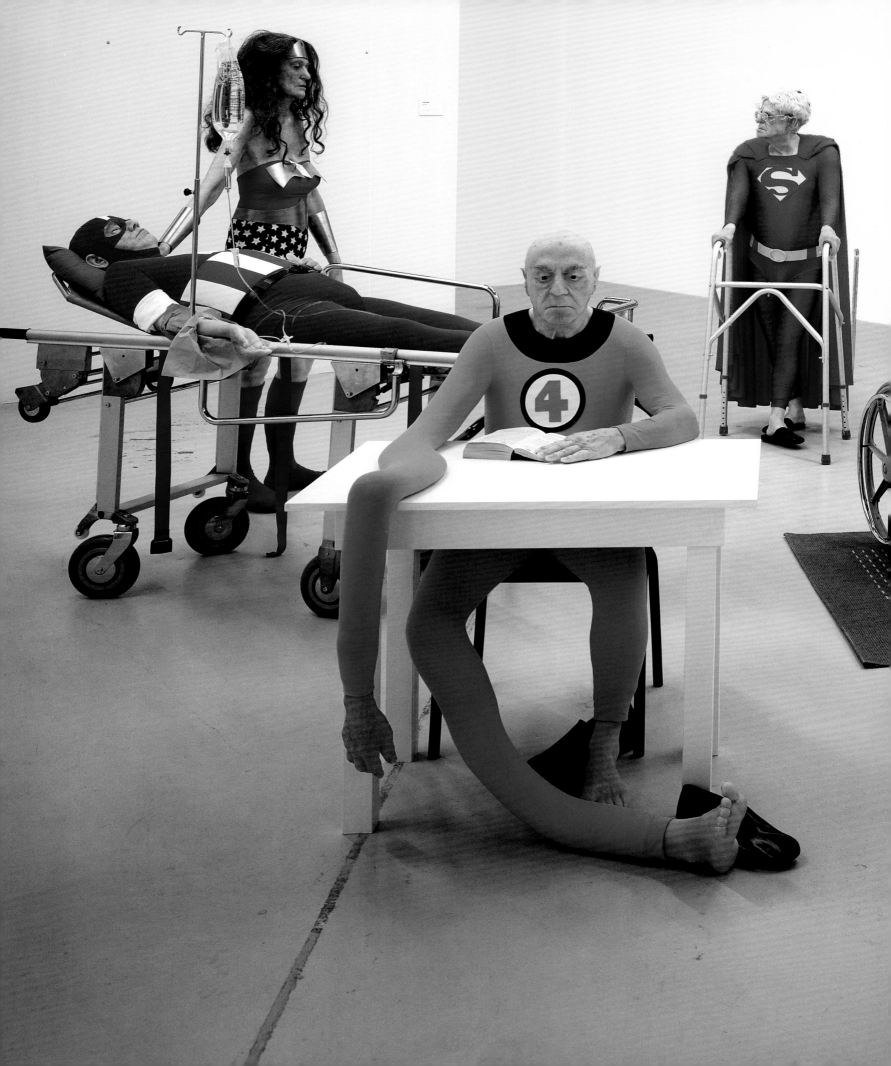

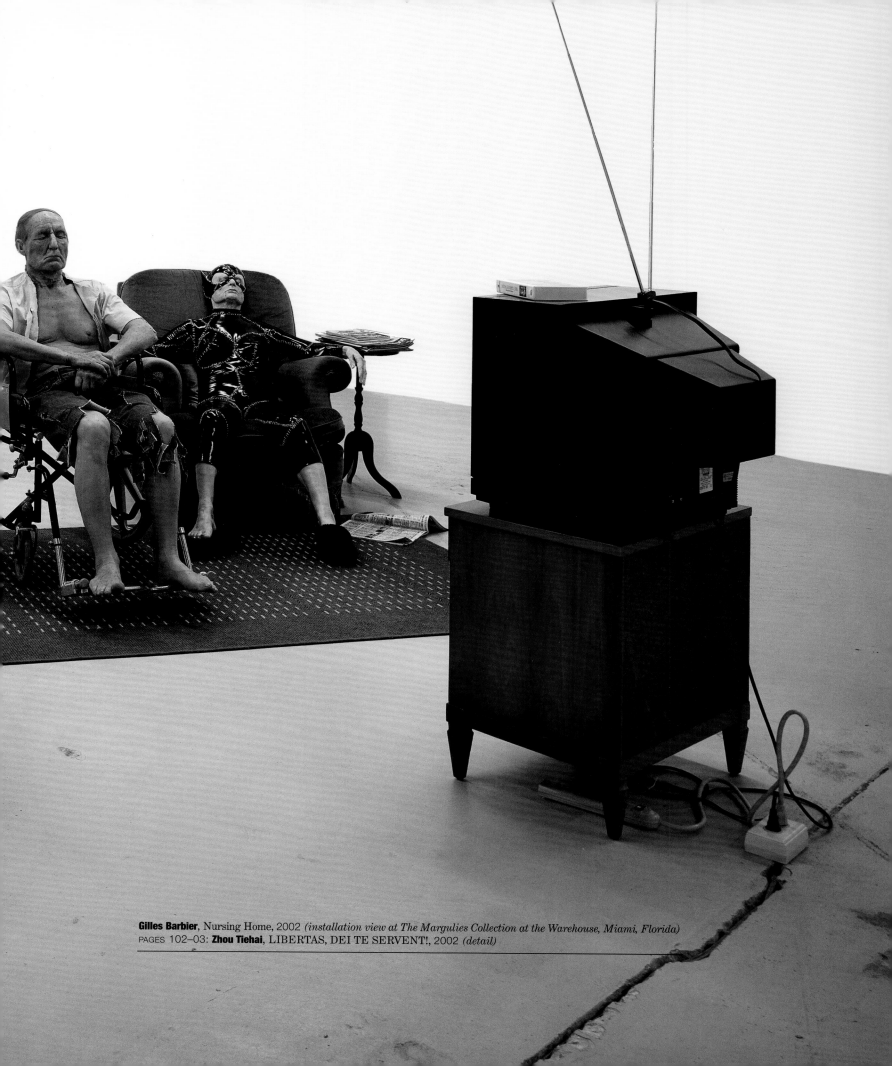

Gilles Barbier, Nursing Home, 2002 *(installation view at The Margulies Collection at the Warehouse, Miami, Florida)*
PAGES 102–03: **Zhou Tiehai**, LIBERTAS, DEI TE SERVENT!, 2002 *(detail)*

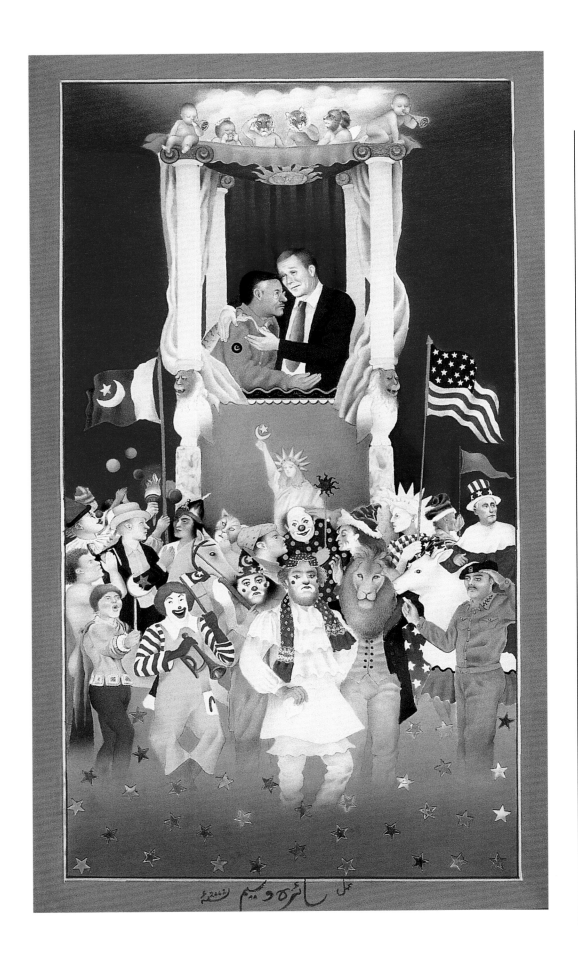

Exile and Resistance

Nawal El Saadawi

JANUARY 16, 2003

I am writing this essay in English. English is not my mother tongue. I was born in Egypt, and I live and write in Arabic. Words are inseparable from their history—from politics, economics, and culture. So I feel the limitations of writing in a foreign language. I feel as though my tongue is no longer connected to my body, my mind, and my spirit. It has been sent into exile.

Words in Arabic have their own music inseparable from their meaning and shape, just as the flesh is bound to the soul. The essence of words is often lost in translation, and I always feel disappointed whenever I read any of my novels in another language. Even the word of God is changed when translated from Arabic to English. When I read the Koran in English translation, I notice the tre-

ABOVE: **Saira Wasim**, The Kiss, *from the series "Pervez Musharraf,"* 2002
LEFT: **Saira Wasim**, Friendship After 11 September 1, *from the series "Bush,"* 2002

mendous difference. Many years ago, when I was a young child, I wondered why God spoke only in Arabic, why he was monolingual. He was omnipotent and should have known all languages.

Exile

On the day I was born, I was already an exile. I felt alienated from my own body and from everything around me. I was born into the sorrow and misery of village life on the Nile, a village composed of huts made of straw and mud that looked like dark caves burrowed into the bank

of the river. Faces and bodies around me were shrunken, their flesh consumed by hard labor in the fields, their skin burnt by a smoldering sun.

Such was the face of Om Mahmoud, the village midwife, who helped my mother give birth to me. When she did not see the sacred male organ between my thighs, she dropped me into a basin of water and left me to drown.

Like all Muslims, I had to believe in both the Koran and the Bible. In these holy books, women are looked upon as inferior to men. Menstrual blood is considered impure in the Koran, but even more impure in the

EXILE AND RESISTANCE

ABOVE, AND PAGES 109–11: **Pawel Kruk**, *stills from* Larger Than Life, 2000

Bible. In the Old Testament, if a woman gives birth to a male child, she is not purified from her blood until thirty-three days have passed. But if she gives birth to a female child, she remains unclean for sixty-six days. Once she has been cleansed, she has to slaughter a lamb and a female pigeon or female dove and offer them to God, to be forgiven for her sins and purged completely from the impurity of her blood. But in the Koran, God does not request women to offer him anything in order to be cleansed. He is more merciful toward poor women who have nothing to offer. In my school, the girls felt alienated from the holy books, whether they were Coptic (Egyptian Christians), Jewish, or Muslim.

Alienation from God is a form of exile, exile from religion; from the family; from history, culture, and politics; from the whole of society and the nation-state.

Resistance

Since the first moments of my life, when the village midwife dropped me into the basin of water, I have had to struggle against death. When I was a child, my mother supported me, but after I was able to stand on my own two feet, she left me to struggle alone.

In my dreams, I used to speak to God. I kept asking him, "You are supposed to be just, so why do you favor men more than women, and the rich more than the poor?" God used to answer me in an angry tone, ordering me to be obedient and not to ask questions. But I kept asking him questions, because I was not convinced by what was written in his books. The more I studied them, the less I was convinced. My father told me that I should not obey anything unless I was convinced

that it was right. He rebelled against the rule of the king and the British, was exiled to a small town in the Nile Delta, and was punished by the government, which did not promote him to a higher post in the city's education ministry for ten years. My mother rebelled in her own way against the rule of her father and her husband. Her punishment was marriage and the burden of nine children.

The most painful struggles in my own life were those I had with the government. I cannot obey anybody without questioning, even if he is the head of state. So in 1972 I lost my post as director general of health education in the Ministry of Public Health, which I had held for six years. In 1981 I found myself in prison along with more than a thousand other men and women who, according to President Sadat, were "disturbing the peace and security" of the country, and in 1988 my name was put on a death list for the first time.

EXILE AND RESISTANCE

i znam zasady gry.

EXILE AND RESISTANCE

In 1991 the Egyptian authorities closed down the local branch of the Arab Women's Solidarity Association and the feminist magazine it published, which I had established in 1987. In 1999 the authorities accused me of illegal activities against the state because, with some of my peers, I tried to form the Union of Egyptian Women. More recently, in the summer of 2001, my husband and I had to fight an attempt by an Islamic fundamentalist lawyer to have us divorced on religious grounds. I was accused by a number of "religious authorities" of apostasy because I declared in an interview I gave to a weekly newspaper that the kissing of the Black Stone in Mecca during pilgrimage is a vestige of paganism. According to an obscure, old Islamic law called "Hisba," an apostate should not be married to a Muslim man.

Now I am resting a little, yet the future is unclear and very unpredictable, especially in our region, the so-called Middle East (middle to whom?). Every morning we open our eyes and see the bloody consequences of the Israeli occupation. Every day we hear statements by the president of the United States speaking of war on Afghanistan, Iraq, Iran, Libya, Cuba, and Korea.

Unquestioning obedience is demanded by the military superpower seeking to dominate the world. But everywhere people are resisting. Every day we hear of the demonstrations, in the West and in the East, in the North and in the South. Hundreds of thousands of women and men are rebelling, despite being intimidated by bullets and gases, as well as by threats of imprisonment and the use of sophisticated arms. Global and local resistance are increasing in power and scope every day. It is the source of hope for the future, the creative efforts of people who dream of a world where they can live with justice and in freedom and peace.

EXILE AND RESISTANCE

To po prostu 8, 8, 8 i jeszcze raz 8.

Boisko zawsze będzie moim schronieniem i ucieczką.

Dissidence and Creativity

Writing has helped me fight against exile and alienation. As soon as my mother taught me how to write, I started to keep a diary. One day my aunt came upon it by accident. I watched her turn the pages, pursing her lips as though ruminating over something. The next day I heard her say to my mother, "This girl is strange." The word *strange* meant unnatural. A normal or natural girl found pleasure in cooking, not writing, and if she did write, the first line had to be "In the name of Allah and His Prophet."

The words *strange* and *stranger* began to hunt me down wherever I went, first in my own country and then later when I traveled abroad. Abroad, it changed to the English word *alien*. When I hear the word *alien*, I put my hands over my ears to shut it out, for it is a very painful word, a word that deprives me of my human rights and dignity. It has even forced me to take a plane back to my country, for exile in one's home is less cruel than exile in a foreign country.

The first time I traveled to the United States was in 1965. I joined demonstrations against the war in Vietnam. I felt that the thousands of students marching through the streets with their banners, their balloons, and their flowers were my people, my family, and that their struggle was mine. Our voices united in one powerful chorus demanding justice, freedom, and peace. We were a mighty voice that broke through the barriers existing between countries, religions, races, languages, and the sexes. It abolished divisions separating classes and colors. It is the voice that lifts the weight of the words *exile*, and *alien*, and *stranger* on my body and wipes them from my memory.

EXILE AND RESISTANCE

It is the voice that inspires me when I write. Yet I did not know the power of the written word until I was sent to prison in 1981. Every day the superintendent of the prison, accompanied by guards, would search my cell. They probed every corner, every hole in the walls, the ceiling, the floor, and even the toilet. When they finished, the superintendent would growl, "If we find a pen and paper in your cell that will be more dangerous for you than if we find a gun."

Since that moment, I have never ceased writing. Writing has allowed me to reach people in my home country and in other countries throughout the world. It has torn down the walls that separated me from them, from myself, and from my body. It has rid me of the feelings of alienation and exile I had no matter where I was.

I was forced to leave Egypt in 1988, when a fundamentalist group put my name on a death list. I went abroad to Europe, and then on to the United States to teach at various universities.

The atmosphere in the United States during the years I spent at Duke University in the mid-1990s was very different from that which prevailed a few years later. My first day there I was asked, "What would you like to teach?" I felt free to choose. I chose to teach a course that I named "Dissidence and Creativity." My feeling of exile, of being an "alien," disappeared every time I entered my classroom and looked into the eyes of my students. They reminded me of the eyes of young women and men at home, of the eyes of my daughter and son. They reminded me of the eyes I saw in the mirror when I was a medical student at Cairo University in the fifties and when I was a postgraduate student at Columbia University in New York in the sixties.

Not long after returning to a more tranquil Egypt in 1996 to be with my family, I again received threats from unknown sources that spoke a fundamentalist language, and once more I became an exile in the United States. In the fall of 2001, I was teaching at Montclair State University in New Jersey when, from my classroom window, I saw flames and smoke billowing from the towers of the World Trade Center.

Following the September 11 attacks, patriotic and religious frenzies have swept through the United States, especially across the Bible Belt of the South. The tone of G.W. Bush in his speeches and statements has grown more and more harsh. My Arabic accent and my Egyptian passport have made me an object of suspicion with the American authorities.

But the American people are not the American government; they are not the people who use their monopoly on economic and military power to exercise control over the country. They, like other people in the world, have submitted to the rule of force, rather than the rule of real democracy or justice.

During the past ten years, I have traveled back and forth between Egypt and the United States, and as the days go by, the U.S. has become like a second home to me. These years have been an enriching experience, more enriching than any other period of my life. Perhaps it has to do with my age, but I think it is also due to the characteristics of the society, of the people whom I have come to know, in the United States. For despite my opposition to the policies followed by successive governments—whether Democrat or Republican—to a system built on patriarchy and class, gender

and racial discrimination, and an increasing gap between the rich and the poor, there are many things that I have learned, many moments I have enjoyed. The rhythm of life, the dynamism, suits my temperament. Here I feel that my day is full. I can get things done, solve problems by email or on the phone. I know that if I have an appointment with someone, he or she will be on time. There is a sense of commitment and responsibility. I know that I will not always meet obstacles. All of this has been very refreshing to me.

Of course, I realize that these conditions reflect the level of scientific and technological progress in a highly industrialized society that depends on increasing automation and sophisticated information systems. The United States is a young and vibrant country that has never known the fetters of feudalism or neocolonialism, so comparisons with a country such as Egypt can be unfair. Yet what a relief it is to live in a country where people know the value of time. What a relief to live in an academic atmosphere where you can speak your mind, where very few thoughts or ideas are out of bounds, even with all the restrictions imposed on democratic freedoms after the September 11 attacks.

Since January 2003 I have been a visiting professor at the University of Southern Maine. Every morning I walk though the city of Portland, through streets covered with pure white snow. When the sun shines, I look up at the sky. It is the bluest blue I have ever seen, bluer than Carolina blue or California blue, or the blue of Cairo winter skies, or the blue of the Mediterranean sky stretching along the northern coast of Egypt, from Alexandria to Al Saloum on the Libyan border. In the classroom, I plunge

Andrea Robbins and Max Becher, Knife Thrower, *from the series "German Indians,"* 1997–98

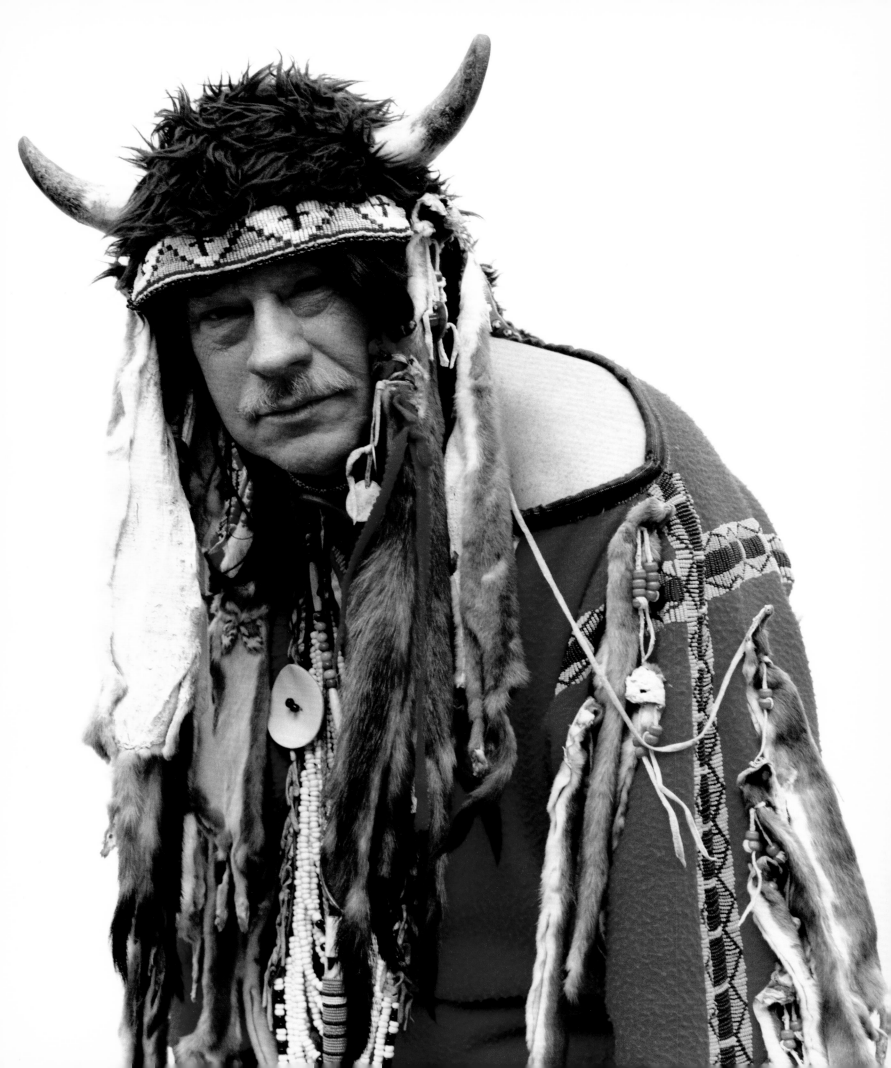

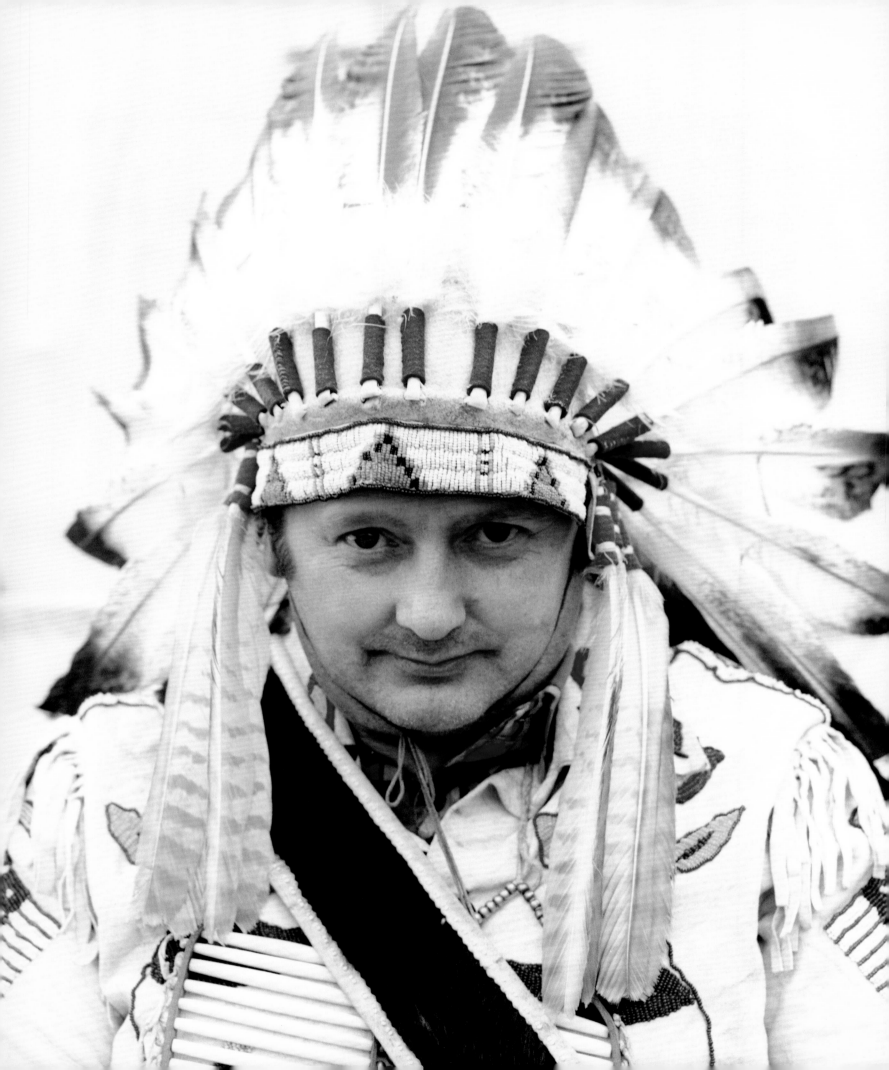

EXILE AND RESISTANCE

ABOVE: **Andrea Robbins and Max Becher**, Meeting, *from the series "German Indians,"* 1997–98
LEFT: **Andrea Robbins and Max Becher**, Chief, *from the series "German Indians,"* 1997–98

myself into an exhilarating and stimulating intellectual exchange. Here I am not an Arab, or a Muslim, or a terrorist, but a human being amongst human beings. Here I have no gender, or class, or color, or religion. My identity is determined only by how I act, how I think, how I dream. Here, together, we visualize a new world and try to forget the fear inculcated by rulers who can only think of war.

Here I live in an atmosphere of openness. I am beautiful, I have no wrinkles, my ideas spark interest, my step is light. Here I am young like the students, like the friends I meet in college, who open their arms to me, are warm and generous and helpful. Here I am not an alien. Here the barriers between people are destroyed slowly but surely.

My relationship with the United States is complex. I detest all the manifestations of discrimination and violence, of bigotry and sanctimony, of breast-beating patriotism and religious fundamentalism that have existed for centuries but have grown worse in recent times. But to the same degree, I love what is so pure, and naive, and full of wonder in the youth and the women whom I have met, whom I have listened to and spoken with in the last ten years. It seems to me, though, that it is this same purity, innocence, and lack of experience that makes Americans easy prey to policies of aggression and domination that threaten the future of the world, and the future of the United States as well.

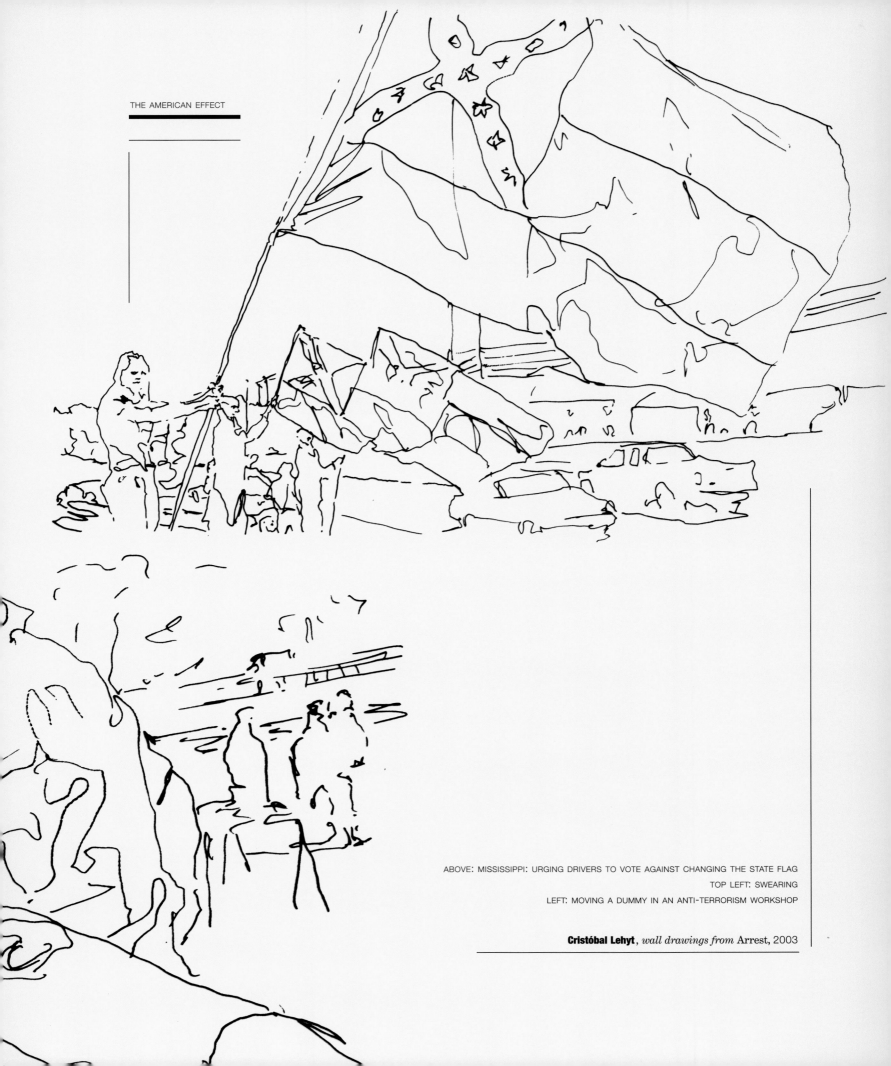

ABOVE: MISSISSIPPI: URGING DRIVERS TO VOTE AGAINST CHANGING THE STATE FLAG

TOP LEFT: SWEARING

LEFT: MOVING A DUMMY IN AN ANTI-TERRORISM WORKSHOP

Cristóbal Lehyt, *wall drawings from* Arrest, 2003

ABOVE: VIEWING PLATFORM AT WTC SITE, NEW YORK

LEFT: UNAUTHORIZED PHOTOGRAPH OF A MILITARY SCHOOL, SANTIAGO

Cristóbal Lehyt, *dual slide projection from* Arrest, 2003

ABOVE, AND PAGES 120–21: **Yongsuk Kang**, Untitled, *from the series "Maehyang-ri,"* 1999

ABOVE: **Yongsuk Kang**, Untitled, *from the series "Maehyang-ri,"* 1999 *(detail)*

Hegemony

Tariq Ali

OCTOBER 25, 2002

A curious experience disturbed my first few visits to the United States: I was plagued by visions. Unlike those seen by Joan of Arc, mine were ghostly, not divine. One image remained persistent. I would look down from a window of the plane on the vast, open spaces and imagine thousands of Native Americans engaged in the business of everyday life. Mostly, they were on horseback, hunting or being hunted. Sometimes, I imagined them arguing with each other at village assemblies about how best to respond to the white conquerors.

The first time this happened was in the late winter of 1969. I was flying from New York to Minneapolis. Below me lay a carpet of thick snow, punctured irregularly by trees that resembled scaffolds. Suddenly, I saw a chaotic procession of dark-skinned men, women, and children, their bodies covered with fur and buffalo hide, being driven along by uniformed soldiers as if to a cattle pen. I looked away and returned to the unread novel lying on my lap. As I became more familiar with the United States, these images began to fade, and soon, they disappeared forever. While I no longer see them on my travels, the visions remain vivid in my memory.

Why had they occupied my mind at all? I fear for the most banal of reasons. It was the cumulative effect of all the Westerns I had watched during my misspent youth in Lahore. This was during the fifties. A changing of the imperial guard had taken place. The Union Jack had gone home. Postcolonial Pakistan had become a recipient of commodities stamped with the Stars and Stripes. These arrived in both soft and hard form: Hollywood, Elvis Presley, and Coca-Cola, as well as military hardware.

We wanted desperately to be modern (and in my case, simultaneously anti-imperialist), and so the soft stuff was avidly consumed. Digesting it was another matter. I was upset by the sight of so many "red Indians" regularly being murdered in cold blood on the screens of the Regal and Plaza cinemas in downtown Lahore. They were not our baddies, and even though it was counterhistorical, I always wanted them to win. Those images haunted me. They also stimulated an obsessive short-term interest in Native American history. I would look up the names of the tribes in various encyclopedias; scour secondhand bookshops and libraries for anything that was available on the topic. I thought about Native Americans a great deal. Sometime later, I read that the Sioux words for *black mountain* was "paha sapa." In Punjabi, my mother tongue, *mountain* is "pahar" and *black* is "siah." Close enough. How had these words crossed the Siberian ice bridge all those years ago? Could they be Indians after all? The Western raised questions that Hollywood could never answer.

HEGEMONY

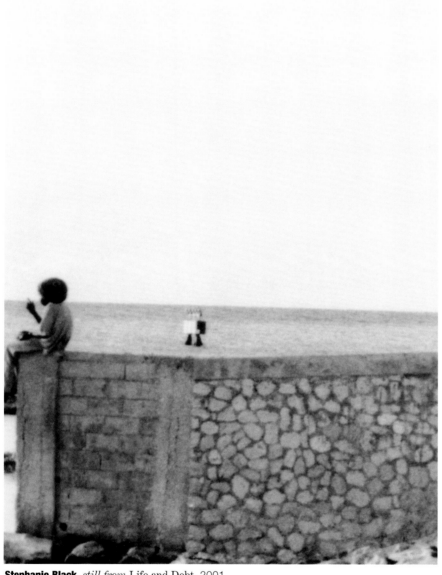

Stephanie Black, *still from* Life and Debt, 2001

skills, was the foundation stone of the new colonies: "Thus God made way for his people, by removing the heathen." In 1637, the zealots set fire to the Pequot settlement in Connecticut. Four hundred members of this tribe were burned alive as they sought to escape. A colonist wrote: "It was a fearful sight to see them frying in the fire . . . and horrible were [*sic*] the stink and scent thereof; but the victory seemed a sweet sacrifice, and they gave the praise thereof to God."

Their mission was not to "civilize" the heathen. That was a Catholic machination deployed by the Spaniards and Portuguese, who took the southern half of the continent, but provided the whole with a European name: America (after the Florentine explorer Amerigo Vespucci, who had sailed with a Spanish expedition to Venezuela in 1499 and later with the Portuguese down the coast of what became Brazil). They, too, killed natives in large numbers, but with labor in short supply to provide for nearly 57 million of them, some had to be converted. After this cleansing process, intermarriages multiplied. The Protestants who stayed in the Northern Hemisphere were puritans. Well versed in the Old Testament, they argued in favor of a literal interpretation. They genuinely believed that extermination was the simplest and the kindest solution. It was God's will. The confidence and righteousness that has marked America's imperial adventures was present from the beginning.

Two hundred years after the Pequot massacre, some of the country's finest—poets, writers, intellectuals—were reciting from the same hymnbook. Listen to the great judicial mind of Oliver Wendell Holmes pontificating on civilized values and speaking of the natives as a "red-crayon sketch of humanity laid on the canvas before the colors of real manhood were ready. . . . Irreclaimable, Sir—irreclaimable!

Those distant thoughts concerning the original inhabitants of the Americas remained hidden in my memory bank until the first time I actually visited the United States, whereupon they erupted. What did they teach me, those endless afternoons spent watching the cinematic reconstruction of a violent past, a history of an ever-expanding frontier? Whichever side

you supported, one fact was unchallengeable. The hegemony achieved by the settler-republic over its native inhabitants was the result of pure coercion. Consent was neither sought nor desired.

Protestant fundamentalism had fueled the migratory urges of the first settlers, and this ideology, combined with superior technology and

HEGEMONY

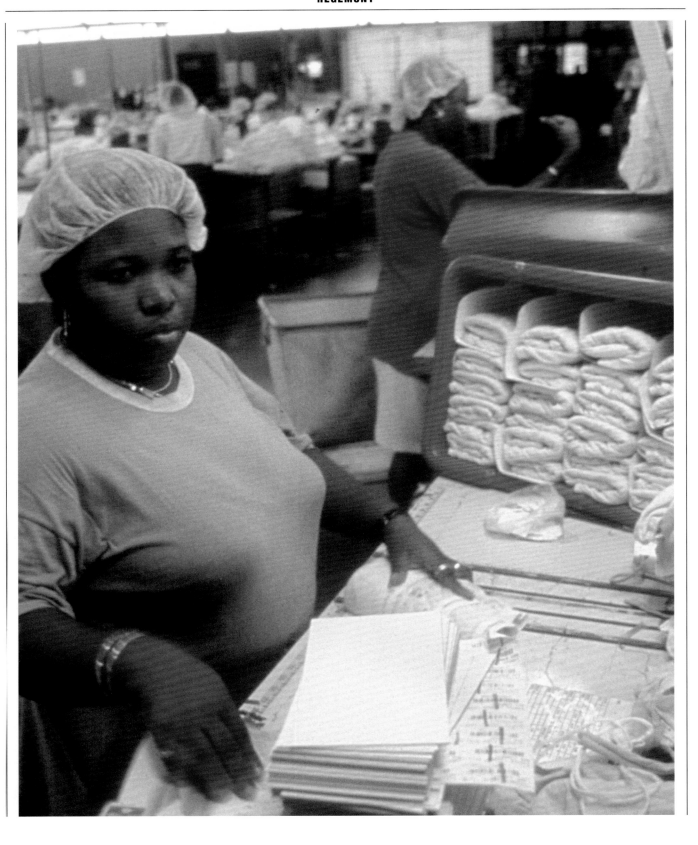

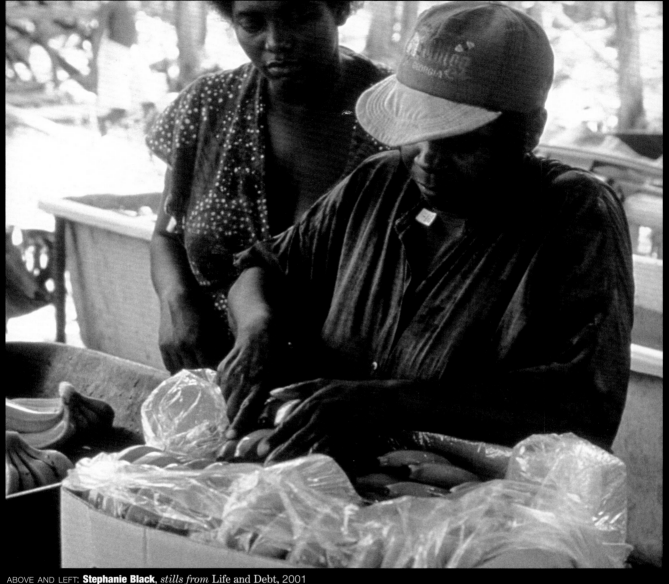

ABOVE AND LEFT: **Stephanie Black**, *stills from* Life and Debt, 2001

A provisional race, Sir—nothing more . . . passing away according to the programme."

This is Walt Whitman writing in patriotic mode, excited, like many other citizens of the "athletic democracy," by the expanding frontier of the dynamic new republic: "What has Mexico, inefficient Mexico—with her superstition, her burlesque upon freedom, her actual tyranny by the few over the many—what has she to do with the great mission of peopling the

new world with a noble race? Be it ours to achieve that mission. . . . For our part, we look upon the increase of territory and power, not as the doubter looks, but with the faith which the Christian has in God's mystery."

Melville, too—the greatest of American novelists—was tempted by the "programme," but similar to his friend Hawthorne, could not stomach the atrocities. Like Whitman, he celebrated the Mexican War, but a fevered patriotism often collided with more

decent instincts that sought to protect and defend the rights of the so-called primitives. This insoluble contradiction is at work throughout *Moby Dick*, first published in 1815. The ship that goes in search of the white whale is named the *Pequod*. The tribe, which occupied parts of Connecticut and Massachusetts, had been destroyed and dispersed (In recent decades, the Pequot has regained its tribal unity). Melville will immortalize its name. And in the concluding pages of his

HEGEMONY

Aarti Angelo, CALL CENTER OPERATOR

Now awareness is building up that multinationals are coming over to India and using Indians to telemarket for them. But I'd say on a scale of 10, maybe 8.5 people are still in the dark about the fact that there's an Indian sitting in India, in Bangalore, calling them in America. I don't know how people would take that, especially during the World Trade Center crisis that happened. People all of a sudden had this awareness about the "East", the "Asians", and so much so that even things like accent—they were so sensitive to it. I know a lot of cases where people would say: "Are you a Muslim?" And here we are taught to transcend those barriers of religion, of race, whatever else, we're not allowed to let that affect us. And people who are Muslims had to say "No, I'm not." And I don't know how well [the Americans] would have taken it if they actually knew who was calling them. As it is, telemarketing is not something that is embraced over there. People get an average of 8 calls a day, and they are fed up. If you can get one person to listen to you ... and then if you have to transcend other barriers of religion and politics, it makes quite a tough job. There are a lot more things to take into consideration besides just calling someone up and selling them a product. [...] Our perceptions (of America) are media–born, media–based— we watch so much television and we've forgotten where to draw the line between media and real life. People are actually very conservative there. You'd think they were really open-minded, broad-minded, but they have their own classes, their own groups, their cultures, so much that I hadn't really given much consideration to before we started training. We go into a lot of detail as to the various ethnic groups, their tastes, their choices, their family life and I could see a lot of simi- larities within certain ethnic groups. And each group does have a culture of their own, something I didn't really think existed in America.

HEGEMONY

THIS PAGE AND LEFT: **The Builders Association and moti**roti, *stills and text from* How to Neuter the Mother Tongue, 2003, *excerpt from* ALLADEEN

Riaz Basha, CALL CENTER OPERATOR

Is India getting exploited? Let me answer that by saying: we are not jerks. We're actually using the opportunity given by your company for our personal growth and the growth of our nation. And in turn what we're doing is cutting your costs and making it a valuable experience, to make you a lot more money. So if you think about it, the backup for word processors in your country is by the guys working over here, and that's for your own profit. So we're not the jerks, we're the dudes. Thank you.

Natasha Sabharwal, CALL CENTER OPERATOR

I've been making calls for the past 6 months now, probably 200 calls every day. So earlier my perspective about America was all too rosy since that's what you see on television and through the media—that it was the best country and the land of opportunity—and it is definitely. But I think the people there are very lonely and some of them are very depressed. Their family ties seem to be wavering off and I don't think it's all that nice. Every place has it's own problems.

HEGEMONY

Gail Dolgin and Vicente Franco, *still from* Daughter From Danang, 2002

great novel, we read of the American eagle—"the bird of heaven with archangelic shrieks"—going down with the damned ship. Both the *Pequod* and the eagle lie buried in Melville's ocean. The whale took Ahab.

There was no peace, even after the bloodletting of the Civil War: a Wagnerian epic destined to be part-myth, part-tragedy. The aged Whitman was filled with gloom and despair. How would it all end? But the two states would be welded together by a common destiny. Their unity sealed with the blood of Indians and the conquest of the Philippines. Not all the wounds of the Civil War would be forgotten, but global piracy was a healing elixir, although not to everybody's taste.

The Anti-Imperialist League was formed in late 1898 as a response to the war in the Philippines. Its founding members included Mark Twain and T.W. Higginson, who had commanded the first American black regiment, cre-

ated during the Civil War. Twain and Higginson were pitched in battle against L.E. Wright, the second governor-general of the Philippines. He had once fought for the Confederacy and knew how to treat the Filipinos.

The old empires of Europe (the Ottomans were an exception) had been built in distant lands. In North America, the newly conquered territories were amalgamated with the rest of the states, a process aided by events such as the Californian gold rush, which ensured the voluntary migration of people to these regions. It was well after the internal empire had been consolidated that President Monroe enunciated a doctrine that declared its intention to control and dominate the Latin American backyard, a process which was later described by General Smedley Butler (1888–1940) of the United States Marine Corps as "naked gangsterism." In his book, *War as a Racket*, and other writings and lectures,

Butler insists that the notion of preemptive or offensive wars was simply "racketeering for capitalism." He explains it thus: "I helped make Honduras 'right' for the American fruit companies in 1903. I helped make Mexico safe for U.S. oil interests in 1914. I helped make Haiti and Cuba a decent place for the National City Bank boys to collect revenues in. I helped in the raping of half a dozen Central American republics for the benefits of Wall Street. The record of racketeering is long. I helped purify Nicaragua for the international banking house of Brown Brothers in 1909–12. I brought light to the Dominican Republic for American sugar interests in 1916. In China I helped to see to it that Standard Oil went its way unmolested."

The imperialist ambitions of the United States long predate the victory of the Russian Revolution in 1917. There is a lengthy tradition of empire building in the United States.

HEGEMONY

ABOVE, AND PAGE 132: **Bjørn Melhus**, *stills and text from* America Sells, 1990

HEGEMONY

Here we go...

Come to America !
Guten Tag. Diese Sendung: America Sings.

We gather here together,
to sing in harmony.
There is no one who I'd rather,
have standing here with me.

So put your hands together,
and raise them to the sky.
We can make a difference,
at least, I know we'll try.

America s - i - n - g - s !
huuh ! huuh ! huuh ! huuh !

From the shore of the Pacific,
to the rugged coast of Maine,
the roar is just terrific,
aboard a freedom train.

We come because we're caring,
we gather because we're free,
with love and hope for sharing,
from sea to shining sea.

America s - i - n - g - s !

America sings from the mighty Mississippi.
America hears the children rock.
America lives in the hearts of all the people.
America, want it for all.

America sings—America sings !
America cries—America cries !
America hopes—America hopes !
America t - r - i - e - s !

America sings—America sings !
America cries—America cries !
America hopes—America hopes !
America tries—America tries !

America s - i - n - g - s !
America sings !!!

Don't forget, ladies and gentlemen, that,
in order to pay for our trip to come to
Germany,
we sell wonderful T-shirts and sweatshirts !
very cheap ! very cheap !
you understand cheap ?
you understand cheap ?
Good !

very cheap and very beautiful - wunderbar
very cheap and very beautiful - wunderbar

w - u - n - d - e - r - b - a - r !
Once again, we present our, our gift to you:
Please, feel free, feel free, feel free,
f - e - e - l f - r - e - e !

To sing along and clap your hands

and buy T-shirts
and buy T-shirts
and buy T-shirts
buy T-shirts
T-shirts, T-shirts, T-shirts

ahem, we are one, we are one
and buy T-shirts

ahem, we are one we are one
aaah ! aaah ! aaah ! aaah !
aaah ! aaah ! aaah ! aaah !

America s - i - n - g - s !

America sings from the mighty Mississippi.
America hears the children rock.

America lives in the hearts of all the people.
America lives in the hearts of all the people.
America, want it for all.
America, want it for all.
...

HEGEMONY

Teddy Roosevelt and Woodrow Wilson operated in very different styles, but their aims were not that dissimilar. The first was a unilateralist, who enjoyed remapping the Americas. The second was a multilateralist, who sought leadership of the West after Lenin's victory in Russia.

The Cold War was a real conflict. Capitalism did feel threatened after 1917—and for good reason. It remained on the defensive till the late seventies. The U.S. victory was complete after 1989, but the disintegration of the tried and tested enemy that was the Soviet Union also meant that its leadership over Western capitalism could face challenges in the future, especially from a revived Far Eastern sector.

What we are witnessing today is not a "war against terror," but the first shots in a new struggle for hegemony over former allies. It is back to "racketeering for capitalism" with a vengeance, but under new conditions and with a military superiority that Smedley Butler could not have imagined. The new Bush doctrine makes it very clear. If any state attempts to challenge U.S. hegemony, it will have to be crushed by preemptive strikes.

It is the imposition of this hegemony, the forms it assumes as well as the resistance it generates, that will mark the politics of the present century.

Meanwhile reflect on the following symbols of contemporary warfare: a killer helicopter, the Apache, commemorates a tribe made nearly extinct by the predecessors of those who make use of the machine today, and a U.S. oil company has named a tanker *The Condoleeza Rice* to honor an imperial princess.

Andrea Robbins and Max Becher, Johnson Drugstore, *from the series "Wall Street in Cuba,"* 1993

THE TRUST COM

Andrea Robbins and Max Becher, Trust Company Building, *from the series "Wall Street in Cuba,"* 1993

ABOVE: **Miguel Angel Rojas**, Go On, 1999 *(detail)*
PAGES 136–37: **Miguel Angel Rojas**, It's Better To Be Rich Than Poor, 2001 *(details)*

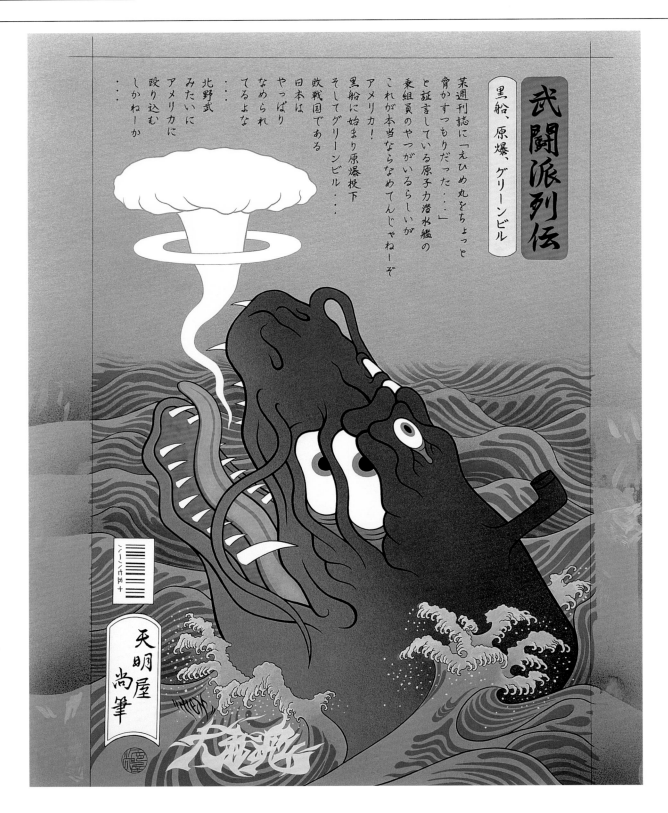

Hisashi Tenmyouya, Black Ships, Atomic Bombs, and the Greenville, 2001, *from the series "Legendary Warriors,"* 2000–02

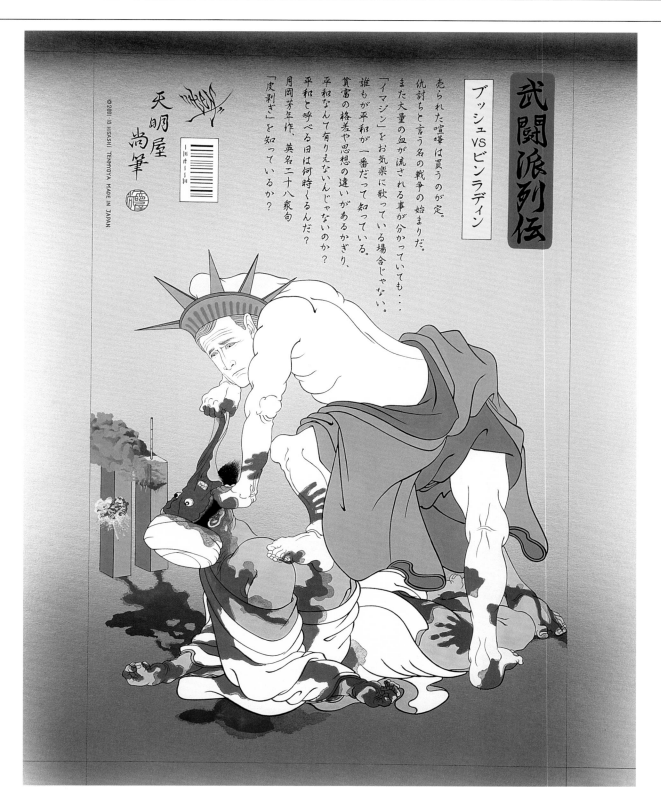

Hisashi Tenmyouya, Bush vs. Bin Laden, 2001, *from the series "Legendary Warriors,"* 2000–02

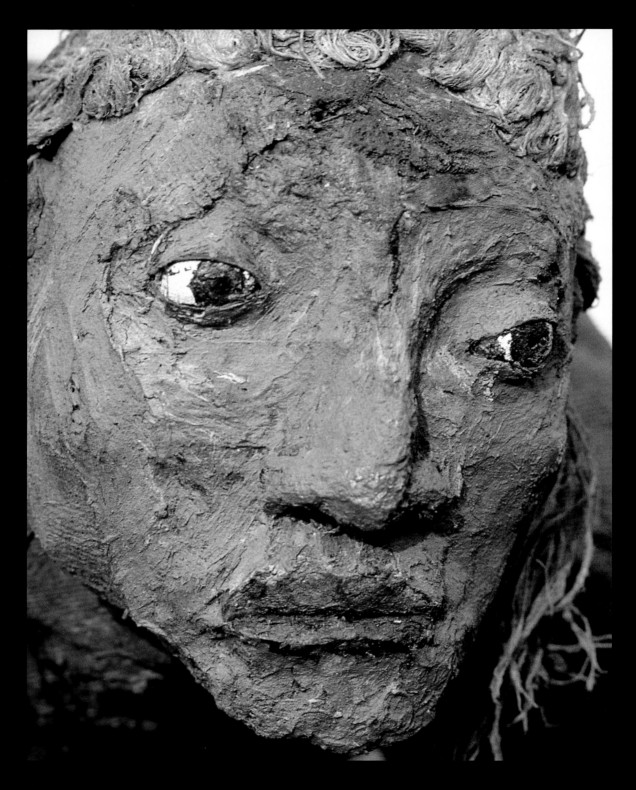

Ousmane Sow, The Unseated Cavalryman, *from the series "The Battle of Little Big Horn,"* 1998 *(detail)*

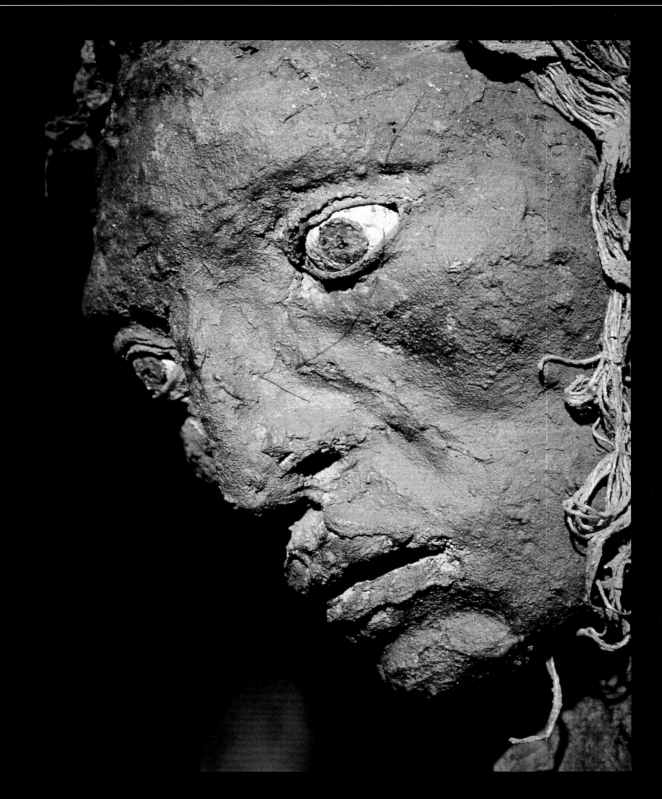

ABOVE, AND PAGE 144: **Ousmane Sow**, The Death of Custer, *from the series "The Battle of Little Big Horn,"* 1998 *(details)*

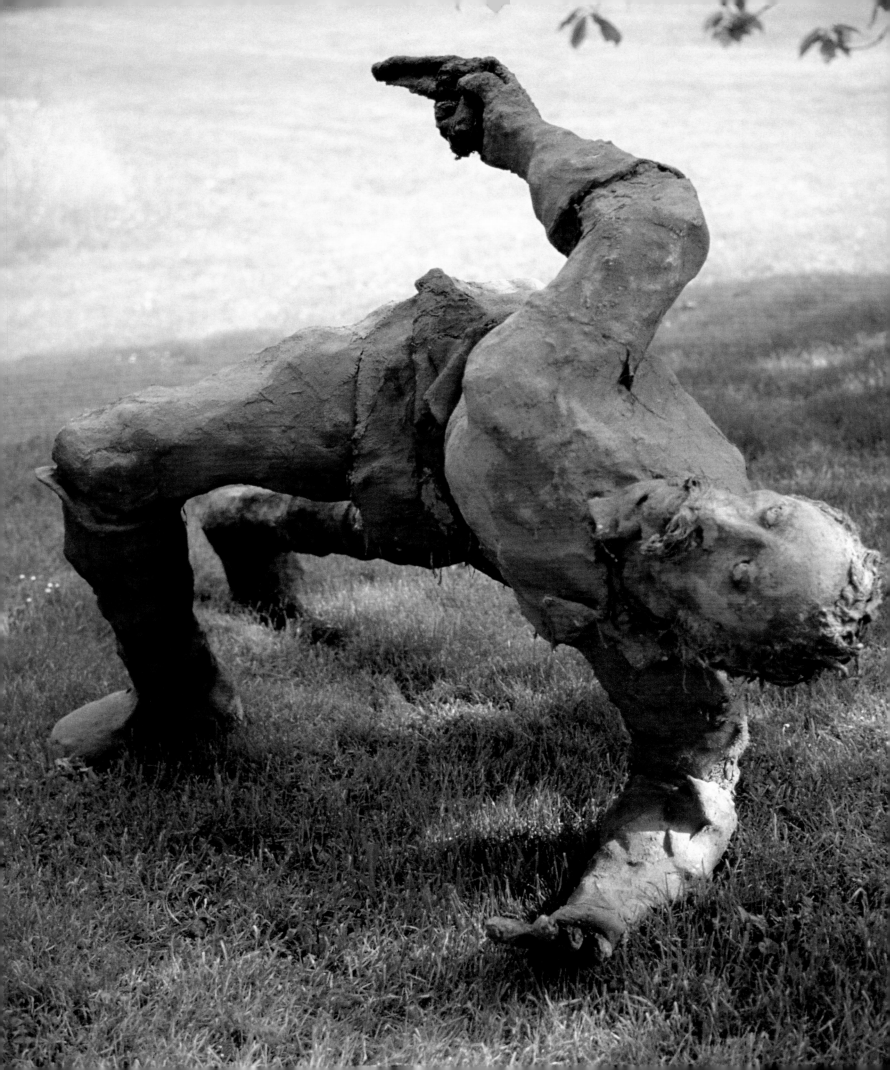

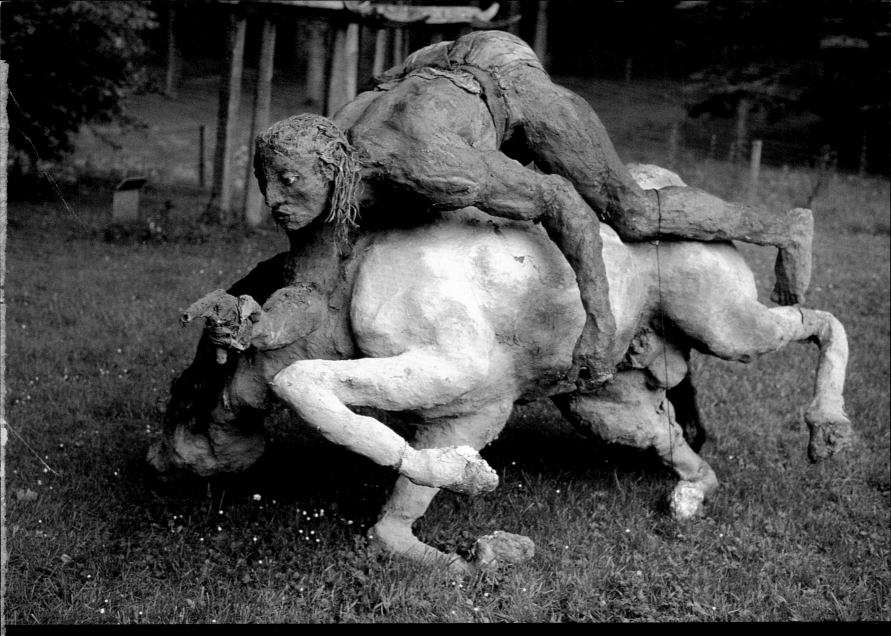

Ousmane Sow, The Unseated Cavalryman, *from the series "The Battle of Little Big Horn,"* 1998

Sweet Violence

Ian Buruma

OCTOBER 14, 2002

What was it that made some Chinese laugh when they saw the TV images of the Twin Towers crumbling on September 11, 2001? Not all Chinese, of course, only some, the same people perhaps who might have bought those videotapes, quickly marketed in China, with pictures of the collapsing towers spliced together with takes from *Towering Inferno* and other disaster movies. They were, so one gathers, not poor people. Some of them might have been described as yuppies: young, educated, urban, the kind of people who go to study in the United States, or aspire to work for U.S. companies, or at least lead the kind of lives associated with American high-living. What, then, made them laugh?

It could have been a nervous reaction. Giggling is a fairly common human response to shock, especially in east Asia. One can't be sure, but I believe there was an element of schadenfreude as well, which was by no means confined to the yuppies of Shanghai or Beijing. A month or so after September 11, I had dinner with an old Japanese friend in Tokyo, a well-known artist, sophisticated, well-traveled. Before the recession devastated everyone's savings in Japan, he had even considered investing in a New York loft. Yet he too confessed that the sight of New York burning had given him a moment of guilty pleasure.

SWEET VIOLENCE

It wasn't just the spectacle, which was, after all, extraordinary enough to elicit all kinds of strange comments from artists all over the world. No, it was more like a quiet satisfaction that a giant, whose presence affects so many aspects of our daily lives, a giant of commercial cinema, fast food, financial markets, corporate and military power, pop music, advertising, fashion, and whatnot, had come a cropper, at least for a short while. That is why this type of schadenfreude was perhaps more in evidence among the better educated and better off than among the poor, whose lives are also affected by American power, but who have more pressing things to worry about.

Those who don't aspire to American success, or an American life-style, or American recognition, don't feel that special humiliation of the disappointed supplicant, that sense of inadequacy that comes from longing for something forever out of reach. The American Way of Life, after all, is promised everywhere, in TV commercials for soft drinks, billboards for the latest Hollywood blockbuster, the soft-porn pop of MTV, and the glossy magazines in all the million varieties of the same thing. Even at the top end of the cultural market, America has a commanding presence. Bookstores in Beijing, no less than in Hamburg or Bombay, have shelves piled up with the works of U.S. academics theorizing about their own marginality. So it is not so surprising, really, that there are times when frustration tips over into fantasies of revenge, of wanting to see the whole giant edifice come tumbling down.

There is a genre in the movies that specializes in stories of country boys or country girls who move to the big city, driven by poverty or ambition, only to fall on even harder times. I have often seen such films in developing countries, such as Thailand or the Philippines, but the theme is also relevant to life in the United States itself. The city— Manila, Jakarta, or New York (think of *Midnight Cowboy*)—is where the lights shine brightest, the sex is easy, and the money is ready to be taken.

Soon, however, in these movies, as in real life, the poor country boy or country girl realizes that things

BELOW AND RIGHT: **Jannicke Låker**, *stills from* No. 17, 1997

SWEET VIOLENCE

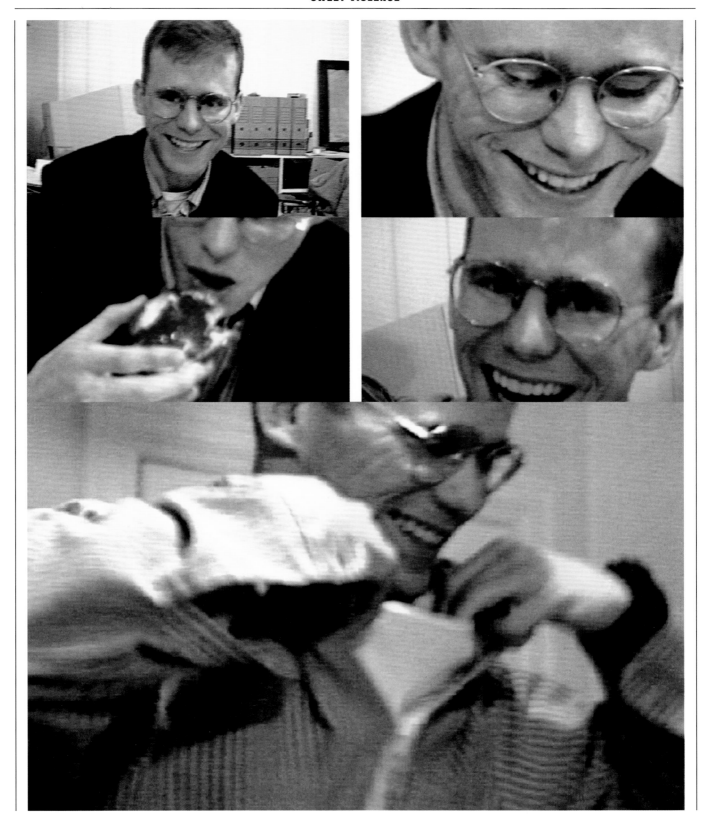

SWEET VIOLENCE

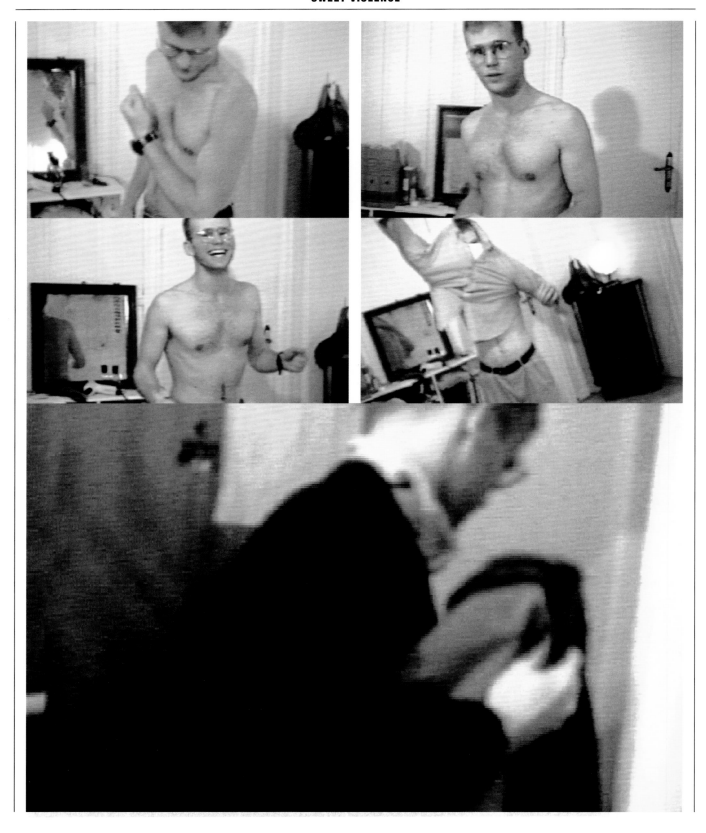

SWEET VIOLENCE

ABOVE AND LEFT: **Jannicke Låker**, *stills from* No. 17, 1997

are not so easy. The city is a cold, indifferent place, and the certainties of village life are gone. Lonely country folk are there to be tricked, robbed of their meager belongings, and left destitute. The boy falls into crime, often in a gang, whose social relations still show some dark traces of the old village certainties. The girl becomes a prostitute. And there comes a time when all the humiliation and degradation of thwarted longings comes to a head and the country boy, like Samson, wants to bring the big city pillars down. And so the story ends, in an act of extreme violence, a final explosion of rage, the revenge of the small man cheated out of his dreams.

The Big City in our time is the West in general, and America in particular. It is the locus of longing for millions of people. And American generosity is no prophylactic against resentment or revenge. Many a Fullbright scholar has gone back home

smarting from feelings of inferiority or filled with a sense of rage, sometimes fed by ideas picked up in the Western metropole. Pol Pot imbibed his lethal potion of anti-Western Maoist rage in Paris. Sayyid Qutb, the Egyptian Islamist revolutionary, whose ideas still inspire the followers of Osama bin Laden today, developed his rage against the West in 1948, while living amidst the well-tended lawns and barbecue pits of Greeley, Colorado.

There is a reason for the rage of the world's country boys and girls. The Big City, for which one can read capitalism, sexual license, pop culture, and civil liberties, does indeed help to destroy the old village certainties. The new liberties promised by America and the West may be desirable in themselves. Opening hitherto closed societies to the new possibilities of political freedom and global commerce may be a fine thing. But such freedoms do undermine the authority, not just of

political dictators, but of those whose status derives from their guardianship of traditions: the patriarchs who keep their women in subservience, the priests and teachers who pass on the culture of their forbears.

These traditions are often imaginary, to be sure. The politicized Islamic revivalism in Indonesia or Malaysia is based on a fantasy of ancient tradition imported by Arab activists. These fantasies have nothing to do with the indigenous cultures of Southeast Asia. But such invented traditions, because of their air of absolute purity, appeal to half-educated youths, caught between the vanishing village certainties and the modern world in which they only have a tenuous place, or perhaps no place at all.

The vengeful priests and teachers are not limited to closed political or religious societies of the non-Western world. They might be intellectuals in Paris or Berlin, or

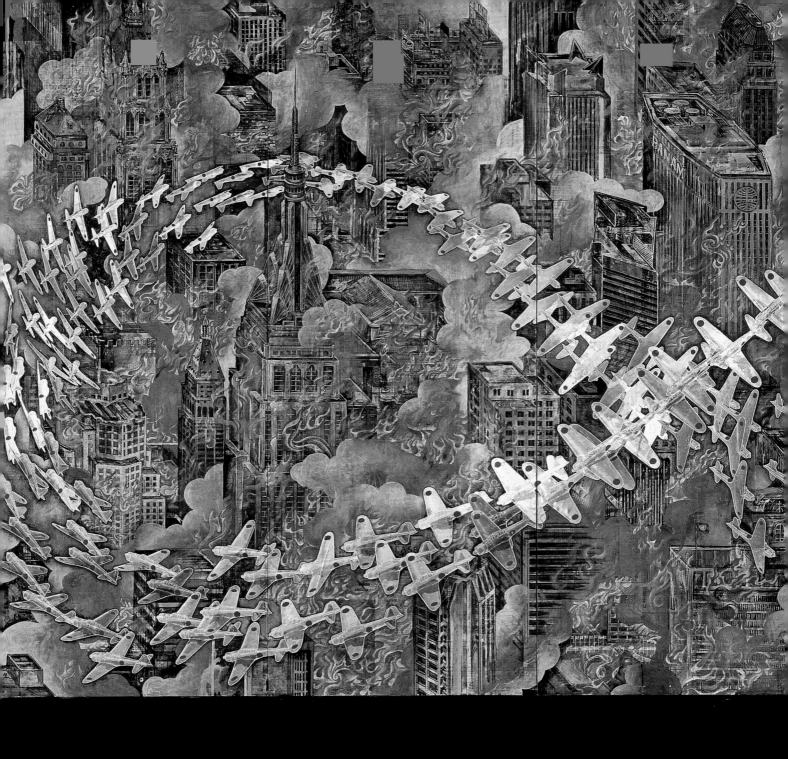

akoto Aida, A Picture of an Air Raid on New York City (War Picture Returns), 1996

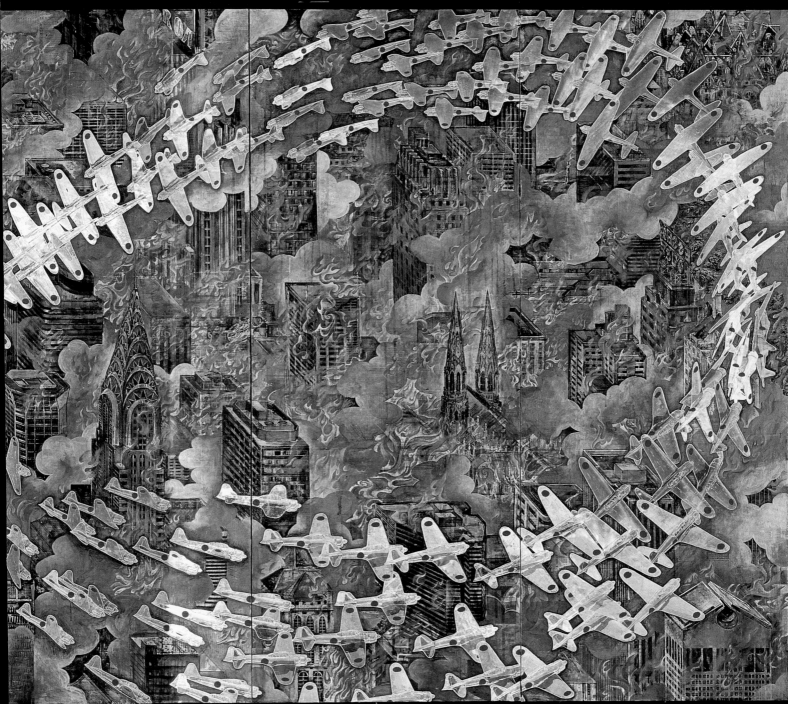

SWEET VIOLENCE

Tokyo, who feel that their traditional roles as subsidized arbiters of taste and articulators of national or cultural identity are threatened by the wave of commercial culture, produced in, or inspired by, the United States. Again, this is no reason to feel sorry for them; it might be all to the good, but they are right to feel threatened. For when people can choose to watch or read or listen to anything they want, pop usually wins.

What happens to individuals can happen to entire nations too. Many roads led to Pearl Harbor. The reasons Japan went to war with the United States and its allies in World War II were complicated and partly the result of happenstance. Few Japanese leaders at the time really wanted a war, through an accumulation of bad decisions, Japan had forced itself into a position that made war almost inevitable. Even so, when Pearl Harbor blew up in flames, quite a few Japanese, including some prominent artists and intellectuals, voiced a kind of vengeful satisfaction that little Japan had finally landed such a spectacular punch in the Western giant's solar plexus.

This was not just a matter of perversity or malice. There was a history there. For more than fifty years, Japan had tried to impress the West with its modernity, its adoption of Western ways, its military prowess, its progress. The key slogan of the late nineteenth century in Japan was "civilization and enlightenment," that is to say, Western civilization and enlightenment. At times the Japanese were applauded for their successes, especially when they managed to defeat imperial Russia in the brutal modern war of 1905. But at other times, they felt slighted, when Japanese emigration to the United States was blocked,

for example, or the Western powers refused to sign a pledge against racial discrimination. After all their efforts to live up to the ideals of being a modern, Western-style power, Japanese still felt they were not treated as equals. Pearl Harbor was, among many other things, their revenge.

In some ways, America brings this kind of animus upon itself. Excepting France, the United States is the only democratic Western nation-

state born from a revolution. For this reason, the United States, like France, sees its destiny in universal terms. American values are universal values, and in times of active nationalism, U.S. governments behave as if it were their duty to bring those values to the benighted world, with force if need be. Even in less activist periods, this still lends a moralistic tone to U.S. foreign policy, which comes across as arrogance, and invites resentment. That this resentment is especially keenly felt in France is surely no coincidence: nothing is more explosive than the rivalry of universal principles.

In fact, of course, French values are not so very different from American ones, and the rivalry is unlikely to end in violent conflict. The potential clash is far more lethal in theocracies, which need an external enemy as a demonic contrast to their own universal pretensions. That is why Islamist regimes or groups are at war with the West, or, as they prefer to put it, with Crusaders and Zionists, or the Great American Satan. We have to be careful not to slip into similar ways of thinking. It is bad enough when dictatorships use religious zeal to oppress their own people. Using our own brand of zeal, tinged with vengeance, for wars that were lost or unfinished as an excuse to attack them is no way to make the world a safer place. If our best qualities, such as freedom, democracy, and the right to pursue our own ideas of happiness, excite the envy of others less fortunate, then so be it. But it is foolish to compromise those qualities in order to defend them.

ABOVE, AND PAGES 153–57: **Arno Coenen**, *stills from* The Last Road Trip, 2000

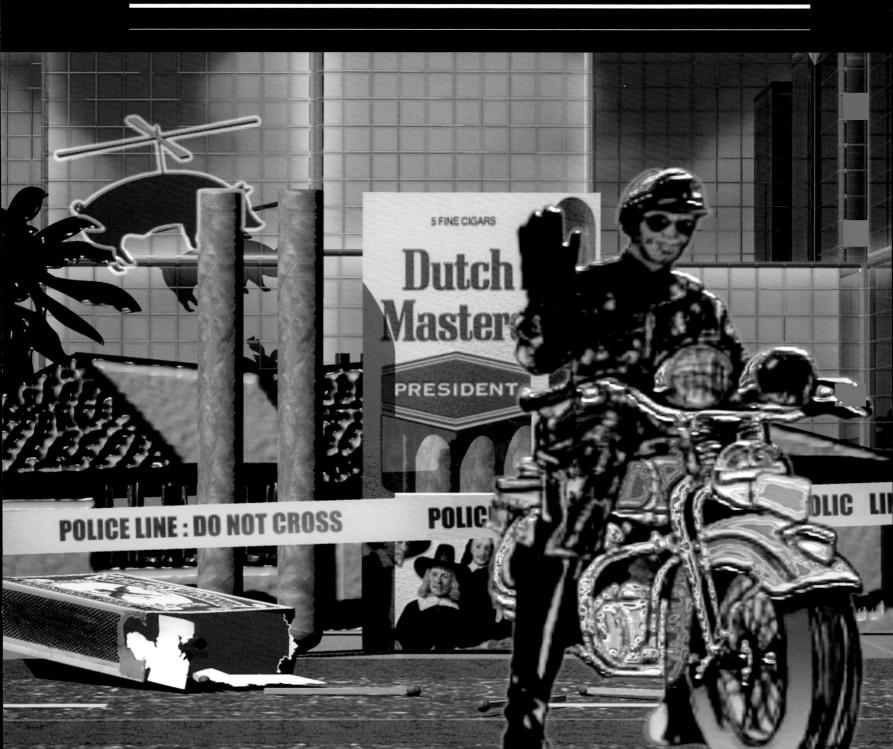

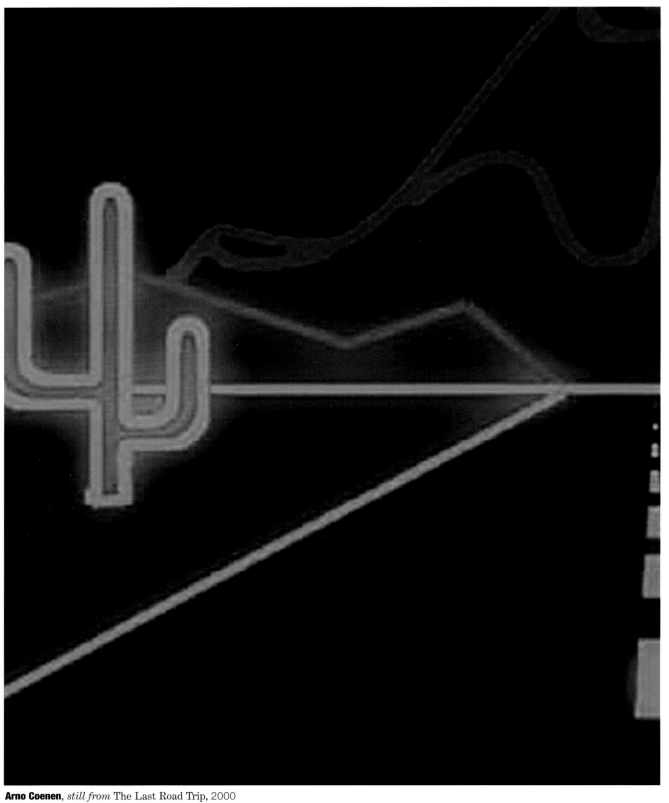

Arno Coenen, *still from* The Last Road Trip, 2000

Global Crisis Over Iraq

Edward Said

MARCH 18, 2003

A small news item reported that Prince Walid Ibn Talal of Saudi Arabia had donated $10 million to the American University of Cairo to establish a centre of American studies. The young billionaire had offered an unsolicited $10 million to New York City soon after 11 September 2001, with a letter that described the gift as a tribute to New York and suggested that the United States might reconsider its policy toward the Middle East. He had in mind the total, unquestioning U.S. support for Israel, but his polite proposition seemed also to cover the general policy of denigrating, or at least showing disrespect for, Islam.

In rage, Rudolph Giuliani, then mayor of New York (which has the largest Jewish population of any city in the world), returned the cheque, with an extreme, and I would say racist, contempt, meant to be insulting. On behalf of a certain image of New York, he was upholding its bravery and principled resistance to outside interference. And pleasing, rather than trying to educate, a purportedly unified Jewish constituency.

His behaviour was in accord with his refusal in 1995, well after the Oslo signings, to admit Yasser Arafat to Philharmonic Hall for a concert to which everyone at the United Nations had been invited. So what he did in response to the gift of the young Saudi Arabian was predictable. Although the money was intended, and greatly needed, for humanitarian aid in a city wounded by a terrible atrocity, the U.S. political system and its actors put Israel ahead of everything, whether or not Israel's amply endowed and well-mobilised lobbyists would have done the same thing.

No one knows what would have happened if Giuliani had not returned the money; but as things turned out, he had pre-empted the pro-Israeli lobby. As the novelist Joan Didion wrote in the *New York Review of Books*,[1] it is a staple of U.S. policy, as first articulated by F. D. Roosevelt, that America has tried against all logic to maintain both a contradictory support for the Saudi monarchy and for the state of Israel; so much so that "we have become unable to discuss anything that might be seen as touching on our relationship with the current government of Israel."

Those stories about Prince Walid show a continuity rare in Arab views of the U.S. For at least three generations, Arab leaders, politicians, and their more-often-than-not U.S.–trained advisers have formulated policies for their countries with, at basis, a near-fictional, fanciful idea of what the U.S. is. The basic idea, far from coherent, is about how Americans run everything; the idea's details encompass a wide, jumbled range of opinions, from seeing the U.S. as a conspiracy of Jews, to believing that it is a bottomless well of benign help for the downtrodden, or that it is utterly ruled by an unchallenged white man sitting, Olympian-like, in the White House.

I recall many times during the 20 years that I knew Arafat well trying to explain to him that the U.S. was a complex society with many currents, interests, pressures, and histories in conflict within it. It was not ruled in the way that Syria was: a different model

GLOBAL CRISIS OVER IRAQ

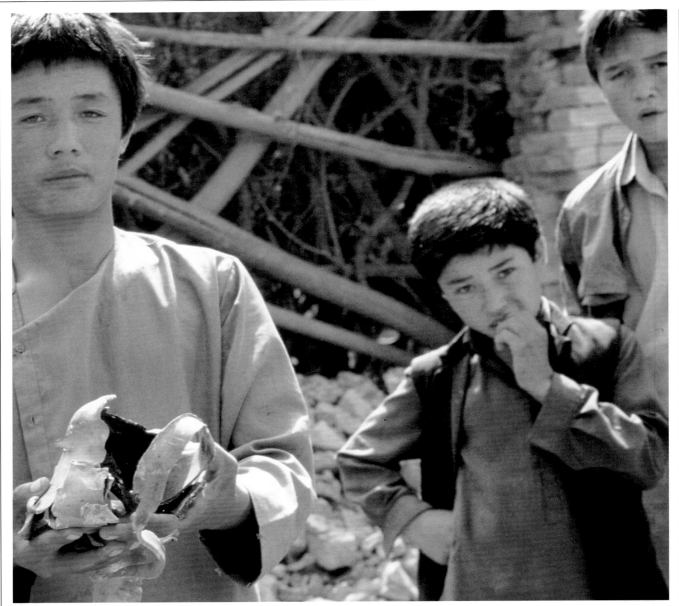

ABOVE AND PAGES 162–63: **Heiner Stadler,** *stills from* Eat, Sleep, No Women, 2002

of power and authority needed to be studied. I enlisted a friend, the late scholar and political activist, Eqbal Ahmad, who had expert knowledge of U.S. society (and was perhaps the world's finest theorist and historian of anticolonial national liberation movements), to talk to Arafat and bring other experts to develop a more nuanced model for the Palestinians during preliminary contacts with the

U.S. government in the late 1980s. To no avail. Ahmad had studied the relationship of the Algerian FLN (Front de libération nationale) with France during the war of 1954–62, as well as the way in which the North Vietnamese had negotiated with Henry Kissinger in the 1970s. The contrast between the scrupulous, detailed knowledge of the metropolitan society that these Algerian and

Vietnamese insurgents had, and the Palestinians' caricatured view of the U.S. (based on hearsay and cursory readings of *Time*) was stark. Arafat's obsession was to go into the White House and talk to that whitest of white men, President Bill Clinton, which, Arafat thought, would be the equivalent of getting things done with Mubarak of Egypt or Hafez al-Assad of Syria.

GLOBAL CRISIS OVER IRAQ

If Clinton revealed himself as the master-creature of U.S. politics, overwhelming and confusing the Palestinians with his charm and his manipulation of the system, so much the worse for Arafat and his men. Their simplified view of the U.S. was unchanged, and it remains so today. As for resistance or knowing how to play the game of politics in a world with only one superpower, matters remain as they have done for more than half a century. Most people throw up their hands in despair—"the U.S. is hopeless, and I don't ever want to go back there."

The more hopeful story is the one about Prince Walid's change of direction, about which I can only surmise. Apart from a few courses on U.S. literature and politics throughout the universities of the Arab world, there has never been anything like an academic centre for the systematic, scientific analysis of the U.S., its people, society, and history. Not even in institutions like the American Universities of Cairo and Beirut. This may be true throughout the Third World, and even in some European countries.

To live in a world gripped by such an unbound great power as the U.S. there is a vital need for as much knowledge as possible about its swirling dynamics. And that includes an excellent command of the English language, something few Arab leaders possess. The U.S. is the country of McDonald's, Hollywood, CNN, jeans, and Coca-Cola, all available everywhere through globalisation, multinational corporations, and the world's appetite for articles of easy consumption. But we must be conscious of their source, and how the cultural and social processes from which they derive can be interpreted, especially since the danger of thinking about the U.S. too simply and statically is obvious.

As I write, much of the world is being bludgeoned into a restive submission by (or, as with Italy and Spain, an opportunistic alliance with) the U.S., as it readies itself for a deeply unpopular war against Iraq. But for the demonstrations and protests that have erupted at popular level around the world, the war would be a brazen act of unopposed domination. The degree to which it is contested by those many Americans, Europeans, Asians, Africans, and Latin Americans who have taken to the streets suggests that at last some have awakened to the fact that the U.S., or rather the few Judeo-Christian white men who currently rule its government, is bent on world hegemony. What are we to do?

I want to sketch the extraordinary panorama of the U.S. now, as I see it as an insider, an American who has lived there comfortably for years, but who, by virtue of his Palestinian origins, still retains his perspective as a comparative outsider. My interest is to suggest ways of understanding, intervening in, and resisting a country that is far from the monolith it is taken to be, especially in the Arab and Muslim worlds.

The difference between the U.S. and the classic empires of the past is that, although each historical empire has asserted its determination not to repeat the overreaching ambitions of predecessors, this latest empire astonishingly affirms its sacrosanct altruism and well-meaning innocence. This alarming delusion of virtue is endorsed, even more alarmingly, by formerly left-wing or liberal intellectuals, who in the past opposed U.S. wars abroad but who are now prepared to make the case for virtuous empire (the image of the lonely sentry is favoured), using styles from tub-thumping patriotism to cynicism.

The events of 11 September do play a role in this volte-face. But it is surprising that the horrible Twin Towers–Pentagon attacks are treated as if they had come from nowhere, rather than from a world across the seas driven crazy by U.S. intervention and presence. This is not to condone Islamic terrorism, which is hateful in every way. But in all the pious analyses of U.S. responses to Afghanistan, and now Iraq, history and a sense of proportion have disappeared.

The liberal hawks do not refer to the Christian right (so similar to Islamic extremism in its fervour and righteousness) and its massive, decisive presence in the U.S. Its vision derives from mostly Old Testament sources, very like those of Israel, its close partner and analogue. There is a peculiar alliance between Israel's influential neo-conservative U.S. supporters and the Christian extremists, who support Zionism as a way of bringing all the Jews to the Holy Land to prepare for the Messiah's second coming, when the Jews will either have to convert to Christianity or be annihilated. These rabidly antisemitic teleologies are rarely referred to, and certainly not by the pro-Israeli Jewish phalanx.

The U.S. is the world's most avowedly religious country. References to God permeate national life, from coins to buildings to speech: in God we trust, God's country, God bless America. President George Bush's power base is made up of the 60 to 70 million fundamentalist Christians who, like him, believe that they have seen Jesus and that they are here to do God's work in God's country. Some commentators, including Francis Fukuyama, have argued that contemporary religion in the U.S. is the result of a desire for community and a sense of stability, based on the fact that some 20 percent of the population moves from home to home all the time. But that is true only up to a point: what matters more is the nature of the religion—prophetic illumination, unshakeable conviction in

an apocalyptic sense of mission, and a heedless disregard of small complications. The enormous physical distance of the U.S. from the turbulent rest of the world is a factor, as is the fact that Canada and Mexico are neighbours without a capability to temper U.S. enthusiasm.

All of these come together around a concept of U.S. rightness, goodness, freedom, economic promise, and social advancement so woven into daily life that it does not appear to be ideological but a fact of nature. The U.S. equals goodness, and goodness requires total loyalty and love for the U.S. There is unconditional reverence for the founding fathers, and for the constitution—an amazing document, but a human creation. Early America is the anchor of authenticity.

In no other country I know does a waving flag play so central an iconographical role. You see it everywhere, on taxicabs, on jacket lapels, on the front windows, and roofs of houses. It is the main embodiment of the national image, signifying heroic endurance and a sense of being beleaguered by unworthy enemies. Patriotism remains the prime virtue, tied up with religion, belonging, and doing the right thing at home and all over the world. Patriotism is now represented, too, as consumer spending: Americans were enjoined after 9/11 to shop in defiance of evil terrorists.

Bush, and Donald Rumsfeld, Colin Powell, Condoleezza Rice, and John Ashcroft have tapped into that patriotism to mobilise the military for a war 7,000 miles from home "to get Saddam." Underlying all this is the machinery of capitalism, now undergoing radical and destabilising change. The economist Juliet B. Schor has shown that Americans now work far more hours than three decades ago, and make relatively less money.[2] But there is no serious political challenge to the

dogmas of "the opportunities of a free market." It is as if no one cares whether the corporate structure, in alliance with the federal government, which still has not been able to provide most Americans with decent health cover and a sound education, needs change. News of the stock market is more important than any re-examination of the system.

This is a crude summary of the American consensus, which politicians exploit and simplify into slogans and sound bites. But what one discovers about this complex society is how many currents flow counter to the consensus all the time. The growing resistance to war, which the president has minimised and pretended to ignore, derives from that other and less formal U.S. that the mainstream media (newspapers of record such as *The New York Times,* the broadcast networks, the publishing and magazine industries) always tries to suppress. Never has there been such unashamed and scandalous complicity between broadcast news and the government: newsreaders on CNN or the networks talk excitedly about Saddam's evils and how "we" have to stop him before it is too late. The airwaves are filled with ex-military men, terrorism experts, and Middle East policy analysts who know none of the relevant languages, may never have been to the Middle East, and are too poorly educated to be expert about anything, all arguing in a ritualised jargon about the need for "us" to do something about Iraq, while preparing our windows with duct tape against a poison gas attack.

Because it is managed, the consensus operates in a timeless present. History is anathema to it. In public discourse even the word *history* is a synonym for nothingness, as in the scornful phrase "you're history." History is what as Americans we are supposed to believe about the U.S. (not

about the rest of the world, which is "old" and therefore irrelevant)—uncritically, unhistorically. There is an amazing contradiction here. In the popular mind the U.S. is supposed to stand above or beyond history. Yet there is an all-consuming general interest in the U.S. in the history of everything, from small regional topics to world empires. Many cults in the U.S. develop from these balanced opposites, from xenophobia to spiritualism and reincarnation. A decade ago a great intellectual battle was waged over what kind of history should be taught in schools in the U.S. The promoters of the idea of U.S. history as a unified narrative with entirely positive resonances thought of history as essential to the ideological propriety of representations that would mould students into docile citizens, ready to accept certain basic themes as the constants in U.S. relationships with itself and the world. From this essentialist view the elements of postmodernism and divisive history (minorities, women, and slaves) were to be purged. But the result, interestingly, was a failure to impose such risible standards.

Linda Symcox wrote that the neoconservative "approach to cultural literacy was a thinly disguised attempt to inculcate students with a relatively conflict-free, consensual view of history. But the project ended up moving in a different direction. In the hands of social and world historians, who wrote the Standards with the teachers, the Standards became a vehicle for the pluralistic vision the government was trying to combat. Consensus history was challenged by those historians who felt that social justice and the redistribution of power demanded a more complex telling of the past."[3]

In the public sphere presided over by mass mainstream media there are what I will call "narrathemes" that structure, package, and control discus-

GLOBAL CRISIS OVER IRAQ

Heiner Stadler, *still from* Eat, Sleep, No Women, 2002

sion, despite an appearance of variety and diversity. I shall discuss those that strike me as pertinent now. One is that there is a collective "we," a national identity represented without demurral by president, secretary of state at the UN, armed forces in the desert, and "our" interests, seen as self-defensive, without ulterior motive, and "innocent," as a traditional woman is supposed to be innocent—pure and free of sin.

Another narratheme is the irrelevance of history, and the inadmissibility of illegitimate linkages: for example, any mention that the U.S. once armed and encouraged Saddam Hussein and Osama bin Laden, or that Vietnam was "bad" for the U.S. or, as President Jimmy Carter once put it, "mutually self-destructive." Or a more staggering example, the institutional irrelevance of two important, indeed

constitutive, U.S. experiences, the slavery of African-Americans and the dispossession and quasi-extermination of Native Americans. These have yet to be figured into the national consensus. There is a major Holocaust museum in Washington, D.C., but no such memorial exists for African-Americans or Native Americans anywhere in the country.

Then there is the unexamined conviction that any opposition is

GLOBAL CRISIS OVER IRAQ

anti-American, based on jealousy about "our" democracy, freedom, wealth, and greatness or (as the obsession with French resistance to a U.S. war against Iraq has it) foreign nastiness. Europeans are constantly reminded of how the U.S. saved them twice in the twentieth century, with the implication that Europeans sat back watching while U.S. troops did the real fighting.

When it comes to places where the U.S. has been entangled for at least 50 years, such as the Middle East or Latin America, the narratheme of the U.S. as honest broker, impartial adjudicator, and well-intentioned force for good has no serious competitor. This narratheme cannot deal with any of the issues of power, financial gain, resource grabbing, ethnic lobbying, or forcible or surreptitious regime change (as in Iran in 1953 or Chile in 1973); it remains undisturbed except when it occasionally attempts to recall the issues. The closest anybody gets to the reality of these issues is through the euphemistic idioms of the think tanks and government, idioms that discuss soft power, projection, and U.S. vision. Still less represented or alluded to are invidious policies for which the U.S. is directly responsible: the Iraq sanctions that cause civilian casualties, the support for Ariel Sharon's campaign against Palestinian civilian life, the support for Turkish and Colombian regimes and their cruelties against citizens. These are out of bounds during serious discussions of policy.

There is, finally, the narratheme of unchallenged moral wisdom represented by figures of official authority (Henry Kissinger, David Rockefeller, and every official of the current administration), which is repeated without any doubts. That two Richard Nixon–era convicted felons, Elliott Abrams and John Poindexter, have recently been given significant

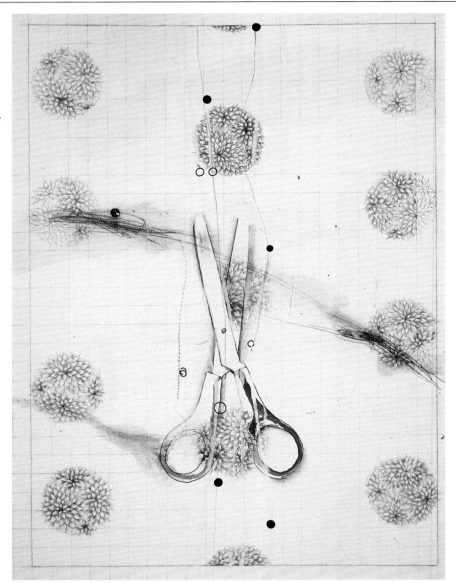

Muhammad Imran Qureshi, None of Your Business I, 2002

government positions attracts little comment, and much less objection. This blind deference to authority past or present, pure or sullied, is seen in the respectful, even abject, forms of address used by commentators, and in an unwillingness to notice anything about an authority figure but his or her polished appearance, unblemished by any incriminations on record.

Behind that behaviour is, I think, the U.S. belief in pragmatism as the right philosophy to deal with

reality—pragmatism that is antimetaphysical, antihistorical, and, curiously, antiphilosophical. Post-modern antinominalism, which reduces everything to sentence structure and linguistic context, is allied with this; it is an influential style of thought alongside analytic philosophy in U.S. universities. In my own university, Hegel and Heidegger are taught in literature or art-history departments, rarely in philosophy. The newly organised U.S. information effort (especially in the

GLOBAL CRISIS OVER IRAQ

Customs are unwritten laws to which our cultures adhere. They are socially governed, and somewhat difficult to determine. Many ways of life have been melted together to build our identity. The diverse make-up of the culture assures that different Americans will adhere to different customs. Still, many salient features stand out among our people. These features help international visitors recognize what is valued and accepted in our culture.

Andrea Geyer, Interim, 2002 *(installation detail)*

Islamic world) is designed to spread these persistent master stories. The obstinate dissenting traditions of the U.S.—the unofficial counter-memory of an immigrant society—that flourish alongside or deep inside narrathemes are deliberately obscured. Few commentators abroad notice this forest of dissent. A trained observer can see in that forest links between the narrath-emes that are not otherwise in evidence.

If we examine the components of the impressively strong resistance to the war against Iraq, a very different picture of the U.S. emerges, more amenable to foreign cooperation, dialogue, and action. I shall leave aside those many who oppose the war because of its cost in blood and treasure, and disastrous effect on an already disturbed economy. I shall also not discuss right-wing opinion that regards the U.S. as traduced by treacherous foreigners, the UN, and godless communists.

The libertarian and isolationist constituency, a strange combination of left and right, needs no comment. I also include among unexamined categories a large and idealistically inspired student population deeply suspicious of U.S. foreign policy, especially of economic globalisation: this is a principled, sometimes quasi-anarchical, group that kept campuses alive to the war in Vietnam, South African apartheid, and civil rights at home.

This leaves several important and formidable constituencies of experience and conscience. These pertain, in European and Afro-Asian terms, to the Left, although an organised parliamentary left-wing or socialist movement never really existed for long in the post–Second World War U.S., so powerful is the grip of the two-party apparatus. The Democratic Party is in a shambles from which it will not soon recover.

I would have to include the disaffected and fairly radical wing of the African-American community—those urban groups that agitate against police brutality, job discrimination, housing and educational neglect, and are led or represented by charismatic figures such as the Reverend Al Sharpton, Cornel West, Muhammad Ali, Jesse Jackson (faded leader though he is), and others who see themselves as being in the tradition of Martin Luther King, Jr.

Associated with this movement are other activist ethnic collectivities, including Latinos, Native Americans, and Muslims. Each of these has devoted considerable energy to trying to slip into the mainstream, in pursuit of important political assignments in

ABOVE AND RIGHT: **Andrea Geyer**, Interim, 2002 *(details)*

government, appearances on television talk shows, and membership of governing boards of foundations, colleges, and corporations. But most of these groups are still more activated by a sense of injustice and discrimination than by ambition, and are not ready to buy completely into the American (mostly white and middle-class) dream. The interesting thing about Sharpton, or Ralph Nader and his loyal supporters in the struggling Green party, is that though they may have visibility and a certain acceptability, they remain outsiders, intransigent, and insufficiently interested in the routine rewards of U.S. society.

A major wing of the women's movement, active on behalf of abortion rights, abuse and harassment issues, and professional equality, is also an asset to dissent in U.S. society. Sectors of normally sedate, interest- and advancement-oriented professional groups (physicians, lawyers, scientists, and academics, as well as some labour unions, and some of the environmental movement) feed the dynamic of countercurrents, even though as corporate bodies they retain a strong interest in the orderly functioning of society and the agendas that derive from that.

The organised churches can never be discounted as seedbeds of change and dissent. Their membership is to be distinguished from the fundamentalist and televangelist movements. Catholic Bishops, the laity and clergy of the Episcopalian church, the Quakers and the Presbyterian synod—despite travails that include sexual scandals among the Catholics and depleted memberships of most churches—have been surprisingly liberal on war and peace, and quite willing to speak out against human-rights abuses, hyperinflated military budgets, and neoliberal economic policies.

Historically there has always been a part of the organised Jewish community involved in progressive minority rights causes domestically and abroad. But since the Reagan era the ascendancy of the neo-conservative movement, the alliance between Israel and the U.S. religious right, and Zionist-organised activity that

equates criticism of Israel with anti-semitism, have considerably reduced its positive agency.

Many other groups and individuals that joined rallies, protest marches, and peace demonstrations have resisted the mind-deadening patriotism post-9/11. They have clustered around civil liberties, including free speech, threatened by the U.S.A. Patriot Act. Protest against capital punishment and at the abuses represented by the detention camps at Guantanamo Bay, plus a distrust of civilian authorities in the military, as well as a discomfort at the privatised U.S. prison system that locks up the highest number of people per capita in the world—all these disturb the middle-class social order.

A correlative of this is the rough and tumble in cyberspace, fought by the U.S. official and unofficial. In the current steep decline in the economy, disruptive themes such as the differences between rich and poor, the profligacy and corruption of the corporate higher echelons, and the danger to the social-security system from rapacious schemes of privatisation seriously damage the celebrated virtues of the uniquely American capitalist system.

Is the U.S. united behind Bush, his bellicose foreign policy, and his dangerously simple-minded economic vision? Has U.S. identity been fixed forever, or is there, in a world that has to live with U.S. military power, something other that the U.S. represents which

those parts of the world not prepared to be quiescent can deal with?

I have tried to suggest another way of seeing the U.S., as a troubled country with a contested reality. I think it is more accurate to apprehend the U.S. as a nation that is undergoing a serious clash of identities, similar to other contests in the rest of the world. The U.S. may have won the Cold War, but the results of that victory within the U.S. are far from clear and the struggle is not yet over. Too much of a focus on the U.S. executive's centralising military and political power ignores the internal dialectics that continue, and are far from settlement. Abortion rights and the teaching of evolution are still unsettled issues.

The fallacy of Fukuyama's

GLOBAL CRISIS OVER IRAQ

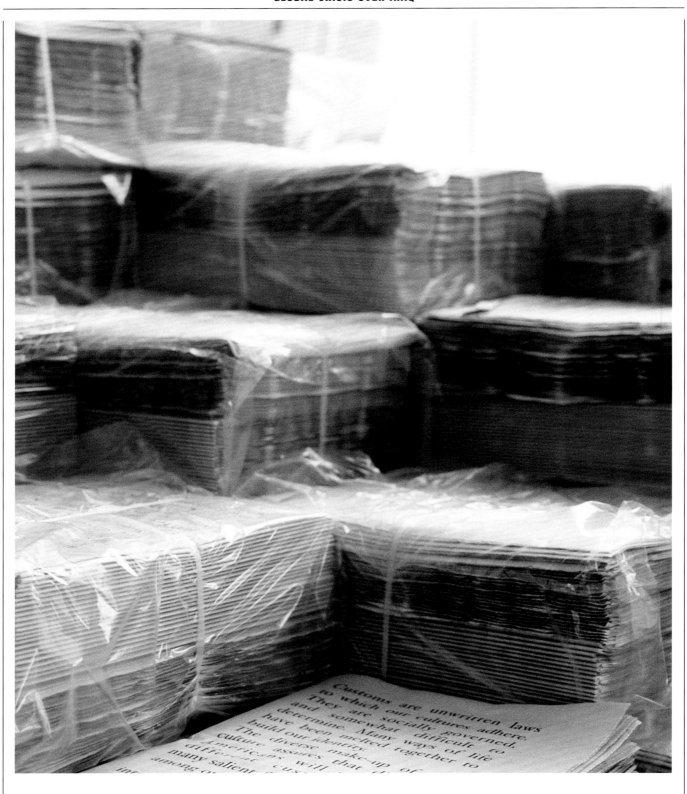

Andrea Geyer, Interim, 2002 *(installation view at Manifesta 4: European Biennial of Contemporary Art, Frankfurt, Germany)*

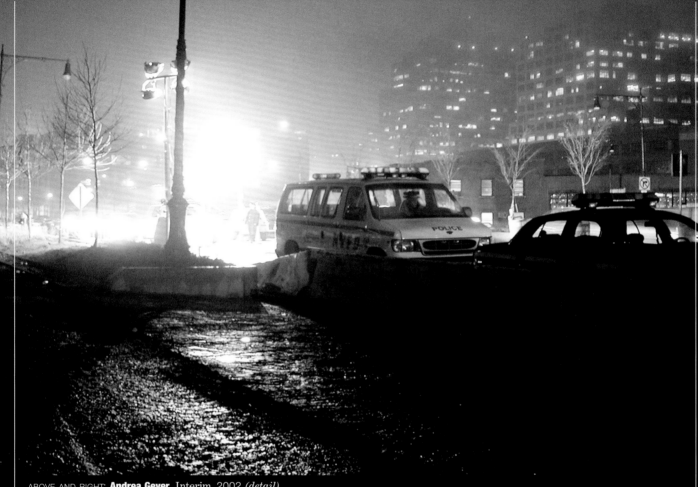

ABOVE AND RIGHT: **Andrea Geyer**, Interim, 2002 *(detail)*

thesis about the end of history, or of Samuel Huntington's clash of civilisation theory, is that both wrongly assume that cultural history has clear boundaries, or beginnings, middles, and ends, whereas the cultural-political field is a place of struggle over identity, self-definition, and projection into the future. Both theorists are fundamentalist about fluid cultures in constant turbulence and try to impose fixed boundaries and internal order where none can exist.

Cultures, and especially the immigrant culture of the U.S., overlap with others; one of the perhaps unintended consequences of globalisation is the appearance of transnational communities of global interests—the human

rights, women's, and antiwar movements. The U.S. is not insulated from this, but we have to go behind the intimidatingly unified surface of the U.S. to see the disputes to which many of the world's other people are party. There is hope and encouragement in that.

Notes

1 Joan Didion, "Fixed Opinions, or The Hinge of History," *The New York Review of Books*, January 16, 2003: http://www.nybooks.com/articles/15984

2 Schor, Juliet B., *The Overworked American: The Unexpected Decline of Leisure* (Basic Books, 1993).

3 Symcox, Linda. *Whose History? The Struggle for National Standards in American Classrooms* (Teachers College Press, 2002), 101,

"Cash."
The room she enters is carpeted. What are the colors of our flag? Red, white, blue. What do the stars on the flag mean? One star for each state. How many stars are there on our flag? 50. What color are the stars on our flag? White. How many stripes are there on the flag ? 13. What do the stripes on the flag represent? The first 13 states. What colors are the stripes on the flag? Red and white. How many states are there in the Union? 50. What do we celebrate on the Fourth-of-July? Independence Day. Independence Day celebrates independence from whom? England. There are two windows, a door, a closet. The bathroom is simple but clean. No room-service. She lights a cigarette. She walks to the room's center and lies down on her back. The carpet feels soft. She turns her head and sees some dust under the heater. Who said, *"Give me liberty or give me death?"* Name some countries that were our enemies during World War II. Which was the 49th state added to *our Union* ? How many full terms can a President serve? Who was Martin Luther King, Jr.? What are some of the requirements to be eligible to become President? She gets up and examines the furniture. Reflected sunlight moves quickly over the ceiling. She stops at the mirror. She turns her head from the left to the right, then away. *For most of the country, a "Yankee" is a person who lives north of the Pennsylvania/Maryland border. To those people who live north of that border, a "Yankee" is someone from one of the New England states. In the New England states, a "Yankee" is someone from New Hampshire. In New Hampshire, a "Yankee" is someone who comes from the swamp, and eats pie for breakfast.* It is important for you to know that what you feel right now is a typical pattern of experience, encountered by many others before you. "Nothing to worry about." "Yes, who cares." "Like yesterday." It is the afternoon. The radio is playing in the background. *...this song was written in 1967. It is fifteen minutes to the hour. Returning to our report...* You can hear a noise next door. Her hand is reaching out and touching the wall for a moment. She doesn't move. *...In this conversation, that we recorded yesterday, community advocates assume the slightest transgression or misunderstanding could plunge them into a very difficult situation. Many standard legal safeguards —*

Andrea Geyer, *photograph and text from* Interim, 2002
PAGES 174–75: **Ane Lan**, *still from* Amerika, 2002

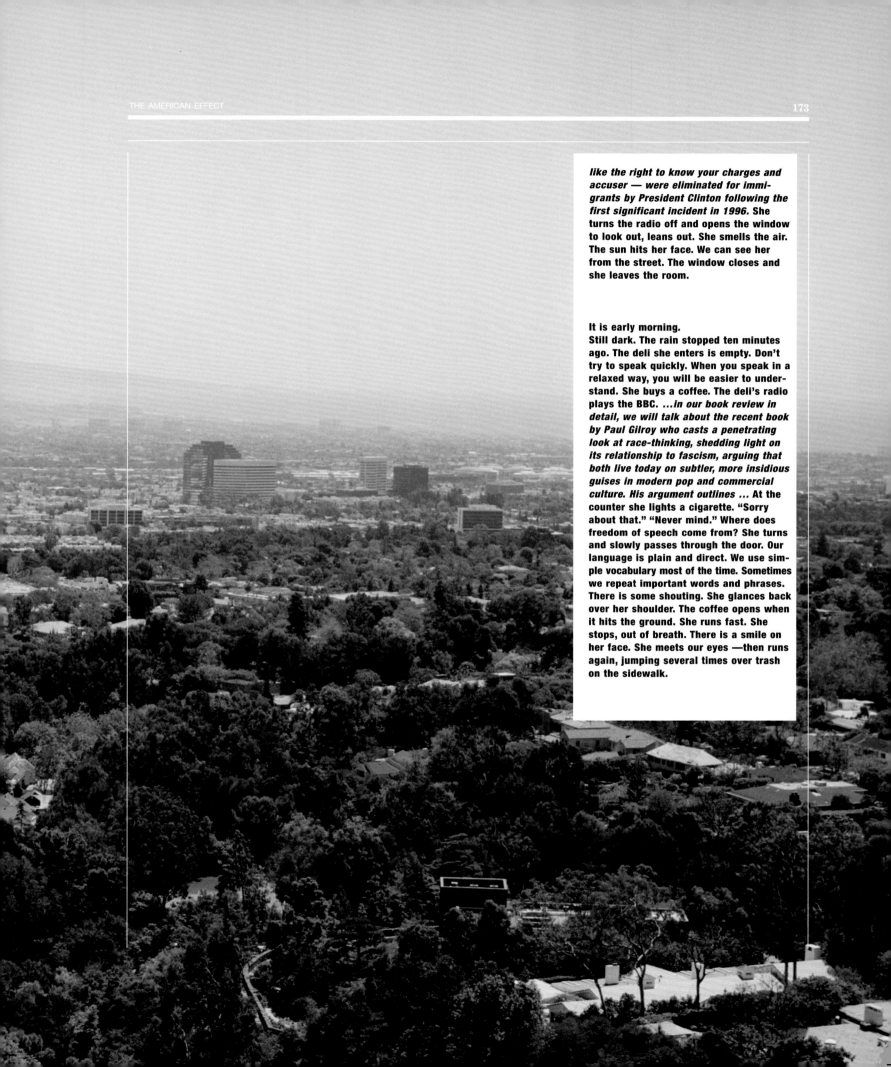

like the right to know your charges and accuser — were eliminated for immigrants by President Clinton following the first significant incident in 1996. She turns the radio off and opens the window to look out, leans out. She smells the air. The sun hits her face. We can see her from the street. The window closes and she leaves the room.

It is early morning.
Still dark. The rain stopped ten minutes ago. The deli she enters is empty. Don't try to speak quickly. When you speak in a relaxed way, you will be easier to understand. She buys a coffee. The deli's radio plays the BBC. *...in our book review in detail, we will talk about the recent book by Paul Gilroy who casts a penetrating look at race-thinking, shedding light on its relationship to fascism, arguing that both live today on subtler, more insidious guises in modern pop and commercial culture. His argument outlines ...* At the counter she lights a cigarette. "Sorry about that." "Never mind." Where does freedom of speech come from? She turns and slowly passes through the door. Our language is plain and direct. We use simple vocabulary most of the time. Sometimes we repeat important words and phrases. There is some shouting. She glances back over her shoulder. The coffee opens when it hits the ground. She runs fast. She stops, out of breath. There is a smile on her face. She meets our eyes —then runs again, jumping several times over trash on the sidewalk.

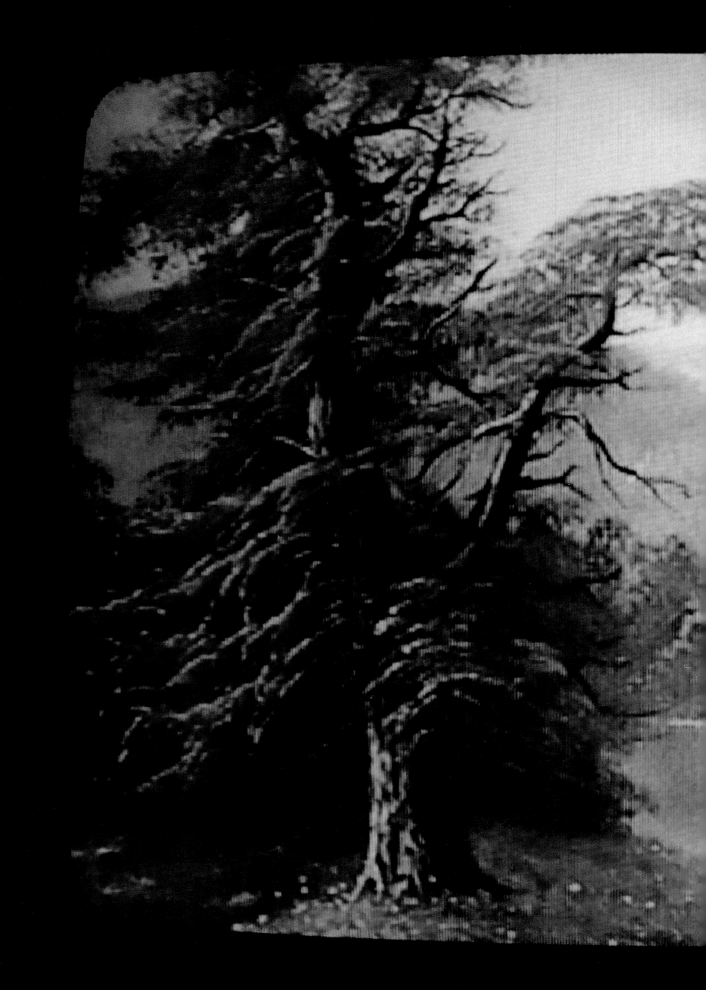

AMERICANIZATION, HISPANIZATION

Americanization, Hispanization

Elena Poniatowska
MARCH 18, 2003

To live and write has a different meaning in Latin America than it has in the United States or in Europe, though I suppose it is similar to how it is in Africa. Latin America invades, possesses, interferes, gets into the smallest cracks. Latin America is always out there, behind the window, watching, spying, ready to jump. The street enters through the door, people find their way in, look at you while you are sleeping, eating, and making love. The path is public. In great cities of the United States, everyone has something to do, people go somewhere, walk quickly, never turn their heads to look at their neighbors. In Latin America, in Mexico, no one has anywhere to go. Thousands and thousands of people with nothing for themselves. Nothing. Not a single opportunity. Their empty hands hang near their bodies, in front of their mouths, on top of their knees, their hands waiting without any use. All this human energy is there, wasted. They look, they wait, they fall asleep, they wait again. Nobody loves them, nobody misses them, they are not needed anywhere. They are nobody. They do not exist. So much to do in the world, and there is no place for them, so much lost energy. There is no one to tell them let's get up, let's get going, let's save, let's build. Outside my window, ready to burst, the multitude is always present— people, the same cannon fodder that nourishes great universal misfortunes, *les condamnés de la terre*, the wretched of the earth, as the writer Franz Fanon called them. Suddenly, during an

earthquake, one of them saves a life. We have no idea who this person is, what their name is, no way to thank them; they don't expect to be thanked. We never see them again; they saved our lives. They are there latent, frightfully present.

As the Latin American novelist Carlos Fuentes puts it, Mexico and the United States share the longest guarded border between two countries and it is the only visible border between the developed and the developing worlds. Fuentes calls it a scar. It is also the border between Anglo-America and Latin America. But it is an unfinished border, made up of barriers, ditches, walls, and wire fences erected by North Americans to keep out the Latino and Latina American migrants. (In 1996, as a candidate for the American presidency, Pat Buchanan said that if he won, he would build a very high wall of stone.)

The frontier is simple to cross where the Rio Grande is shallow or the hills abandoned, but it is still difficult to reach the northern side. Many of the men and women make it across the river only to be run down by cars speeding along a highway. In between is a no-man's-land where the migrants must escape the clutches of the U.S. border patrol, helicopters' searchlights, and other technological devices. The migrant workers are so desperate that they are willing to risk their lives rather than stay on the Mexican side. Between 1984 and 1994, 3,200 men drowned trying to cross the Rio Grande (of course without death certificates and autopsies, the only proof of their existence is their nude bodies; their papers and clothes have disappeared, taken by the water currents), and every year at least 330 people die at the border. They come mostly from Mexico, but also from Central America and the Caribbean and as far south as

Colombia, motivated by economic reasons. Mainly, they are hungry; their own countries are not capable of feeding them. More than 650,000 people a year join an army of more than 7 million undocumented workers who do not speak English and fear authorities, not realizing they are needed in the United States because they do the jobs no one else is willing to do. They are the ones who pick, lean over, stoop, cut, and kneel. Without them, the American economy would surely crumble.

The Spanish Empire extended as far north as Oregon in 1848. The Mexican Republic inherited vast lands and lost them to the United States, territories that now comprise Arizona, New Mexico, Texas, Colorado, California, and Utah. The Spanish names of cities there—Los Angeles, Sacramento, San Francisco, Santa Barbara, San Diego, San Luis Obispo, San Bernardino, Monterey, Santa Cruz, San Antonio, Santa Fe—are proof

AMERICANIZATION, HISPANIZATION

of how Latin were these Western states that once belonged to my country. The United States has continued to expand. More than any other country in the world, it has acquired land and the people native to those regions. Alaska, Florida, Louisiana, Hawaii, Puerto Rico, and the Virgin Islands are now part of the most powerful nation in the world.

But still we ask ourselves, has Uncle Sam been a good uncle? The Americanization of daily life in Mexico dates back a hundred years. Since 1880 the soap we use is imported, Procter and Gamble; toilet paper and Kleenex are Kimberly-Clark; hamburgers come from McDonalds, Burger King, Fudd-

ruckers, and Burger Boy. Cosmetics are by Revlon and Max Factor. We shave with Gillette. We dance to the music played in the USA. Our TV's are developed from North American and Japanese patents. The cars we drive are American. The transnational companies run our lives. ITT dictates our communications and information. Anderson Clayton, Black and Decker, Sunbeam, Kenmore, Zenith, General Motors, Westinghouse, Farah, IBM, Sheraton, Ramada Inn, Holiday Inn, etc., fill our lives. The dollarization of our countries is a fact.

Foreign debts are choking the economies of Latin America.

This results in the destruction of national markets, in our subordination to the external economies of North America and Japan. Most of our middle classes have one desire—to become Americans—and the American Way of Life is their dream. We jog, although doctors have forbidden that we run early in the morning because of smog. We eat fiber, use Reebok tennis shoes, and don polo shirts. Our television programs and news coverage come from North American agencies. The American image is everywhere. Dark-skinned Mexicans appear only when there is an earthquake, a war, or a revolution.

Mexicans choose American names for their businesses and shops because it will assure their success, or at least so they hope. They also choose American names for their children. Before, in states like Tabasco, names were Socrates, Greek, and Parmenides; now, the children are called Patricia, Samantha, and Deborah.

Americanization is equated with prosperity in Latin America. Mexicans are fanatics about home appliances—dishwashers, salad mixers, can openers. In his novel *Where the Air is Clear,* published thirty years ago, Carlos Fuentes tells of how a wetback brings his mother an Osterizer blender. The mother looks at it and says, "What do I need this fucking thing for? We don't have any electricity." We continue being fanatics. Monterrey has bought more parabolic antennas than any other city in the world, more than Dallas, Texas.

The price America pays for the Monroe Doctrine is that the migrants keep coming, not only to the Southwest but to major cities in the Northeast and the Midwest, where they shake hands with the Chicanos, the North Americans of Mexican origin. They all join to make more than 34 million Hispanics in the United

AMERICANIZATION, HISPANIZATION

ABOVE AND RIGHT: **Patricia Clark, Meira Marrero Díaz, and José Angel Toirac**, *stills from* The Golden Age, 2000

AMERICANIZATION, HISPANIZATION

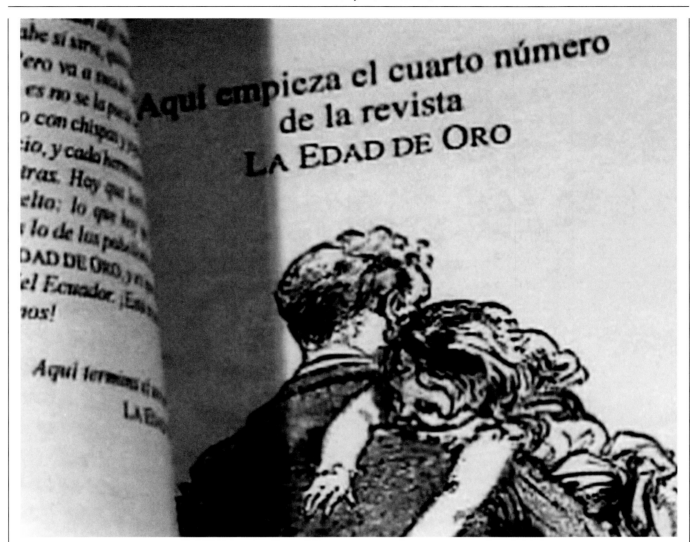

States—the vast majority of whom are of Mexican origin but many of whom are from Puerto Rico, Cuba, and Central and South America. Hispanics are the fastest-growing minority in the United States, and, as we all know, for the time being, they are doing the jobs that Americans don't want to do.

Even if you only speak Spanish, you can be understood in Miami, as the population is predominantly Cuban. San Antonio, largely populated by Mexicans, has been a bilingual city for 150 years. By the middle of the coming century, almost half the population of the United States will be Spanish-speaking. A whole civiliza-

tion with a Hispanic background has been created in the United States. Selena, the Mexican-American country-folk singer murdered in Corpus Christi, Texas, could be a symbol of Hispanic or Latino power that aspires to be a cultural power.

Latin America is recovering many of its territories through migrant tactics, as Mexicans and Central and South Americans come to settle north of the border. In 1979, Marta Traba published *Homérica Latina*, a novel whose characters are the losers of our continent—those on foot, those who pick up the garbage and live from it, the inhabitants of the slums, the

masses who trample each other to see the Pope, those who travel on crowded buses, those who cover their heads with straw hats, those who fear God in the land of Indians. The people of the bedbugs, the fleas, and the cockroaches, the miserable people that at this moment are gobbling down the planet. This formidable mass extends and crosses frontiers working as carriers and mechanics, ice-cream vendors and cleaners of anything and everything, errand boys and shoe shiners. They take their dead children to be blessed and photographed so as to transform them into "holy little angels." They tumble down the platforms of

AMERICANIZATION, HISPANIZATION

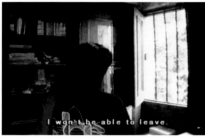

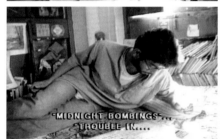

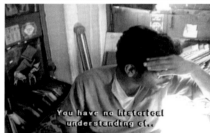

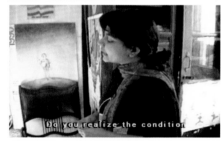

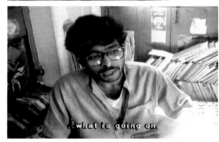

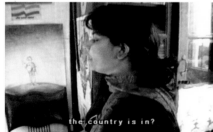

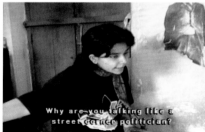

ABOVE AND RIGHT: **Sandeep Ray**, *stills from* Leaving Bakul Bagan, 1994

military parades and suddenly, without effort, cause all the badly intentioned policies of good neighborhood to fall. This anonymous mass, obscure and unpredictable, is slowly advancing from as far as Patagonia to the United States.

Are we still being conquered? In many ways, we are—through our own local and paternalistic dictatorships, our ignorance, our lack of technology, our corrupt politicians, our political backwardness, our political parties, our bad philosophies, our own misery, our lack of opportunities, the very heavy burden of Catholic religion that teaches us that we will be happy in heaven and we should reverence tradition. Christian Spain lives in our countries, but the paternalistic Anglo-Saxon United States also has a very definite influence.

Our culture is universal. Jorge Luis Borges, Alfonso Reyes, Gabriela Mistral, Pablo Neruda, Miguel Ángel Asturias, Alejo Carpentier, Octavio Paz created a humanistic space in which all literatures and philosophies meet. Nevertheless, only very few Latin Americans have access to education, much less to culture. I always remember a young Mexican peasant girl who once asked, "Why do I have to go to school if I'm going to continue eating beans?" It was difficult to convince her, in her dirt-floor house, that if she went to school, she would be able to eat something else.

Jesusa Palancares, the principle character of my novel *Here's to you, Jesusa!*, thinks very little of herself, although she is an extraordinary heroine. She says: "I am like the gypsies, from nowhere. I don't feel Mexican, and I don't recognize Mexicans. If I had money, I would be considered Mexican, but I am worse than dirt, I am nothing. That's right, that's what I am: garbage for the dogs to pee on and keep on walking. The wind comes and blows it away, and that's the end of it. There's

AMERICANIZATION, HISPANIZATION

nothing else for me to be. I've never been worth anything. My whole life I've been this same good-for-nothing germ you're looking at right now."

The dead is the poor of always, the same cannon fodder of always who nourish universal misfortune. And yet we have the hope that it is them who, in spite of their anonymity, will win the battle at the end, because better than anyone else, in every circumstance, at all times, they have known, the Mexican people have known, how to resist. And finally, in contradiction to all evidences, it is them who will end up changing history.

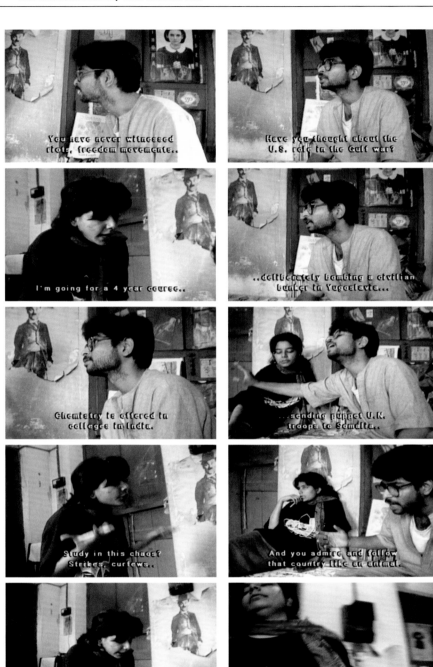

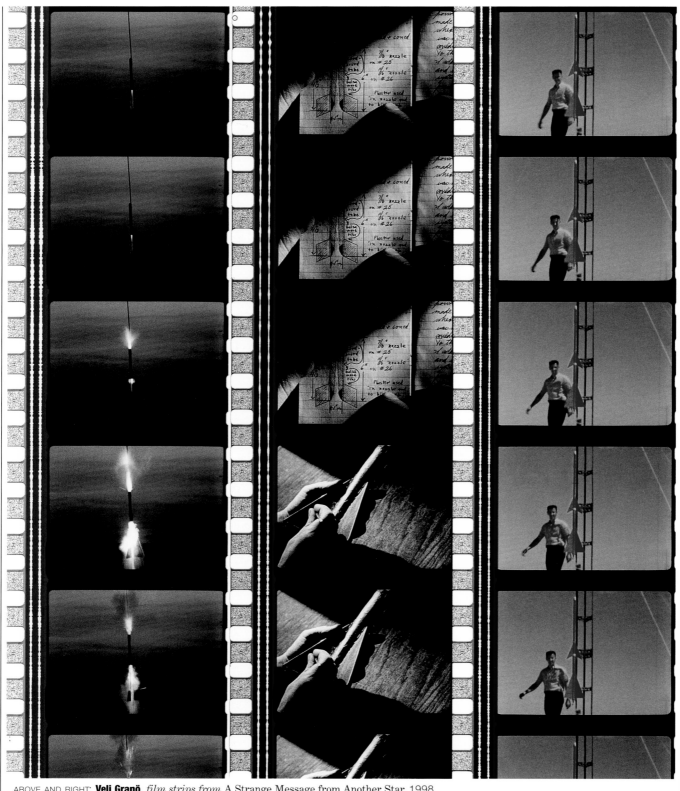

ABOVE AND RIGHT: **Veli Granö**, *film strips from* A Strange Message from Another Star, 1998

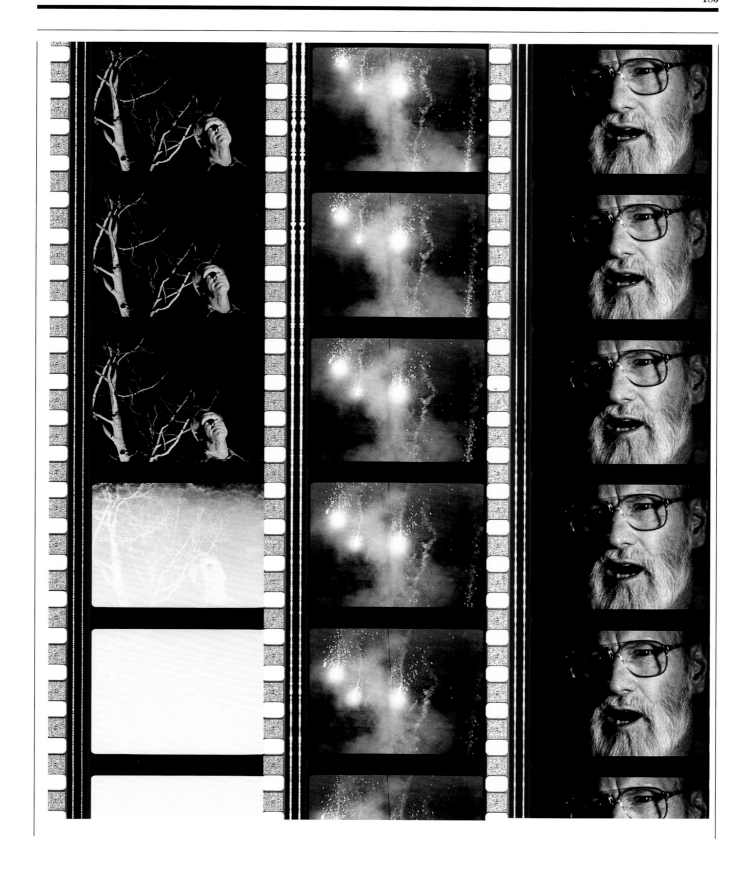

A STRANGE MESSAGE FROM ANOTHER STAR

02.47.30 **I think the reason my father came to America was the Civil War in Finland, in around 1917. He wanted to leave Finland.**

He didn't talk about it very much, he only said that many people were killed.

03.35 **He must have been about 20 at the time of the Civil War.**

03.57 **I grew up during the World War. People just killed each other as much as they could, bullets, bombs. Whole cities and families destroyed.**

04.20 **These are my parents standing in front of our house 4 or 5 years before my mother died.**

04.34 **My mother supported the family, my father could not hold down a job. He lasted about 6 months, then he would either quit or be fired. He told me God didn't exist, it was all superstition. People were like wild lions in the forest.**

04.58 **Jussi walked around Brooklyn, around the grave yard, around Prospect Park; he was in training for marathon walking.**

Mom and Dad were constantly arguing.

So I thought that the world was filled with hatred and war, that's how I grew up.

05.32 **I said to my father: "When you die, I'll put you in the wooden box and bury you with all those medals and cups that you won."**

It was 1945. I was on my way to school on the subway. People were carrying newspapers, and the *New York Daily News* headline said: "Atomic bomb dropped on Japan." The whole city was destroyed. I thought that now the crazy people, who ascended from apes, had invented a way to

murder all the people on the earth. I decided I just had to get away from this world.

07.00 **If I only could find another planet in space where human beings could live in peace, I'd go there.**

07.17 **My ship would have to be a rocket, jets or propellers wouldn't do. That is the only means to get up there.**

On a piece of paper we wrote that we swore with our hearts and souls to build a rocket, and fly into space. We both signed it.

Money meant nothing to me, love meant nothing to me, only rockets... and space. In front of a mirror I told myself "space is your life story."

08.25 **My father looked at it and asked what it was. I answered it was the model of the rocket I was going to fly into space in. He told me it was crazy, that no-one could leave the earth. That we were meant to stay down here, the gravity keeps us here.**

The basic principle upon which a rocket travels is found in Newton's third law of motion. To every action there's always an equal and opposite reaction. The rocket travels upon the reaction of the escaping gas....

Two parts potassium chloride, two parts magnesium dioxide. two parts charcoal and one part sulphur.

So far, with all my experimenting, I have had poor success. I begin to wonder if I am using a wrong system.

10.25 **The war ended, and the Americans brought in the German V-2 rockets. I just loved to see the V-2 rockets fly.**

I wanted to go to Germany to see the people who built rockets, Werner von Braun and other rocket scientists. But I couldn't find anybody there who knew.

12.00 **I was at a small airport outside Munich. One day I was wondering what to**

do. So, I went to a small town. The name of the town was Dachau.

12.30 **That is where I lost all my religion. I knew God couldn't exist.**

14.16.20 **I didn't have time for the family, just worked all the time. She left me in 1982.**

14.54 **The guy said: "So you want to be a chemist. Have you worked as a chemist?" I said No. "What makes you think you could be a chemist?" I took some rocket fuel out of my pocket, and the guy said: "Where did you get that?" I said I made it. I'd been making rocket fuel since I was a kid. So we went into the lab to see if it would burn. It did, and he said it was really good fuel, and I told him rocket fuel's the only thing I know about, been studying for years and years. So he gave me the job.**

I was the only chemist working there who hadn't been to university, but I got the job anyway.

16.43 **My job was what they called propellant chemist. I had to test different chemicals to find the most powerful fuel.**

One was Minute Man... Intercontinental ballistic missile.

17.30 **This is the rocket fuel they use in the space shuttle. I've got 165 barrels full of it. I could easily build myself a space shuttle engine.**

17.50 **I'd just need the place, an area big enough, and enough electricity to drive the mixers.**

18.16 **Finally, it is actually my formula they use in the space shuttle engine in Thiokol. That's the work I did for the space shuttle engine.**

ABOVE AND RIGHT: **Veli Granö**, *text from* A Strange Message from Another Star, 1998

19.46 **The boss gave me this white powder to grind up really finely, to put it in the blender. So I did, I put the lid on and started it up. I thought he knew what he was doing, but no.** The lid started leaking, then it blew off, hit the ceiling and I was covered from head to foot with Freon.
It was up my nose, in my mouth, my ears, everywhere. Hydroazoic Acid.
In one minute my head was aching as if I`d been hit with a hammer.

20.41 **I went home, woke up at 2 o'clock in the morning, standing on my pillow.** I saw a big black crow half a kilometre away, as it flew I could see its wings and everything as if it was one metre away.

21.13 **Epilepsy, a seizure. That chemical poisoned my brain... Everything was gone, my memory was gone.**

21.35 **I lost my memory, couldn't remember how to work anymore.** Nobody went to the hospital and told them what happened to me. They felt sorry for me, thought I was an odd character. I was as thin as a rake.

22.22 **I took out as much of life insurance I could, and wrote a letter to my wife. I told her I was going for a little drive, hugged her, started up the car. That's when I had a fit.** When I came to, I realised the engine was still running, I was on the floor and I couldn't figure out what had happened to me. Only the next day did I remember. There was the letter I'd written to Pirkko, telling her to take the money and take the kids back to Finland. I didn't want to suffer, my head hurt so much and I was so confused. Suicide is the easy way out.

24.02 **It was Dialantin that cured me.**

24.19 **The astronauts landed on the moon in 1969, the same year I had my fits.**

24.55 **One day I was sitting on the sofa in our old house. Tears came to my eyes and I thought it was my big dream to fly into space and speak to another human being.**

25.23 **The Holy Spirit appeared to me, stood right next to me, I could feel his presence.** He said: "Paavo, you couldn't come to me, so I came to you". He knew that one person couldn't do something like that...
fly far up into space all on his own.

26.04 **There's one rich man who lives around here.** He can't understand why the government wants to take all the guns away. So he decided to buy a rifle and bullets and hide them. I think they lie.... They talk about about basketball, O.J. Simpson's murder, but they don't talk about world matters. The U.S. government hides information from the public. That's why people suspect the government, they know something is wrong.

26.51 **Three men picked up the barrels where all the rifles were. I was in the ditch putting them into rows.** 4–5 thousand of them. They threw two metres of sand on top of them to hide them. If somebody needs to defend himself, he just needs to go and dig them up.

27.54 **The tanks came and killed thousands of people in Tiananmen Square.** People had no weapons. That's what the government does. People have no rights, they die like rats.
You could build something out of these that could destroy a tank. It wouldn't be hard.
3-2-1-FIRE

28.57 **He who forgets the past is condemned to relive it.**
People don't learn in life, they forget their mistakes.
That's man´s law.

29.44 **5-4-3-2-1-FIRE**

30.15 **I could put my life story in here, and a couple of photos.** And label it: Not to be opened before the year 5555. So it would become a time capsule.

30.41 **Then he took my soul from my body and said: "Come with me". We went into the dark sky. I could see my house down there, and all around me, the Milky Way.**
I'd never seen anything like it before. It was so wonderful, I can't find the words to describe it. Man's brain hasn't got the capacity to understand how wonderful it is there where God has come from.
I felt so peaceful inside.
It just ... overwhelmed me.

Selected Bibliography

Sean Rocha

With the collapse of the Soviet Union in 1989, the United States emerged with unprecedented power to shape the lives of people around the world. America not only engages in the traditional types of statecraft, such as imposing economic sanctions or launching military actions, but it also intervenes in the most intimate details of people's existence in other countries, affecting, for example, whether ill individuals get access to affordable medicine or women can abort unwanted pregnancies, how husbands should behave toward their wives and which of their children should receive an education, what crops a farmer can grow and whether there will be a market for them at harvest time. Only the biggest and most significant of America's actions are retained in the superpower's memory, but every one of them, no matter how small or accidental, is remembered by the people whose lives are changed by them.

The memories of shared history differ, as do the abilities to record that history. American media is the de facto world media, from CNN and *The New York Times* to MTV and Hollywood. The determination of what is newsworthy and what is inconsequential, what is credible and what is biased, is made by Americans in Atlanta and New York and Los Angeles and not by Vietnamese in Hanoi or Congolese in Kinshasa. When the weak want to make themselves heard, they must do so through the television channels, newspapers, and radio stations of the powerful; the views articulated in their own media are largely unheard beyond their borders. As a result of this asymmetry, the United States is able to project its own image of itself across vast distances, while the reflection that returns of what others think of it is fainter. Often, the echo that can be heard is America's own voice speaking for others, in the form of American pundits anticipating the views of "Europe" or the so-called Arab street; much can be learned from these American mediators, but also much lost in the voices they drown out.

Power insulates, as well as deafens, so the divergence between what America says of itself and what others say of it can seem of little consequence—indeed, even go unnoticed—until events, such as those that occurred on September 11, 2001, intervene to make clear its critical importance. What follows is a subjective guide to some of the literature available in English about America's presence in the world. The most recent edition is cited, unless otherwise indicated.

I.
The World's View of America

In broad terms, the debate within America about its place in the world is between the political Right, which regards the country as an exemplar nation and a defender of freedom around the world, and the Left, which tends to think of America as a hypocritical power that frequently fails to promote abroad the values it advocates at home. As often with apposite types, each is accurate at different times and in different settings, but both agree on the basic principles of democracy and individual liberty while disagreeing on how best to achieve them. A third dimension of the political spectrum, one in which liberal democracy itself is critiqued as a challenge to traditional values and social cohesion, is commonly voiced in developing countries but is largely absent from debate in America about its place in the world.

For many people around the globe, America seems to be everywhere: on television, at the movies, in soda bottles, buying tourist souvenirs, running multinationals, manning development-aid stations, posted at military bases, and hovering in some shadowy and undefined way behind all the local tragedies. Ironically, America's ubiquity makes it a difficult subject to contain in a book; it more often appears in newspaper and magazine articles (see following section), where the praise or criticism is usually pegged to a discrete action. The process of selection used by publishers in the United States to decide which books by non-Americans are translated into English also fails to capture the full spectrum of criticism. Because there is a substantial readership in both the United States and Europe for the liberal critique of America, many books addressing that

audience are written in English or get translated. As there is little such market for an antiliberal critique and generally the people who make that argument (including, but not exclusively, Islamic fundamentalists) are not addressing themselves to an American or European audience, few such texts appear in the English language. The range of debate accessible to most Americans is therefore truncated.

Achebe, Chinua
Things Fall Apart
NEW YORK: ANCHOR BOOKS, 1994

First published in 1959 and still the landmark novel concerning decolonization in Africa, it tells the story of a wrestler named Okonkwo and the elaborate moral codes that govern his life in a Nigerian village. On the final page, the perspective switches to that of a British colonial officer who reveals that Okonkwo's tale would be relegated to perhaps a paragraph in the official history of Nigeria that he is writing. The novel represents all that is lost when a person's story is told by outsiders, a role that was once played by European colonizers and now by the American media.

Arenas, Reinaldo
Before Night Falls
TRANSLATED BY DOLORES M. KOCH
NEW YORK: VIKING, 1993

In this memoir of a Cuban homosexual growing up under Castro who makes sexual liberation a form of political rebellion, America appears as the unreachable sanctuary just across the water, a constant lure but a place that a Cuban in love with Cuba tries to resist. After a harrowing imprisonment, Arenas escapes and lives freely but unhappily in exile.

Baudrillard, Jean
America
TRANSLATED BY CHRIS TURNER
LONDON: VERSO BOOKS, 1989

Recording a postmodern Frenchman's travels through the United States in the tradition of Alexis de Tocqueville, this book finds a country of light, illusion,

and simulacra. The result may bear scant resemblance to the nuts-and-bolts land seen by its citizens, but makes for an interesting excursion into French cultural theory.

Chua, Amy
World on Fire: How Exporting Free Market Democracy Breeds Ethnic Hatred and Global Instability
NEW YORK: DOUBLEDAY, 2003

This book challenges one of the fundamental principles of American foreign policy—that the spread of free markets and democracy work hand in hand to create stability—by arguing that the two empower different groups, creating conflict. The American-born Chua descends from a Filipino-Chinese family and is herself an example of what she calls a "market dominant minority." Like the Lebanese in West Africa and the Indians in East Africa, the Chinese in Southeast Asia control an overwhelming share of the local economy and thus are the first to capture the gains of free markets. Democracy, by empowering the majority, provides a vehicle for exacting revenge on the market dominant minority.

Diawara, Manthia
"The Song of the Griot"
Transition 74 (1997): 16–30

This professor's memoir describes his youth in Mali emulating black Americans by growing an Afro and organizing a Woodstock-in-Bamako along with the rediscovery in middle age of the seductive powers of traditional griot singers. With photographs by Malian studio photographer Malick Sidibé.

Fallaci, Oriana
The Rage and the Pride
NEW YORK: RIZZOLI INTERNATIONAL
PUBLICATIONS, 2002

Italy's most renowned journalist and the author of the spectacularly combative *Interview with History*, Fallaci wrote this book in response to the events of September 11th. Once again, she is not bashful. In an impassioned defense of America not often heard from a European, Fallaci launches a vitriolic attack against Islam and an only slightly

SELECTED BIBLIOGRAPHY

gentler one against criticism of America among European intellectuals.

Friese, Kai
"White Skin, Black Mask"
Transition 80 (1999): 4–17
According to this Indian journalist, in the closed economy of his childhood nothing was more treasured than imports and, for him, the most treasured import of all was an American comic book from the 1930s called *The Phantom*. In its pages, he found an exotic fantasyland of dark natives and an impenetrable jungle called Bangalla that turns out to be India.

Hitchens, Christopher
The Trial of Henry Kissinger
LONDON: VERSO BOOKS, 2001
Framed as a legal case against former Secretary of State Henry Kissinger for war crimes, this book reads as a chilling indictment of American foreign policy in the 1970s. The war in Vietnam is the most famous, but only marks the beginning, according to Hitchens, who also points to assassinations in Chile and Cyprus, sanctioning the Indonesian invasion and subsequent massacre in East Timor, bombing Cambodia and Laos, and on and on. It challenges the view that America should be seen as a beacon of freedom.

Ibrahim, Saad Eddin
Egypt, Islam, and Democracy:
Critical Essays
CAIRO: AMERICAN UNIVERSITY IN CAIRO PRESS, 2002
In this collection of essays, one of Egypt's most prominent liberal intellectuals reflects on his country's experience in the 1980s and '90s with many of the issues American policy is most concerned with addressing: democracy, civil society, free markets, individual liberty, and Islamic political activism. The message that emerges from the writings is of the immense difficulty in enabling liberal policies to take root in the absence of wholesale changes to the political system.

Jack, Ian, ed.
"What We Think of America"
Granta 77 (SPRING 2002)
Inspired by the events of September 11th, this issue of the long-running British literary magazine brings together reflections on America on that fateful day from writers around the world, along with a few related extended essays. The publication captures the conflicted mix of longing, admiration, awe, sorrow, fear, and dismay that many feel for the United States.

Kapuscinski, Ryszard
Shah of Shahs
TRANSLATED BY WILLIAM R. BRAND AND KATARZYNA MROCZKOWSKA-BRAND
NEW YORK: VINTAGE BOOKS, 1986
During the Cold War, this veteran Polish correspondent was able to go places and see things in a way many Western correspondents could not. His 1978 book *The Emperor: Downfall of an Autocrat*, about Haile Selassie's court in Ethiopia, is a classic. *Shah of Shahs*, however, involves America more directly, given that the United States returned the Shah of Iran to power and then propped him up until Ayatollah Khomeini and the revolution swept him away. The book is more impressionistic than scholarly, and reading it one wonders how the American government believed the Shah's rule served anyone's interest save his own.

Lee, Kuan Yew
From Third World to First:
The Singapore Story: 1965–2000
NEW YORK: HARPERCOLLINS PUBLISHERS, 2000
Independent Singapore's founding father, Lee Kuan Yew, is one of the most fascinating political figures of our time: brash, stubborn, fiercely intelligent, and, depending on the view, either a miracle worker or longtime autocrat. His complex personality and the path of Singapore's remarkable modern history are both revealed in his memoirs. Lee has been one of the most outspoken critics of America's proselytizing on human rights and is a leading proponent of an "Asian Way" that views economic, rather than political, liberalization as more appropriate to local cultural values.

"Living with a Superpower"
The Economist 367 (JANUARY 2, 2003): 18–20
The article sheds light on global perceptions of America by reviewing a survey of world values based on twenty-five years of polling data, plotting the results on a matrix that reveals the nation's peculiar place in the world: the United States clusters near most other rich Western countries in valuing self-expression and individualism over survival issues like economic and physical security, but is closer to poor developing countries like India and Vietnam in favoring traditional values of God and country over secular-rational ones.

Naipaul, V.S.
Among the Believers:
An Islamic Journey
NEW YORK: VINTAGE BOOKS, 1982
The Nobel Prize–winning author gives an account of his travels in 1979 through the converted Islamic lands of Indonesia, Pakistan, Malaysia, and Iran. As an Indian growing up "displaced" in Trinidad, Naipaul is much concerned with the roots of identity. But he also recounts how the Islamic movements in many of those states, during the period of his visit, were moving from opposition to governance and beginning to build the infrastructure of administration on the foundation of faith. This process (except for Iran) drew little attention from America at the time, but would one day come to dominate America's foreign-policy agenda.

Qutb, Sayyid
Social Justice in Islam
TRANSLATED BY HAMID ALGAR. ONEONTA, N.Y.: ISLAMIC PUBLICATIONS INTERNATIONAL, 2000
The leading theoretician of the Muslim Brotherhood in Egypt, Qutb was executed by Gamal Abdel Nasser in 1966 but his work has since served as the inspiration for jihadi movements throughout the Islamic world. Qutb represents a classic illustration of the insular nature of American political debate: for better or worse, there are few writers who have had a greater impact on the world, but he remains almost unknown in the United States. This book, written in 1949, is Qutb's most famous. Criticizing

the corruption and inequality of contemporary Islamic societies as well as the crusading ambitions of the West, he makes the case for an Islamic renaissance through a return to the purity of early Islam.

Shehadeh, Raja

Strangers in the House: Coming of Age in Occupied Palestine
SOUTH ROYALTON,VT.: STEERFORTH PRESS, 2002

This lyrical and humane memoir of a Palestinian lawyer and human-rights activist who has long worked for a two-state solution is a wrenching tale of dispossession, deferred justice, and powerlessness in the face of occupation in which America is profoundly implicated.

Sinduhije, Alexis

"Welcome to America"
Transition 78 (1998): 4–23

Fed up with his countrymen obsessing about America and thinking even its black people are better, this journalist for a radio station in Burundi comes to the United States to find out the other side of the story by interviewing "white" black people (as Burundians call African-Americans) about Africa. The results astonish him: no one knows about Africa, or cares, and most African-American leaders won't even answer his calls. In black America, it seems, Africa exists as a mythological point of origin with little current-day existence. With photographs by Dawoud Bey.

Veloso, Caetano

Tropical Truth: A Story of Music and Revolution in Brazil
TRANSLATED BY BARBARA EINZIG AND ISABEL DE SENA. NEW YORK: ALFRED A. KNOPF, 2002

A legendary Brazilian singer, songwriter, and activist, Veloso spearheaded the musically and politically transgressive Tropicalia movement in the 1960s with his friend and fellow musician João Gilberto. Tropicalia coincided with the counterculture in the United States, but drew heavily on earlier American musical inspirations, such as Frank Sinatra and Chet Baker. The result was the same: a music-driven youth movement that ran

headlong into establishment politics, which, in Brazil's case, meant a government run by a military junta. A story of Brazil, this autobiography reveals the way American culture could be seen as a liberating force in the world even as its politics were seen as a force of oppression.

Wrong, Michela

"A Question of Style"
Transition 80 (2000): 18–31

In this engaging essay, Wrong discusses the ironic, playful way in which Africans can appropriate Western culture and make it their own. The sapeurs of the Congo are young men with little money but lots of style. They all own a few items of Western designer clothing but swap with each other so that everyone can be dressed in the latest fashions when they hit the dance halls, where the moves they invent to show off their clothes are copied throughout Africa.

Zhang, Boli

Escape from China: The Long Journey from Tiananmen to Freedom
NEW YORK: WASHINGTON SQUARE PRESS, 2002

This is the story of a leader of the 1989 student uprising that led to the Tiananmen Square massacre and his subsequent escape, via Russia, to the United States, where he became an inspirational speaker. It stands as testimony to America as a symbol of democracy but also reveals, inadvertently, the way in which the country is a crass commercializer of human suffering.

II.
Journalism as the First Draft of History

During the last decade, much of the American media concluded that the big stories were happening at home: technology, the stock market, the Monica Lewinsky scandal. The world, by comparison, seemed a distant, slow-moving place full of irresolvable conflicts in which America would be only briefly engaged before moving on. As a result, international coverage by the American media declined and its character changed. In an effort to engage a public increasingly disinterested in foreign news, editors recast much of their international coverage to reflect domestic political concerns: treatment of minority Christian or Jewish communities, women's rights, race, democracy, economic liberalization, etc. These are important issues, but they represent fundamentally American priorities. Fortunately, the Internet has revolutionized the flow of information, and now the world's newspapers and magazines can be accessed right from one's desk. Most such publications reflect a local perspective on global issues and offer a greater level of detail on the issues affecting its surrounding region. In English, unless otherwise indicated.

United States

The New York Review of Books
HTTP://WWW.NYBOOKS.COM

It is a rare American forum for extended international debate among policymakers and intellectuals, primarily from Europe, America, and the Middle East.

SELECTED BIBLIOGRAPHY

Transition
HTTP://WWW.TRANSITIONMAGAZINE.COM

Founded in Uganda in 1961 as the primary continent-wide forum for debate about decolonization, *Transition* is now published out of Harvard and is a unique specimen among American journals, offering sassy, engaging, eye-opening essays about culture by writers from around the world, with a particular emphasis on Africa.

Europe

BBC News
UNITED KINGDOM, HTTP://NEWS.BBC.CO.UK

The legendary BBC service runs an excellent online news site that covers the world in-depth. It also maintains one of the most extensive world news archives still accessible without charge.

The Economist
UNITED KINGDOM, HTTP://WWW.ECONOMIST.COM

Regarded as the best single source of world news in the English language and the only publication that manages to be both global and local on a range of subjects far broader than its title would suggest, extending from politics and business to science and culture.

The Guardian
UNITED KINGDOM, HTTP://WWW.GUARDIAN.CO.UK

When Europeans argue there is no true Left in American politics, the editorial views of *The Guardian* are what they believe is missing.

Libération
FRANCE, HTTP://WWW.LIBERATION.FR

The organ of the French Left and generally somewhat skeptical of American intentions in the world, *Libération* is arguably the best of the French newspapers. In French.

Le Monde diplomatique
FRANCE, HTTP://MONDEDIPLO.COM

The newspaper of the French establishment, it exudes appropriate gravitas. An abbreviated version is available in English.

Middle East and Africa

The Cairo Times
EGYPT, HTTP://WWW.CAIROTIMES.COM

It is the best English-language news magazine in the Arab world and a bastion of independent journalism. Selections from each issue are available online.

Mail & Guardian
SOUTH AFRICA, HTTP://WWW.MG.CO.ZA

The first newspaper in Africa to have an online edition, with extensive coverage of southern Africa and beyond.

Ha'aretz
ISRAEL, HTTP://WWW.HAARETZDAILY.COM

The most important Left-leaning newspaper in Israel, *Ha'aretz* is an invaluable source for news on the region.

Al Jazeera
QATAR, HTTP://WWW.ALJAZEERA.NET

Although demonized by the Bush administration for airing tapes of Osama bin Laden, this satellite channel is actually the news source that most embodies the professed "American" value of free expression in a region dominated by submissive state-owned media. *Al Jazeera* offers a critical, outspoken view of almost every leader and hot-button social issue in the Middle East. In Arabic, with plans for an English-language service (HTTP://WWW.ENGLISH.ALJAZEERA.NET).

Jerusalem Post
ISRAEL, HTTP://WWW.JPOST.COM

It is one of the leading newspapers of the Israeli Right, taking a hard-line view on settlements and the Palestinians.

Asia

Far Eastern Economic Review
HONG KONG, HTTP://WWW.FEER.COM

A weekly magazine primarily focused on business in Asia, it offers extensive region-wide coverage.

The Nation
THAILAND, HTTP://WWW.NATIONMULTIMEDIA.COM

One of the leading newspapers in the only country in Southeast Asia with a tradition of independent journalism. Except for coverage of the Thai royal family, everything is fair game.

New Straits Times
MALAYSIA, HTTP://WWW.NSTP.COM.MY

The official paper of a government long dedicated to taking an independent line on globalization and America's presence in the world.

The Times of India
INDIA, HTTP://TIMESOFINDIA.INDIATIMES.COM

It is the grand dame of Indian newspapers. No longer the most vibrant, but still the paper of record.

Latin America

Reforma
MEXICO, HTTP://WWW.REFORMA.COM

The leading Mexico City newspaper, *Reforma* is from the group that pioneered independent journalism in Mexico. In Spanish.

Buenos Aires Herald
ARGENTINA,
HTTP://WWW.BUENOSAIRESHERALD.COM

Founded in 1876 and one of the few substantial English-language newspapers in South America, it offers coverage of Argentina and the world.

Works in the Exhibition

Dimensions are in inches followed by centimeters; height precedes width precedes depth.

Sergei Bugaev Afrika

Dream Machine, 2002
Mixed-media installation, dimensions variable.
COLLECTION OF THE ARTIST

Makoto Aida

A Picture of an Air Raid on New York City (War Picture Returns), 1996
Six-panel folding screen, hinges, black-and-white photocopy on hologram paper (produced by Nihon Keizai Shinbun), charcoal, watercolor, acrylic, oil marker correction fluid, and graphite, 66-9/16 x 148-13/16 x 1-3/16 (169 x 378 x 3) unfolded.
COLLECTION OF RYUTARO TAKAHASHI

Chantal Akerman

From the Other Side, 2002
Video, color, sound; 99 min.
COURTESY FIRST RUN/ICARUS FILMS, BROOKLYN, NEW YORK

Siemon Allen

Newspapers, 2002–03
Newspapers, tracing paper, polystyrene, cloth, and pins, dimensions variable
COLLECTION OF THE ARTIST;
COURTESY FUSEBOX, WASHINGTON, D.C.

Gilles Barbier

Nursing Home, 2002
Mixed-media installation with wax sculptures, dimensions variable
COLLECTION OF MARTIN Z. MARGULIES

Stephanie Black

Life and Debt, 2001
35mm film transferred to DVD, color, sound; 86 min.
COURTESY NEW YORKER FILMS, NEW YORK

The Builders Association and motiroti

How to Neuter the Mother Tongue, 2003, excerpt from ALLADEEN
Video, color, sound; 17 min.
COURTESY THE ARTISTS

Gerard Byrne

why it's time for Imperial, again, 1998–2000
Video installation with five chromogenic color prints, chairs, media stand, monitor, and platform, dimensions variable
COLLECTION OF THE ARTIST

Anita W. Chang

She Wants to Talk to You, 2001
16mm film transferred to DVD, color, sound; 29 min.
COURTESY WOMEN MAKE MOVIES, NEW YORK

Patricia Clark, Meira Marrero Díaz, and José Angel Toirac

The Golden Age, 2000
Three-channel video, color, sound; 11 min.
COLLECTION OF THE ARTISTS;
COURTESY ARIZONA STATE UNIVERSITY ART MUSEUM AND THE INSTITUTE FOR STUDIES IN THE ARTS, TEMPE

WORKS IN THE EXHIBITION

Arno Coenen

The Last Road Trip, 2000
Computer animation, color, sound;
18 min.
COLLECTION OF THE ARTIST;
COURTESY NETHERLANDS MEDIA ART
INSTITUTE, AMSTERDAM, AND EUROPEAN
MEDIA ART FESTIVAL, OSNABRÜCK,
GERMANY

Gail Dolgin and Vicente Franco

Daughter from Danang, 2002
35mm film transferred to DVD, color,
sound; 81 min.
COURTESY BALCONY RELEASING, BOSTON,
MASSACHUSETTS

Alfredo Esquillo, Jr.

MaMcKinley, 2001
Oil on canvas, 48 x 36 (122 x 91.4)
COLLECTION OF KIM ATIENZA

Fiona Foley

Wild Times Call 2, 2001
Chromogenic color print,
33 x 44 (84 x 102)
COLLECTION OF THE ARTIST;
COURTESY ROSLYN OXLEY9 GALLERY,
SYDNEY, AUSTRALIA

Wild Times Call 6, 2001
Chromogenic color print,
44 x 33 (102 x 84)
COLLECTION OF THE ARTIST;
COURTESY ROSLYN OXLEY9 GALLERY,
SYDNEY, AUSTRALIA

Andrea Geyer

Interim, 2002
Installation with newspapers,
dimensions variable
COLLECTION OF THE ARTIST

Veli Granö

A Strange Message from Another
Star, 1998
35mm film transferred to DVD,
black-and-white, sound; 30 min.
COURTESY THE ARTIST

Yongsuk Kang

Untitled, *from the series*
"Maehyang-ri," 1999
Gelatin silver print, 20 x 24 (50.8 x 61)
COLLECTION OF THE ARTIST

Untitled, *from the series*
"Maehyang-ri," 1999
Gelatin silver print, 20 x 24 (50.8 x 61)
COLLECTION OF THE ARTIST

Untitled, *from the series*
"Maehyang-ri," 1999
Gelatin silver print, 20 x 24 (50.8 x 61)
COLLECTION OF THE ARTIST

Untitled, *from the series*
"Maehyang-ri," 1999
Gelatin silver print, 20 x 24 (50.8 x 61)
COLLECTION OF THE ARTIST

Untitled, *from the series*
"Maehyang-ri," 1999
Gelatin silver print, 20 x 24 (50.8 x 61)
COLLECTION OF THE ARTIST

Untitled, *from the series*
"Maehyang-ri," 1999
Gelatin silver print, 20 x 24 (50.8 x 61)
COLLECTION OF THE ARTIST

Untitled, *from the series*
"Maehyang-ri," 1999
Gelatin silver print, 20 x 24 (50.8 x 61)
COLLECTION OF THE ARTIST

Untitled, *from the series*
"Maehyang-ri," 1999
Gelatin silver print, 20 x 24 (50.8 x 61)
COLLECTION OF THE ARTIST

Untitled, *from the series*
"Maehyang-ri," 1999
Gelatin silver print, 20 x 24 (50.8 x 61)
COLLECTION OF THE ARTIST

Untitled, *from the series*
"Maehyang-ri," 1999
Gelatin silver print, 20 x 24 (50.8 x 61)
COLLECTION OF THE ARTIST

Bodys Isek Kingelez

New Manhattan City 3021, 2002
Mixed media, 80-3/4 x 118-1/8 x
110-1/4 (205 x 300 x 280)
CONTEMPORARY AFRICAN ART COLLECTION
THE PIGOZZI COLLECTION, GENEVA,
SWITZERLAND

Pawel Kruk

Larger Than Life, 2000
Video, black-and-white, sound;
9 min.
COLLECTION OF THE ARTIST

Andreja Kulunčić

Distributive Justice: America, 2003
Installation with website,
dimensions variable
HTTP://WWW.DISTRIBUTIVE-JUSTICE.COM/
AMERICA
COURTESY ARTSLINK INDEPENDENT
PROJECT, PROGRAM OF CEC INTERNATIONAL
PARTNERS, NEW YORK; AND THE NEW
MEDIA DEPARTMENT, WALKER ART CENTER,
MINNEAPOLIS, MINNESOTA

Jannicke Låker

No. 17, 1997
Video, color, sound; 11 min.
COLLECTION OF THE ARTIST

Ane Lan

Amerika, 2002
Video, color, sound; 3 min.
COLLECTION OF THE ARTIST

Cristóbal Lehyt

Arrest, 2003
Dual slide projection, wooden shelf,
ink wall drawings with text,
dimensions variable
COLLECTION OF THE ARTIST

WORKS IN THE EXHIBITION

Mark Lewis

Jay's Garden, Malibu, 2001

Installation with wood screen,
35mm film transferred to DVD, color,
dimensions variable; 5 min.
MUSÉE D'ART MODERNE GRAND-DUC JEAN,
LUXEMBOURG

Amina Mansour

Vitrine 1 Chapter 1–5, 1998–99

Wood, porcelain, bronze, cotton,
fabric, and glass, 68-7/8 x 69-11/16
x 26-5/16 (175 x 117 x 76)
COLLECTION OF THE ARTIST

Maria Marshall

President Bill Clinton, Memphis,
November 13, 1993, 2000

Installation with 16mm film
transferred to DVD, color, sound,
dimensions variable; 3 min.
COLLECTION OF WILLIAM AND RUTH TRUE;
COURTESY TEAM GALLERY, NEW YORK

Bjørn Melhus

America Sells, 1990

Video, color, sound; 7 min.
COLLECTION OF THE ARTIST;
COURTESY ROEBLING HALL, BROOKLYN,
NEW YORK; AND GALERIE ANITA BECKERS,
FRANKFURT, GERMANY

Far Far Away, 1995

16mm film transferred to DVD, color,
sound; 39 min.
COLLECTION OF THE ARTIST;
COURTESY ROEBLING HALL, BROOKLYN,
NEW YORK; AND GALERIE ANITA BECKERS,
FRANKFURT, GERMANY

Zoran Naskovski

Death in Dallas, 2000

Installation with album cover and
video projection, black-and-white,
color, sound, dimensions variable;
17 min.
COLLECTION OF THE ARTIST

Olu Oguibe

Twenty-two drawings from the suite
Ethnographia 2.1: Drawings,
from the series "Trilogy," 2000

Ink on paper, 9 x 11 (22.9 x 27.9)
each, orientation variable.
COLLECTION OF THE ARTIST

Marlo Poras

Mai's America, 2002

Video, color, sound; 72 min.
COURTESY WOMEN MAKE MOVIES,
NEW YORK

Muhammad Imran Qureshi

God of Small Things, 2002

Gouache and transfer type on wasli
paper, 10-13/16 x 9-1/16 (27.5 x 23)
COLLECTION OF THE ARTIST

None of Your Business I, 2002

Gouache and transfer type on wasli
paper, 11-7/16 x 8-1/4 (29 x 21)
COLLECTION OF THE ARTIST

Take It or Leave It, 2002

Gouache, gold leaf, and transfer type
on wasli paper, 10-1/4 x 6-11/16 (26 x 17)
COLLECTION OF THE ARTIST;
COURTESY CORVI-MORA, LONDON,
UNITED KINGDOM

To Be or Not to Be, 2002

Gouache and transfer type on wasli
paper, 7-7/8 x 7-1/2 (20 x 19)
COLLECTION OF ANITA AND HAMMAD NASAR

Sandeep Ray

Leaving Bakul Bagan, 1994

Video, color, sound; 45 min.
COURTESY THIRD WORLD NEWSREEL,
NEW YORK

Andrea Robbins and Max Becher

Blonde, *from the series "German
Indians,"* 1997–98

Chromogenic color print,
30 x 25-3/8 (76.4 x 64.4)
COLLECTION OF THE ARTISTS;
COURTESY SONNABEND GALLERY, NEW YORK

Chief, *from the series "German
Indians,"* 1997–98

Chromogenic color print,
30 x 25-3/8 (76.4 x 64.4)
COLLECTION OF THE ARTISTS;
COURTESY SONNABEND GALLERY, NEW YORK

Knife Thrower, *from the series
"German Indians,"* 1997–98

Chromogenic color print,
30 x 25-3/8 (76.4 x 64.4)
COLLECTION OF THE ARTISTS;
COURTESY SONNABEND GALLERY, NEW YORK

Meeting, *from the series "German
Indians,"* 1997–98

Chromogenic color print,
30-3/8 x 35-1/8 (77.4 x 89.4)
COLLECTION OF THE ARTISTS;
COURTESY SONNABEND GALLERY, NEW YORK

Johnson Drugstore, *from the series
"Wall Street in Cuba,"* 1993

Chromogenic color print,
27-15/16 x 32-1/4 (82 x 71)
COLLECTION OF THE ARTISTS;
COURTESY SONNABEND GALLERY, NEW YORK

Trust Company Building, *from the
series "Wall Street in Cuba,"* 1993

Chromogenic color print,
27-15/16 x 32-1/4 (82 x 71)
COLLECTION OF THE ARTISTS;
COURTESY SONNABEND GALLERY, NEW YORK

Miguel Angel Rojas

Bratatata, 2001

Coca-leaf cutouts on paper,
19-11/16 x 27-9/16 (50 x 70)
COLLECTION OF THE ARTIST

Go On, 1999

Coca-leaf cutouts on paper,
19-11/16 x 27-9/16 (50 x 70)
COLLECTION OF THE ARTIST

It's Better To Be Rich Than Poor, 2001

Dollar-bill and coca-leaf cutouts
on paper, diptych,
19-11/16 x 55-1/8 (50 x 140)
COLLECTION OF THE ARTIST

Mola, 2001

Dollar-bill cutouts on paper,
19-11/16 x 27-9/16 (50 x 70)
COLLECTION OF THE ARTIST

WORKS IN THE EXHIBITION

Sherine Salama

A Wedding in Ramallah, 2002
> Video, color, sound; 91 min.
> COURTESY HABIBI FILMS,
> SYDNEY, AUSTRALIA

Ousmane Sow

The Death of Custer *from the series
"The Battle of Little Big Horn,"* 1998
> Mixed media, two parts, 49-3/16 x
> 43-5/16 x 90-9/16 (125 x 110 x 230)
> and 35-7/16 x 37-3/8 x 90-9/16
> (90 x 95 x 230)
> COLLECTION OF THE ARTIST

Sitting Bull at Prayer *from the series
"The Battle of Little Big Horn,"* 1998
> Mixed media, 80-11/16 x 41-5/16 x
> 59-1/16 (205 x 105 x 150)
> COLLECTION OF THE ARTIST

The Unseated Cavalryman *from the
series "The Battle of Little Big
Horn,"* 1998
> Mixed media, 66-15/16 x 74-13/16 x
> 88-9/16 (170 x 190 x 225)
> COLLECTION OF THE ARTIST

Wounded Indian *from the series
"The Battle of Little Big Horn,"* 1998
> Mixed media, 57-1/16 x 55-1/8 x
> 41-5/16 (145 x 140 x 105)
> COLLECTION OF THE ARTIST

Heiner Stadler

Eat, Sleep, No Women, 2002
> 35mm film transferred to DVD, color,
> sound; 76 min.
> COURTESY THE ARTIST

JT Orinne Takagi and Hye Jung Park

The Women Outside, 1995
> Video and 16mm transferred to DVD,
> color, sound; 60 min.
> COURTESY THIRD WORLD NEWSREEL,
> NEW YORK

Hisashi Tenmyouya

Bush vs. Bin Laden, 2001, *from the
series "Legendary Warriors,"* 2000–02
> Acrylic on paper, 10-7/16 x 6-7/8
> (26.5 x 17.5)
> COLLECTION OF THE ARTIST;
> COURTESY ASANO LABORATORIES, INC.,
> TOKYO, JAPAN

Black Ships, Atomic Bombs, and the
Greenville, 2001, *from the series
"Legendary Warriors,"* 2000–02
> Acrylic on paper, 10-7/16 x 6-7/8
> (26.5 x 17.5)
> COLLECTION OF THE ARTIST;
> COURTESY ASANO LABORATORIES, INC.,
> TOKYO, JAPAN

Tattoo Man's Battle, 1996,
*preliminary sketch for the series
"Legendary Warriors,"* 2000–02
> Acrylic on wood, 23-5/8 x 16-1/4
> (60 x 41.3)
> COLLECTION OF ASANO LABORATORIES, INC.,
> TOKYO, JAPAN

Zhou Tiehai

LIBERTAS, DEI TE SERVENT!, 2002
> Acrylic on canvas and elephant
> dung, 99-5/8 x 78-3/4 (253 x 200)
> COLLECTION OF THE ARTIST;
> COURTESY SHANGHART, SHANGHAI, CHINA

Saira Wasim

Friendship After 11 September 1,
from the series "Bush," 2002
> Gouache on wasli paper,
> 11-13/16 x 6-1/2 (30 x 16.5)
> COLLECTION OF KOLI BANIK

Friendship After 11 September 2,
from the series "Bush," 2002
> Gouache on wasli paper,
> 10-1/4 x 6-1/2 (26 x 16.5)
> COLLECTION OF THE ARTIST

History till 11 September,
from the series "Bush," 2002
> Gouache on wasli paper,
> 10-1/4 x 6-1/2 (26 x 16.5)
> COLLECTION OF THE ARTIST

The Kiss, *from the series
"Pervez Musharraf,"* 2002
> Gouache on wasli paper,
> 10-7/16 x 6-1/2 (26.5 x 16.5)
> COLLECTION OF SHELAGH CLUETT

Danwen Xing

Untitled, *from the series
"disCONNEXION,"* 2003
> Chromogenic color print,
> 58-1/4 x 47-1/4 (148 x 120)
> COLLECTION OF THE ARTIST

Untitled, *from the series
"disCONNEXION,"* 2003
> Chromogenic color print,
> 58-1/4 x 47-1/4 (148 x 120)
> COLLECTION OF THE ARTIST

Untitled, *from the series
"disCONNEXION,"* 2003
> Chromogenic color print,
> 58-1/4 x 47-1/4 (148 x 120)
> COLLECTION OF JGS, INC., NEW YORK

Untitled, *from the series
"disCONNEXION,"* 2003
> Chromogenic color print,
> 58-1/4 x 47-1/4 (148 x 120)
> WHITNEY MUSEUM OF AMERICAN ART,
> NEW YORK; PURCHASE, WITH FUNDS FROM
> THE PHOTOGRAPHY COMMITTEE 2003.100

Untitled, *from the series
"disCONNEXION,"* 2003
> Chromogenic color print,
> 58-1/4 x 47-1/4 (148 x 120)
> WHITNEY MUSEUM OF AMERICAN ART,
> NEW YORK; PROMISED GIFT OF KATHRYN
> FLECK T.2003.16

Miwa Yanagi

Yuka, 2000, *from the series
"My Grandmothers,"* 2000–
> Chromogenic color print mounted
> on aluminum, 63 x 63 (160 x 160)
> COLLECTION OF LINDA PACE

YOUNG-HAE CHANG HEAVY INDUSTRIES

Dakota, 2002
> Computer animation, black-and-white,
> sound; 6 min.
> COLLECTION OF THE ARTISTS

Artists' Biographies

All citations are selected

Sergei Bugaev Afrika

Born in Novorossisk, Soviet Union, 1966
Lives in St. Petersburg, Russia

One-Artist Exhibitions

I-20 GALLERY, NEW YORK, "Stalker 3," 2002
VENICE BIENNALE, ITALY, 1999
I-20 GALLERY, NEW YORK,
 "Rebus II: Works on Copper," 1997
MAK-AUSTRIAN MUSEUM OF APPLIED ARTS,
 VIENNA, AUSTRIA,
 "Sergei Bugaev Afrika. Krimania:
 Monuments, Icons, Mazafaka," 1995
THE LENIN MUSEUM, LENINGRAD, SOVIET UNION,
 "Donaldestruction," 1990
 (WITH SERGEI ANUFRIEV; TRAVELED TO
 SOUTHERN EXPOSURE AT PROJECT ARTAUD,
 SAN FRANCISCO, CALIFORNIA, 1991;
 INSTITUTE FOR CONTEMPORARY ART,
 CLOCKTOWER GALLERY, NEW YORK, 1991;
 THE POWER PLANT CONTEMPORARY ART
 GALLERY, TORONTO, CANADA, 1991;
 CRDC, L'ESPACE GRASLIN, NANTES, FRANCE,
 1991)

Group Exhibitions

FIRST VALENCIA BIENNIAL, SPAIN, 2001
STEDELIJK MUSEUM, AMSTERDAM,
 THE NETHERLANDS, "Kabinet," 1997
STADTGALERIE IM SOPHIENHOF, KIEL, GERMANY,
 "Self-Identification: Positions in St.
 Petersburg Art from 1970 until today,"
 1994–95 (TRAVELED TO HAUS AM WALDSEE,
 BERLIN, GERMANY,1995;
 THE NATIONAL MUSEUM OF CONTEMPORARY
 ART, OSLO, NORWAY, 1995;
 THE STATE ART GALLERY SOPOT, POLAND,
 1995;
 CENTRAL EXHIBITION HALL MANEGE, ST.
 PETERSBURG, RUSSIA, 1995;
 SOPHIENHOLM, LYNGBY, DENMARK, 1996)
STATE RUSSIAN MUSEUM, ST. PETERSBURG, RUSSIA,
 "The Evolution of Image: Light,
 Sound and Material," 1996
MUSEO NACIONAL CENTRO DE ARTE REINA SOFÍA,
 MADRID, SPAIN, "Cocido y Crudo," 1994–95

Makoto Aida

Born in Niigata, Japan, 1965
Lives in Tokyo, Japan

One-Artist Exhibitions

MURATA & FRIENDS, BERLIN, GERMANY,
 "Edible Artificial Girls, Mi-Mi Chan,"
 2001
NADIFF, TOKYO, JAPAN,
 "Edible Artificial Girls, Mi-Mi Chan,"
 2001
MITSUBISHI-JISHO ARTIUM, FUKUOKA, JAPAN,
 "DOUTEI," 1999
MIZUMA ART GALLERY, TOKYO, JAPAN,
 "Men's Liquar–Millennium," 1999
GALLERY NATSUKA, TOKYO, JAPAN,
 "War Picture RETURNS," 1996

Group Exhibitions

FONDATION CARTIER POUR L'ART CONTEMPORAIN,
 PARIS, FRANCE, "Coloriage," 2002
HIROSHIMA CITY MUSEUM OF CONTEMPORARY
 ART, JAPAN, 2002
SUNGKOK ART MUSEUM, SEOUL, SOUTH KOREA,
 "eleven&eleven: Korea Japan
 Contemporary Art 2002," 2002
SÃO PAULO BIENNALE, BRAZIL, 2002
KANAGAWA, JAPAN,
 "Yokohama 2001: International Triennale
 of Contemporary Art," 2001

ARTISTS' BIOGRAPHIES

Chantal Akerman

Born in Brussels, Belgium, 1950
Lives in Paris, France

Film Projects

From the Other Side, 2002
South, 1999
The Prisoner, 1997
(WITH ERIC DE KUYPER)
A Couch in New York, 1996
(WITH JEAN-LOUIS BENOÎT)
A Portrait of a Young Girl at the End of the
1960s in Brussels, 1993

Group Exhibitions

DOCUMENTA 11, KASSEL, GERMANY, 2002
VENICE BIENNALE, ITALY, 2001

Screenings

INTERNATIONAL FILM FESTIVAL, ROTTERDAM,
THE NETHERLANDS, 2003
CANNES FILM FESTIVAL, FRANCE, 2002
THE FILM SOCIETY OF LINCOLN CENTER,
WALTER READE THEATER, NEW YORK, 2002

Siemon Allen

Born in Durban, South Africa, 1971
Lives in Washington, D.C.

One-Artist Exhibitions

FUSEBOX, WASHINGTON, D.C.,
"Newspapers," 2002
HEMICYCLE AT THE CORCORAN COLLEGE OF ART
AND DESIGN, WASHINGTON, D.C.,
"Stamp Collection: Imaging South
Africa," 2001
GALLERY 400, UNIVERSITY OF ILLINOIS, COLLEGE
OF ARCHITECTURE AND THE ARTS, CHICAGO,
"House," 2000
FLAT GALLERY, DURBAN, SOUTH AFRICA,
"Songs for Nella," 1994

Group Exhibitions

ARTISTS SPACE, NEW YORK,
"Context and Conceptualism," 2002
THE RENAISSANCE SOCIETY, CHICAGO,
"Detourism," 2001
KULTURHUSET, STOCKHOLM, SWEDEN,
"Dreams and Clouds: Contemporary Art
from the New South Africa," 1998
JOHANNESBURG BIENNALE, SOUTH AFRICAN
NATIONAL GALLERY, CAPE TOWN, SOUTH
AFRICA, "Graft," 1997

Gilles Barbier

Born in Port Villa, Vanuatu, 1965
Lives in Marseille, France

One-Artist Exhibitions

GALERIE GEORGES-PHILIPPE & NATHALIE VALLOIS,
PARIS, FRANCE,
"Le bénévolat dans l'action," 2001
RENA BRANSTEN GALLERY, SAN FRANCISCO,
CALIFORNIA, 2001
GALERIES CONTEMPORAINES DES MUSÉES DE
MARSEILLE, FRANCE,
"Pique-nique au bord du chemin," 2001
SANTA BARBARA MUSEUM OF ART, CALIFORNIA,
"Copywork: The Dictionary Pages and
Other Diversions," 1999
HENRY ART GALLERY, UNIVERSITY OF WASHINGTON,
SEATTLE,
"The pack of transschizophrenic clones,"
1999 (TRAVELED TO MUSÉE DE L'ABBAYE
SAINTE-CROIX, LES SABLES D'OLONNE,
FRANCE, 2000)

Group Exhibitions

PORI ART MUSEUM, FINLAND,
"Transformer," 2002
MUSÉE D'ART CONTEMPORAIN DE MONTRÉAL,
CANADA,
"Métamorphoses et clonage," 2001
WHITE BOX, NEW YORK,
"Political Ecology: Five Artists from
France," 2001
DESTE FOUNDATION CENTRE FOR CONTEMPORARY
ART, ATHENS, GREECE,
"Tongue in Cheek: Six Contemporary
French Artists," 2000
VENICE BIENNALE, ITALY, 1999

Stephanie Black

Born in New York
Lives in New York

Film Projects

Life and Debt, 2002
(DIRECTOR AND PRODUCER)
Incident at Oglala, 1992
(CHIEF RESEARCHER AND SECOND UNIT
DIRECTOR)
H-2 Worker, 1990
(DIRECTOR AND PRODUCER)

Screenings

ONE WORLD: INTERNATIONAL HUMAN RIGHTS FILM
FESTIVAL, PRAGUE, THE CZECH REPUBLIC,
2002
HUMAN RIGHTS WATCH INTERNATIONAL FILM
FESTIVAL, NEW YORK, 2001
LOS ANGELES FILM FESTIVAL, CALIFORNIA, 2001
CANNES FILM FESTIVAL, FRANCE, 1990
SUNDANCE FILM FESTIVAL, UTAH, 1990

The Builders Association

(Marianne Weems, artistic director)
Founded in 1994, New York

Theater Projects

ALLADEEN, 2002–04
(COLLABORATION WITH **MOTI**ROTI)
Xtravaganza, 2000–02
Jet Lag, 1998–2000
(COLLABORATION WITH DILLER + SCOFIDIO)
Jump Cut (Faust), 1998
Imperial Motel (Faust), 1997

Performance Venues

BROOKLYN ACADEMY OF MUSIC, NEW YORK,
2003 (ALLADEEN)
ST. ANN'S WAREHOUSE, BROOKLYN, NEW YORK,
2002 (Xtravaganza)
BARBICAN CENTRE, LONDON, UNITED KINGDOM,
2000 (Jet Lag)
THREAD WAXING SPACE, NEW YORK, 1998
(Jump Cut, Faust)
THEATER NEUMARKT, ZURICH, SWITZERLAND,
1997 (Imperial Motel, Faust)

Gerard Byrne

Born in Dublin, Ireland, 1969
Lives in Dublin, Ireland

One-Artist Exhibitions

DOUGLAS HYDE GALLERY, DUBLIN, IRELAND,
 "Herald or Press," 2002
LIMERICK CITY GALLERY OF ART, IRELAND,
 "Gerard Byrne: Op-Ed," 2002
T19-GALERIE FÜR ZEITGENÖSSISCHE KUNST,
 VIENNA, AUSTRIA,
 "Gerard Byrne: Theatre," 2000
GREEN ON RED GALLERY, DUBLIN, IRELAND,
 "Theater-Bunker-Archive," 1999
GALERIA MONUMENTAL, LISBON, PORTUGAL, 1993

Group Exhibitions

MANIFESTA 4: EUROPEAN BIENNIAL OF CONTEM-
 PORARY ART, FRANKFURT, GERMANY, 2002
IRISH MUSEUM OF MODERN ART, DUBLIN,
 IRELAND, "How things turn out," 2002
GALE GATES ET AL., BROOKLYN, NEW YORK,
 "The Light Show," 2001
NIKOLAJ, COPENHAGEN CONTEMPORARY ART
 CENTER, DENMARK,
 "New Settlements," 2001
ART IN GENERAL, NEW YORK,
 "Spaceship Earth," 1999

Anita W. Chang

Born in Morgantown, West Virginia, 1967
Lives in San Francisco, California

Film Projects

An Elegy to Our Small Selves, 2002
She Wants to Talk to You, 2001
Imagining Place, 1999
Mommy, What's Wrong?, 1997
One Hundred Eggs a Minute, 1996

Screenings

ANN ARBOR FILM FESTIVAL, MICHIGAN, 2002
ASIAN AMERICAN INTERNATIONAL FILM FESTIVAL,
 NEW YORK, 2002
ATHENS INTERNATIONAL FILM AND VIDEO FESTIVAL,
 OHIO, 2002
LOS ANGELES ASIAN PACIFIC FILM AND VIDEO
 FESTIVAL, CALIFORNIA, 2002
WOMEN OF COLOR FILM FESTIVAL, BERKELEY,
 CALIFORNIA, 2002

Patricia Clark

Born in Detroit, Michigan, 1956
Lives in Tempe, Arizona

Group Exhibitions

ARIZONA STATE UNIVERSITY ART MUSEUM, TUCSON,
 "Contemporary Art from Cuba: Irony
 and Survival on the Utopian Island,"
 1998 (TRAVELED TO MUSEUM OF LATIN
 AMERICAN ART, LONG BEACH, CALIFORNIA,
 1998;
 UNIVERSITY ART MUSEUM, UNIVERSITY OF
 CALIFORNIA, SANTA BARBARA, 1998;
 SPENCER MUSEUM OF ART, LAWRENCE,
 KANSAS, 1998;
 UNIVERSITY OF SOUTH FLORIDA CONTEMPO-
 RARY ART MUSEUM, TAMPA, 1998)
SCOTTSDALE CENTER FOR THE ARTS, ARIZONA,
 2001

Arno Coenen

Born in Deventer, The Netherlands, 1972
Lives in Amsterdam, The Netherlands

Group Exhibitions

EUROPEAN MEDIA ART FESTIVAL,
 OSNABRÜCK, GERMANY, 2003
DE APPEL CENTRE OF CONTEMPORARY ART,
 AMSTERDAM,
 "Cinema, Sounds, Synergy," 2002
DUTCH ELECTRONIC ARTS FESTIVAL,
 ROTTERDAM, THE NETHERLANDS, 2000
KIASMA, HELSINKI, FINLAND,
 "Alien Intelligence," 2000
PICAF, PUSAN, SOUTH KOREA, 2000

Meira Marrero Díaz

Born in Havana, Cuba, 1969
Lives in Havana, Cuba

Exhibitions

UNIVERSITY OF KENTUCKY ART MUSEUM,
 LEXINGTON, "Miradas y Silencios," 2001
ART IN GENERAL, NEW YORK,
 "Think Different," 2002
 (WITH JOSÉ ANGEL TOIRAC)
CENTRO DE DESARROLLO DE LAS ARTES
 VISUALES, HAVANA, CUBA,
 "En Rojo y Negro," 2001
 (WITH JOSÉ ANGEL TOIRAC AND
 RICARDO G. ELIAS)

Gail Dolgin

Born in Brooklyn, New York, 1945
Lives in Berkeley, California

Film Projects

Daughter from Danang, 2002
 (PRODUCER AND CO-DIRECTOR)
Cuba VA: The Challenge of the Next
 Generation, 1993
 (CO-PRODUCER, CO-DIRECTOR, CO-EDITOR)
Forever Activists: Stories of the Veterans
 of the Abraham Lincoln Brigade, 1991
 (ASSOCIATE PRODUCER)
New Bridges, 1990
 (CO-PRODUCER, CO-DIRECTOR, EDITOR)
Face to Face: U.S. Teenagers Tour
 Nicaragua, 1989
 (CO-PRODUCER, CO-DIRECTOR, CO-EDITOR)

Screenings

AMSTERDAM INTERNATIONAL DOCUMENTARY FILM
 FESTIVAL, THE NETHERLANDS, 2002
NEW DIRECTORS/NEW FILMS, FILM SOCIETY OF
 LINCOLN CENTER, NEW YORK, 2002
SAN FRANCISCO INTERNATIONAL FILM FESTIVAL,
 CALIFORNIA, 2002
SUNDANCE FILM FESTIVAL, UTAH, 2002
HOT DOCS CANADIAN INTERNATIONAL
 DOCUMENTARY FESTIVAL, TORONTO, 2002

Alfredo Esquillo, Jr.

Born in Quezon City, Philippines, 1972
Lives in Cavite, Philippines

One-Artist Exhibitions

FUKUOKA ASIAN ART MUSEUM, JAPAN,
 "Trip to Heaven," 2001
WEST GALLERY, MANDALUYONG CITY,
 PHILIPPINES, "Banig Icons," 2001
RED MILL GALLERY, VERMONT STUDIO CENTER,
 JOHNSON, "Recent Works," 1999
HIRAYA GALLERY, MANILA, PHILIPPINES,
 "Masa Kultura," 1997

Group Exhibitions

CULTURAL CENTER OF THE PHILIPPINES,
 BULWAGANG JUAN LUNA,
 "Anting—Anting," 2002
THE JAPAN FOUNDATION FORUM/TOKYO OPEN CITY
 ART GALLERY, JAPAN,
 "Under Construction: New Dimensions of
 Asian Art," 2002
SAKSHI GALLERY, BOMBAY, INDIA,
 "Clicking into Place," 2002
EARL LU GALLERY LASALLE SIA COLLEGE OF THE
 ARTS, SINGAPORE,
 "Faith + the City: A Survey of
 Contemporary Filipino Art," 2000
 (TRAVELED TO NATIONAL ART GALLERY,
 KUALA LUMPUR, MALAYSIA, 2001;
 ABN AMRO HOUSE, PENANG, MALAYSIA,
 2001)
ASIAN ART MUSEUM OF SAN FRANCISCO,
 CALIFORNIA,
 "At Home & Abroad: Twenty
 Contemporary Filipino Artists," 1998
 (TRAVELED TO UNIVERSITY OF HAWAII AT
 MANOA ART GALLERY, MANOA, 1998;
 CONTEMPORARY ARTS MUSEUM, HOUSTON,
 1999;
 DIVERSEWORKS ARTSPACE, HOUSTON, 1999)

Fiona Foley

Born in Maryborough, Queensland,
Australia, 1964
Lives in Hervey Bay, Queensland,
Australia

One-Artist Exhibitions

ROSLYN OXLEY9 GALLERY, SYDNEY, AUSTRALIA,
 "Fiona Foley: Wild Times Call," 2002
QUEENSLAND ART GALLERY, BRISBANE, AUSTRALIA,
 "Fiona Foley: Pir'ri-Mangrove," 2001
CONTEMPORARY ART MUSEUM, UNIVERSITY OF
 SOUTH FLORIDA, TAMPA,
 "Fiona Foley: River of Corn," 2001
BUNDABERG ARTS CENTRE, AUSTRALIA,
 "Fiona Foley: Invisible Voices," 2000
 (TRAVELED TO UNIVERSITY OF SUNSHINE
 COAST LIBRARY GALLERY, MAROOCHYDORE,
 AUSTRALIA, 2000;
 PINNACLES GALLERY, THURINGOWA,
 AUSTRALIA, 2001;
 GLADSTONE REGIONAL ART GALLERY &
 MUSEUM, AUSTRALIA, 2001;
 WARWICK ART GALLERY, AUSTRALIA, 2001;
 LOGAN ART GALLERY, AUSTRALIA, 2001;
 COOLOOLA SHIRE PUBLIC GALLERY,
 AUSTRALIA, 2001;
 HERVEY BAY REGIONAL GALLERY, PIALBA,
 AUSTRALIA, 2002)
INSTITUTE OF MODERN ART, BRISBANE, AUSTRALIA,
 "Exotica Under the Microscope," 1995

Group Exhibitions

INSTITUTE OF MODERN ART, BRISBANE, AUSTRALIA,
 "Your place or mine? Fiona Foley and
 Simryn Gill," 2002
MUSEUM OF CONTEMPORARY ART, SYDNEY,
 AUSTRALIA, "MCA Unpacked," 2001
HERMITAGE MUSEUM, ST. PETERSBURG, RUSSIA,
 "Aboriginal Art in Modern Worlds,"
 2000 (TRAVELED TO NATIONAL GALLERY OF
 AUSTRALIA, CANBERRA, 2000)
CARLETON AND ST. OLAF COLLEGES, NORTHFIELD,
 MINNESOTA, "Claiming Title," 1999
 (TRAVELED TO LAURENCE UNIVERSITY,
 WISCONSIN, 1999;
 SAMUEL DORSKY MUSEUM, SUNY NEW PALTZ,
 NEW YORK, 1999)
MUSEUM OF CONTEMPORARY ART, SYDNEY,
 AUSTRALIA,
 "Eye of the Storm: Eight Contemporary
 Indigenous Australian Artists," 1997
 (TRAVELED TO MUSEUM OF MODERN ART AT
 HEIDE, MELBOURNE, AUSTRALIA, 1997)

Vicente Franco

Born in Madrid, Spain, 1955
Lives in San Francisco, California

Film Projects

Daughter from Danang, 2002
 (CO-DIRECTOR AND CINEMATOGRAPHER)
I Was Born a Black Woman, 2000
 (DIRECTOR OF PHOTOGRAPHY,
 CO-DIRECTOR, EDITOR)
The Fight in the Fields, 1996
 (DIRECTOR OF PHOTOGRAPHY)
Freedom on my Mind, 1994
 (DIRECTOR OF PHOTOGRAPHY)
Cuba VA: Challenge of the Next Generation,
 1993 (DIRECTOR OF PHOTOGRAPHY,
 CO-PRODUCER, CO-DIRECTOR, CO-EDITOR)

Screenings

AMSTERDAM INTERNATIONAL DOCUMENTARY FILM
 FESTIVAL, THE NETHERLANDS, 2002
NEW DIRECTORS/NEW FILMS, FILM SOCIETY OF
 LINCOLN CENTER, NEW YORK, 2002
SAN FRANCISCO INTERNATIONAL FILM FESTIVAL,
 CALIFORNIA, 2002
SUNDANCE FILM FESTIVAL, UTAH, 2002
HOT DOCS CANADIAN INTERNATIONAL
 DOCUMENTARY FESTIVAL, TORONTO, 2002

Andrea Geyer

Born in Freiburg, Germany, 1971
Lives in New York

One-Artist Exhibitions

O.T. RAUM FÜR AKTUELLE KUNST, LUCERNE,
 SWITZERLAND, "Interim," 2002
PARLOUR PROJECTS, BROOKLYN, NEW YORK,
 "Fantasies are feelings given form. Don't
 worry, they are safe, if understood,"
 2001
GALLERY PAULA BOETTCHER, BERLIN, GERMANY,
 "Information Upon Request," 2001
 (WITH SHARON HAYES)
T19-GALERIE FÜR ZEITGENÖSSISCHE KUNST,
 VIENNA, AUSTRIA,
 "Information Upon Request," 2001
P.S.1 CONTEMPORARY ART CENTER, LONG
 ISLAND CITY, NEW YORK,
 "Cambio de Lugar_Change of Place,"
 2000 (WITH SHARON HAYES)

Group Exhibitions

MANIFESTA 4: EUROPEAN BIENNIAL OF
 CONTEMPORARY ART, FRANKFURT, GERMANY,
 2002
KUNSTHALLE EXNERGASSE, VIENNA, AUSTRIA,
 "Social Sectors," 2002
CENTRAL HOUSE OF ARTISTS, MOSCOW, RUSSIA,
 "The Subject and Power (the lyrical
 voice)," 2001
VON LINTEL GALLERY, NEW YORK,
 "Unconscious Documentaries," 2000
PIEROGI 2000, BROOKLYN, NEW YORK,
 "Andrea Geyer, Tim Maul, Clara
 Williams," 1999

Veli Granö

Born in Kajaani, Finland, 1960
Lives in Helsinki, Finland

One-Artist Exhibitions

HIPPOLYTE PHOTOGRAPHIC GALLERY,
 HELSINKI,FINLAND,
 "The Star Dweller/ Tähteläinen," 2002
PORIGINAL GALLERY, PORI, FINLAND,
 "Retrospective?," 2000
MUSEUM OF CONTEMPORARY ART,
 HELSINKI, FINLAND,
 "The Tangible Cosmologies," 1997

Group Exhibitions

BIENNALE OF SYDNEY, AUSTRALIA,
 "(The World May Be) Fantastic," 2002
KUNSTHALLE LOPHEM, BELGIUM,
 "Symptomania," 2002
CCAC WATTIS INSTITUTE FOR CONTEMPORARY
 ARTS, SAN FRANCISCO, CALIFORNIA,
 "How Extraordinary that the World
 Exists!" 2002
VENICE BIENNALE, ITALY,
 "Plateau of Humankind," 2001
MANIFESTA 3: INTERNATIONAL BIENNIAL OF
 CONTEMPORARY ART,
 LJUBLJANA, SLOVENIA, 2000

Yongsuk Kang

Born in Inchon, South Korea, 1958
Lives in Wanju, South Korea

One-Artist Exhibitions

SK PHOTO GALLERY, SEOUL, SOUTH KOREA,
 "Tongduchon (American G.I.) &
 Maehyang-ri: The Occupied Territory by
 the U.S. Army," 2000
ALTERNATIVE SPACE POOL, SEOUL, SOUTH KOREA,
 "From the Maehyang-ri," 1999

Group Exhibitions

GWANGJU BIENNALE, SOUTH KOREA, 2002
INTERNATIONAL FOTOTAGE, HERTEN, GERMANY,
 "The Century of Korean Photography—
 Images from the Land of Morning
 Calm," 2001
KOREAN CULTURE AND ARTS FOUNDATION,
 SEOUL, SOUTH KOREA,
 "Wandering Bodies on a Shaky Earth:
 Korean Contemporary Art's Shifting
 Center," 2000
SK PHOTO GALLERY, SEOUL, SOUTH KOREA,
 "35mm Personal Scenes," 1999
HAN GA RAM GALLERY, SEOUL ART CENTER,
 SOUTH KOREA,
 "The History of Korean Photography,"
 1998

Bodys Isek Kingelez

Born in Kimbembele Ihunga,
Democratic Republic of Congo (Zaïre), 1948
Lives in Kinshasa, Democratic Republic
of Congo

One-Artist Exhibitions

KUNSTVEREIN IN HAMBURG, GERMANY, 2001
MUSÉE D'ART MODERNE ET CONTEMPORAIN,
 GENEVA, SWITZERLAND,
 "D'autres Ajouts d'Eté, Bodys Isek
 Kingelez," 1996
FONDATION CARTIER POUR L'ART CONTEMPORAIN,
 PARIS, FRANCE, 1995
HAUS DER KULTUREN DER WELT, BERLIN, GERMANY,
 "Bodys Isek Kingelez:
 Architekturvisionen aus Zaire," 1992

Group Exhibitions

DOCUMENTA 11, KASSEL, GERMANY, 2002
MUSEUM VILLA STUCK, MUNICH, GERMANY,
 "The Short Century: Independence and
 Liberation Movements in Africa
 1945–1994," 2001 (TRAVELED TO MARTIN-
 GROPIUS-BAU, BERLIN, GERMANY, 2001;
 MUSEUM OF CONTEMPORARY ART, CHICAGO,
 ILLINOIS, 2001;
 P.S.1 CONTEMPORARY ART CENTER, LONG
 ISLAND CITY, NEW YORK, 2002)
BILDMUSEET, UMEÅ UNIVERSITET, SWEDEN,
 "Mirror's Edge," 2000 (TRAVELED TO
 VANCOUVER ART GALLERY, CANADA, 2000;
 CASTELLO DI RIVOLI, TURIN, ITALY, 2000;
 TRAMWAY, GLASGOW, SCOTLAND, 2001;
 CHARLOTTENBORG UDSTILLINGSBYGNING,
 COPENHAGEN, DENMARK, 2001)
CARNEGIE MUSEUM OF ART,
 PITTSBURGH, PENNSYLVANIA
 "Carnegie International 1999/2000,"
 1999–2000
FONDATION CARTIER POUR L'ART CONTEMPORAIN,
 PARIS, FRANCE, "1 Monde Réel," 1999

Pawel Kruk

Born in Koszalin, Poland, 1976
Lives in Warsaw, Poland

One-Artist Exhibitions

ZACHETA GALLERY, WARSAW, POLAND,
 "Manipulator," 2001
CLUB&GALLERY KISIELICE, POZNAN, POLAND, 2001

Group Exhibitions

AULA GRAN DE LA CAPELLA DE L'ANTIC HOSPITAL,
 BARCELONA, SPAIN,
 "Polacos: New Art from Poland," 2002
THE CENTRE FOR CONTEMPORARY ART,
 WARSAW, POLAND,
 "The Young are Realists, Really," 2002
CSW INNER SPACES, POZNAN, POLAND,
 "Wobec Poznania," 2002
GALLERY ARSENAL, POZNAN, POLAND,
 "The Bridge Project: Charkow, Poznan,
 Hanower," 2001
GOETHE INSTITUTE, KRAKOW, POLAND,
 "Media Art Path," 2001

Andreja Kuluncic

Born in Subotica, Yugoslavia, 1968
Lives in Zagreb, Croatia
www.andreja.org

One-Artist Exhibitions

ARTSPACE, WOOLLOOMOOLOO, AUSTRALIA,
 "Distributive Justice," 2002
GALLERY MULTIMEDIA CULTURAL CENTER,
 SPLIT, CROATIA, 2001
GALERIJA SC ZAGREB, CROATIA,
 "Man Constructor," 1996 (TRAVELED TO
 INTERMEDIA ARTS, MINNEAPOLIS,
 MINNESOTA, 1996)

Group Exhibitions

MUSEUM OF CONTEMPORARY ART,
 ZAGREB, CROATIA,
 "Here Tomorrow," 2002
DOCUMENTA 11, KASSEL, GERMANY, 2002
MANIFESTA 4: EUROPEAN BIENNIAL OF
 CONTEMPORARY ART,
 FRANKFURT, GERMANY, 2002
MUSEUM OF CONTEMPORARY ART,
 ZAGREB, CROATIA, "To Tell a Story," 2001
TRIENNALE-INDIA, NEW DELHI, INDIA, 2001

Jannicke Låker

Born in Drammen, Norway, 1968
Lives in Berlin, Germany

One-Artist Exhibitions

DRAMMEN MUSEUM, NORWAY, 2000
UKS, OSLO, NORWAY, 2000

Group Exhibitions

MUSEUM OF CONTEMPORARY ART, BELGRADE,
 "Bekmörk," 2003
KUNSTNERNES HUS, OSLO, NORWAY,
 "Video Works," 2002
TRONDEIM MUSEUM OF FINE ART, NORWAY,
 "7 Stories about Sex and Identity," 2002
 (TRAVELED TO LILLEHAMMER MUSEUM OF
 ART, NORWAY, 2001)
SPARWASSER HQ, BERLIN, GERMANY,
 "We Want to Believe," 2000
BALTIC BIENNIAL OF CONTEMPORARY ART,
 VISBY, SWEDEN, AND RIGA, LATVIA,
 "News," 2000

Ane Lan

Born in Oslo, Norway, 1972
Lives in Oslo, Norway

One-Artist Exhibitions

GALLERI 3.14, BERGEN, NORWAY, 2000

Group Exhibitions

AKERSHUS KUNSTNERSENTER,
 LILLESTRØM, NORWAY,
 "SHKS/KHIO," 2002
CAP, LONDON, UNITED KINGDOM,
 "additions," 2002
THE NATIONAL MUSEUM OF ARTS AND CRAFTS,
 OSLO, NORWAY, "Masterexhibition," 2002
RA GALLERY, KIEV, UKRAINE,
 "Dreamcatcher," 2002
GALLERY F15, MOSS, NORWAY, 2001

Cristóbal Lehyt

Born in Santiago, Chile, 1973
Lives in New York

One-Artist Exhibitions

ESPACIO LA REBECA, BOGOTÁ, COLOMBIA,
 "Arresto," 2002
MUSEO DE ARTE CONTEMPORÁNEO,
 SANTIAGO, CHILE, "Untitled," 2001 (WITH
 JOE VILLABLANCA AND JUAN CESPEDES)
LA PANADERIA, MEXICO CITY, MEXICO,
 "Marraqueta," 2000
LABORATORIO DE ARTE CONTEMPORÁNEO,
 CARACAS, VENEZUELA, "Malvinas," 1999
GALERÍA CHILENA, SANTIAGO, CHILE,
 "Supermercado," 1997

Group Exhibitions

QUEENS MUSEUM OF ART, NEW YORK,
 "637 Running Feet: Black-and-White
 Wall Drawings by 14 Artists," 2002–03
KUNSTHALLE EXNERGASSE, VIENNA, AUSTRIA,
 "Social Sectors," 2002
TV OR NOT TV, 8TH CELEBRATION OF EXPERIMENTAL
 MEDIA ARTS, LOS ANGELES,
 "Freewaves: Latin America:
 Load (and Unload)," 2002
CORNELL UNIVERSITY, ITHACA, NEW YORK,
 "Sudamericanrockers," 2001
MUSEO DE ARTE CONTEMPORÁNEO,
 VALDIVIA, CHILE, "Doméstico," 1999

Mark Lewis

Born in Hamilton, Canada, 1957
Lives in London, United Kingdom

One-Artist Exhibitions

GALERIE CENT8-SERGE LE BORGNE,
 PARIS, FRANCE, 2002
KUNSTHALLE BERN, SWITZERLAND, 2002
CENTRO DE ARTE DE SALAMANCA, SPAIN, 2002
VILLA ARSON, NICE, FRANCE, 2001
MUSEUM OF MODERN ART,
 OXFORD, UNITED KINGDOM, 2001

Group Exhibitions

TATE LIVERPOOL, UNITED KINGDOM,
 "The Liverpool Biennial," 2002
GWANGJU BIENNALE, SOUTH KOREA, 2002
FRANKFURTER KUNSTVEREIN,
 GERMANY, "Non-places," 2002
TATE BRITAIN, LONDON, UNITED KINGDOM,
 "Intelligence: New British Art 2000,"
 2000
VAN ABBEMUSEUM, EINDHOVEN,
 THE NETHERLANDS,
 "Cinema! Cinema! Contemporary Art
 and the Cinematic Experience," 1999

Amina Mansour

Born in Montgomery, Alabama, 1972
Lives in Cairo and Alexandria, Egypt

One-Artist Exhibitions

TOWNHOUSE GALLERY, CAIRO, EGYPT, 1999

Group Exhibitions

AL-NITAQ ARTS FESTIVAL, TOWNHOUSE GALLERY,
 CAIRO, EGYPT, 2001
GREEK CONSULATE GENERAL,
 ALEXANDRIA, EGYPT, 1997
SPANISH CULTURAL CENTER,
 ALEXANDRIA, EGYPT, 1993
L'ATELIER D'ALEXANDRIE, ALEXANDRIA, EGYPT,
 "Al-Marsam," 1989

ARTISTS' BIOGRAPHIES

Maria Marshall

Born in Bombay, India, 1966
Lives in London, United Kingdom

One-Artist Exhibitions

SITE GALLERY, SHEFFIELD, UNITED KINGDOM,
 "Maria Marshall: Fine Lines," 2002
SWISS INSTITUTE—CONTEMPORARY ART,
 NEW YORK, 2002
TEAM GALLERY, NEW YORK,
 "Maria Marshall: Playground," 2002
ARNDT + PARTNER, BERLIN, GERMANY, 2001
GALLERY 400, UNIVERSITY OF ILLINOIS AT
 CHICAGO, COLLEGE OF ARCHITECTURE AND
 THE ARTS,
 "Maria Marshall: New Works," 2000

Group Exhibitions

S.M.A.K. MUNICIPAL MUSEUM OF CONTEMPORARY
 ART, GHENT, BELGIUM, "Casino 2001," 2001
BORUSAN CENTRE FOR CULTURE AND ARTS,
 ISTANBUL, TURKEY, "Double Trouble," 2001
KUNSTHALLE ST. GALLEN, SWITZERLAND,
 "Some Secrets," 2000
WHITE BOX, NEW YORK, "Topologies," 2000
THE ALDRICH MUSEUM OF CONTEMPORARY ART,
 RIDGEFIELD, CONNECTICUT,
 "Faith: The Impact of Judeo-Christian
 Religion on Art at the Millennium,"
 2000

Bjørn Melhus

Born in Kirchheim/Teck, Germany, 1966
Lives in Hannover and Berlin, Germany

One-Artist Exhibitions

GOETHE INSTITUT INTER NATIONES, NEW YORK,
 "Early Video Works," 2002
KUNSTHALLE BREMEN, GERMANY, "Video," 2002
LOTHRINGER13/HALLE—ORT FÜR AKTUELLE
 KUNST UND NEUE MEDIEN, MUNICH,
 "Primetime," 2002
ROEBLING HALL, BROOKLYN, NEW YORK,
 "Sometimes," 2002
KUNSTVEREIN HANNOVER, GERMANY,
 "Primetime," 2001

Group Exhibitions

RONALD FELDMAN GALLERY, NEW YORK,
 "American Dream: A Survey," 2003
MUSEUM VILLA STUCK, MUNICH, GERMANY,
 "Hautnah: Die Sammlung Goetz," 2002
ZKM CENTER FOR ART AND MEDIA,
 KARLSRUHE, GERMANY,
 "Intermedium 2," 2002

WILHELM-HACK MUSEUM,
 LUDWIGSHAFEN, GERMANY,
 "Utopian heute," 2002
LONG BEACH MUSEUM OF ART, CALIFORNIA,
 "New Visions Video," 1998

motiroti

(Ali Zaidi, Keith Kahn, and Indran
Selvarajah)
Formed in 1991, London, United
Kingdom

Exhibitions

TATE MODERN, LONDON, UNITED KINGDOM
 "Build," 2001
WARWICK ARTS CENTRE,
 "Fresh Masaala," 2000
 (TRAVELED TO THE LAB,
 SAN FRANCISCO, CALIFORNIA, 2000)
INSTITUTE OF CONTEMPORARY ARTS,
 LONDON, UNITED KINGDOM,
 "Wigs of Wonderment," 1995
WALSALL MUSEUM AND ART GALLERY,
 UNITED KINGDOM, "Captives," 1993

Theater/Performance Works

ALLADEEN, 2003–04 (COLLABORATION WITH
 THE BUILDERS ASSOCIATION)
Celebration Commonwealth, 2002
Motiroti Puttli Chunni, 1993–94

Zoran Naskovski

Born in Vojvodina, Yugoslavia, 1960
Lives in Belgrade, Serbia

One-Artist Exhibitions

SALON OF THE MUSEUM OF CONTEMPORARY ART,
 BELGRADE, SERBIA, "Crossover," 2002
CINEMA REX, BELGRADE, SERBIA,
 "The Swing," 2001
CZKD, BELGRADE, SERBIA, " *," 1999
7 STAGES, ATLANTA, GEORGIA,
 "White Light/White Hit," 1998
 (WITH VESNA PAVLOVIC)
SKC GALLERY, BELGRADE, SERBIA,
 "White Cloud," 1994

Group Exhibitions

HAUS DER KULTEREN DER WELT, BERLIN, GERMANY,
 "Transmediale.02: go public!," 2002
SITE GALLERY, SHEFFIELD, UNITED KINGDOM,
 "Imaginary Balkans," 2002
TIRANA BIENNIAL, TIRANA, ALBANIA, 2001
CONTEMPORARY ART CENTRE, VILNIUS, LITHUANIA,
 "Innocent Life," 2000

MODERNA MUSEET, STOCKHOLM, SWEDEN,
 "After the Wall: Art and Culture in
 Post-Communist Europe," 1999
 (TRAVELED TO NATIONALGALERIE BERLIN,
 HAMBURGER BAHNHOF, GERMANY, 2000)

Olu Oguibe

Born in Aba, Nigeria, 1964
Lives in New York

One-Artist Exhibitions

THE SCENE GALLERY, NEW YORK, "Ashes," 2002
ROSLYN OXLEY9 GALLERY, SYDNEY, AUSTRALIA,
 1994
RATHAUS FRIEDBERG, GERMANY,
 "Hunderte Werke," 1994
SAVANNAH GALLERY, LONDON, UNITED KINGDOM,
 "Recent Works," 1993
SAVANNAH GALLERY, LONDON, UNITED KINGDOM,
 "A Gathering Fear: Drawings," 1992

Group Exhibitions

THE ALDRICH MUSEUM OF CONTEMPORARY ART,
 RIDGEFIELD, CONNECTICUT, "Family," 2002
GORNEY BRAVIN + LEE, NEW YORK,
 "Works on paper," 2001
IRISH MUSEUM OF MODERN ART,
 DUBLIN, IRELAND,
 "Marking the Territory," 2001
BILDMUSEET, UMEÅ UNIVERSITET, SWEDEN,
 "Mirror's Edge," 1999–2000
 (TRAVELED TO VANCOUVER ART GALLERY,
 CANADA, 2000;
 CASTELLO DI RIVOLI, TURIN, ITALY, 2000;
 TRAMWAY, GLASGOW, SCOTLAND, 2001;
 CHARLOTTENBORG UDSTILLINGSBYGNING,
 COPENHAGEN, DENMARK, 2001)
P.S.1 CONTEMPORARY ART CENTER,
 LONG ISLAND CITY, NEW YORK,
 "Greater New York:
 New Art in New York Now," 2000

Hye Jung Park

Born in Seoul, South Korea, 1963
Lives in New York

Film Projects

The #7 Train: An Immigrant Journey, 1999
(CO-DIRECTOR AND CO-PRODUCER)
The Women Outside, 1995
(CO-DIRECTOR AND CO-PRODUCER)
Homes Apart: Korea, 1991
(ASSOCIATE PRODUCER)
Until Daybreak: Korea, 1990
(PRODUCER)

Screenings

NEW ASIAN FILM MAKERS SERIES,
ANTHOLOGY FILM ARCHIVE, 2000
"Rewind: Two Decades of Korean
Independent Media," SAN FRANCISCO AND
LOS ANGELES, CALIFORNIA; GRAND RAPIDS,
MICHIGAN; AND NEW YORK, 2000
MUSEUM OF MODERN ART, NEW YORK, 1998
CHICAGO ASIAN AMERICAN FILM FESTIVAL,
ILLINOIS, 1996
SAN FRANCISCO INTERNATIONAL FILM FESTIVAL,
CALIFORNIA, 1992

Marlo Poras

Born in Fort Campbell, Kentucky, 1971
Lives in Brookline, Massachusetts

Film Projects

Mai's America, 2002

Screenings

LINCOLN CENTER, NEW YORK, 2002
MUSEUM OF FINE ARTS,
BOSTON, MASSACHUSETTS, 2002
SOUTH BY SOUTHWEST FILM FESTIVAL,
AUSTIN, TEXAS, 2002
TRIBECA FILM FESTIVAL, NEW YORK 2002
VISIONS DU REEL—INTERNATIONAL DOCUMENTARY
FILM FESTIVAL, NYON, SWITZERLAND, 2002

Muhammad Imran Qureshi

Born in Hyderabad, Pakistan, 1972
Lives in Lahore, Pakistan

One-Artist Exhibitions

CHAWKANDI ART 105, KARACHI, PAKISTAN, 2002
ROHTAS GALLERY, ISLAMABAD, PAKISTAN, 1996
ALLIANCE FRANÇAISE GALLERY, LAHORE, PAKISTAN,
1995

Group Exhibitions

THE ROYAL ACADEMY OF ARTS, LONDON,
UNITED KINGDOM,
"The Galleries Show: Contemporary Art
in London," 2002
CORVI-MORA, LONDON, UNITED KINDOM, 2001
IIC GALLERY, NEW DELHI, INDIA,
"Manoeuvering Miniatures:
Contemporary Art from Pakistan," 2001
(TRAVELED TO SAKSHI GALLERY, MUMBAI,
INDIA, 2001)
VICTORIA ART GALLERY, BATH, UNITED KINGDOM,
"Pakistan: Another Vision," 2000
(TRAVELED TO CENTER OF CONTEMPORARY
ART, GLASGOW, SCOTLAND, 2000;
HUDDERSFIELD ART GALLERY, UNITED
KINGDOM, 2000;
BRUNEI GALLERY, LONDON, UNITED KINGDOM,
2000)
THIRD ASIA PACIFIC TRIENNIAL OF CONTEMPORARY
ART, BRISBANE, AUSTRALIA, 1999

Sandeep Ray

Born in Malacca, Malaysia, 1969
Lives in Cambridge, Massachusetts

Film Projects

A Trial in East Kalimantan: The Benoaq
Dayak Resistance, 2000 (DIRECTOR)
Miyah: The Life of a Javanese Woman, 1999
(CINEMATOGRAPHER, EDITOR, AND SOUND
ENGINEER)
Leaving Bakul Bagan, 1994 (DIRECTOR)
The Sound of Old Rooms, 1993 (DIRECTOR)

Screenings

NEWSCAFE, JAKARTA, 2000
MARGARET MEAD FILM AND VIDEO FESTIVAL,
NEW YORK, 1999
LINCOLN CENTER FILM SOCIETY, NEW YORK, 1996
ROYAL ANTHROPOLOGICAL INSTITUTE FESTIVAL,
KENT, UNITED KINGDOM, 1995
FLAHERTY FILM SEMINAR, NEW YORK, 1994

Andrea Robbins

Born in Boston, Massachusetts, 1963
Lives in New York

and
Max Becher

Born in Düsseldorf, Germany, 1964
Lives in New York

One-Artist Exhibitions

MUSEUM OF CONTEMPORARY PHOTOGRAPHY,
COLUMBIA COLLEGE, CHICAGO, ILLINOIS,
"Andrea Robbins & Max Becher: The
Transportation of Place," 2003
SONNABEND GALLERY, NEW YORK, 2002
SAMUEL P. HARN MUSEUM OF ART, UNIVERSITY OF
FLORIDA, GAINESVILLE,
"German Legacies: Photography by
Andrea Robbins and Max Becher," 2002
YERBA BUENA CENTER FOR THE ARTS,
SAN FRANCISCO, CALIFORNIA,
"German Indians," 2001
DE VLEESHAL, MIDDLEBURG, THE NETHERLANDS,
"Andrea Robbins and Max Becher," 1994
(TRAVELED TO RIJKSARCHIEF, KORTRIJK,
BELGIUM, 1995)

Group Exhibitions

WHITNEY MUSEUM OF AMERICAN ART, NEW YORK,
"What's New: Recent Acquisitions in
Photography," 2002
MUSEUM OF CONTEMPORARY ART,
BARCELONA, SPAIN,
"Documentary Processes: Testimonial
Image, Subalternity and the Public
Sphere," 2001
MUSEUM OF MODERN ART, NEW YORK,
"Documentary Fortnight," 2001
BIENNIAL D'ART CONTEMPORAIN DE LYON,
FRANCE, 2000
NEW MUSEUM, NEW YORK,
"Trade Routes," 1993

Miguel Angel Rojas

Born in Bogotá, 1946
Lives in Bogotá, Colombia

One-Artist Exhibitions

MUSEO NACIONAL, BOGOTÁ, COLOMBIA,
 "La Cama de Piedra," 2002
GALERIA VALENZUELA Y KLENNER,
 BOGOTÁ, COLOMBIA, "Sub," 2001
MUSEO UNIVERSITARIO DEL CHOPO, MEXICO CITY,
 MEXICO, "Pacal y Pascual, La conquista
 debe continuar," 1995
MUSEO DE ARTE MODERNO, BOGOTÁ, COLOMBIA,
 "Bio," 1991
MUSEO DE ARTE MODERNO, CARTAGENA, MEXICO,
 "Miguel Angel Rojas," 1990

Group Exhibitions

GALERÍA DE LA RAZA,
 SAN FRANCISCO, CALIFORNIA
 "Photographic Memory and Other Shots
 in the Dark," 2002
GALERÍA FERNANDO PRADILLA, MADRID, SPAIN,
 "Colombia Visible/Invisible," 2001
APEX ART, NEW YORK, "Define 'Context'," 2000
MUSEO DEL BARRIO, NEW YORK,
 "Re-aligning Vision," 1997 (TRAVELED TO
 ARKANSAS ART CENTER, LITTLE ROCK, 1997;
 ARCHER M. HUNTINGTON ART GALLERY,
 UNIVERSITY OF TEXAS, AUSTIN, 1998;
 MUSEO DE BELLAS ARTES, CARACAS,
 VENEZUELA, 1998;
 MUSEO DE ARTE CONTEMPORÁNEO,
 MONTERREY, MEXICO, 1998)
MUSEUM OF MODERN ART, NEW YORK,
 "Latin American Artists of the Twentieth
 Century," 1993

Sherine Salama

Born in Cairo, Egypt, 1963
Lives in Sydney, Australia

Film Projects

A Wedding in Ramallah, 2002
 (DIRECTOR AND PRODUCER)
Australia Has No Winter, 1999
 (DIRECTOR AND PRODUCER)

Screenings

CINEMA DU REEL, CENTRE POMPIDOU,
 PARIS, FRANCE, 2003
MARGARET MEAD FILM AND VIDEO FESTIVAL,
 NEW YORK, 2002/2003
PUSAN INTERNATIONAL FILM FESTIVAL,
 SOUTH KOREA, 2002
LOS ANGELES INTERNATIONAL FILM FESTIVAL,
 CALIFORNIA 2002
HOT DOCS CANADIAN INTERNATIONAL DOCUMENTARY
 FESTIVAL, TORONTO, 2002

Ousmane Sow

Born in Dakar, Senegal, 1935
Lives in Dakar, Senegal, and Paris, France

One-Artist Exhibitions

GALERIE BAB EL KÉBIR, RABAT, MOROCCO, 2002
MUSÉE DES BEAUX ARTS, OTTAWA, CANADA, 2001
MUSÉE DAPPER, PARIS, FRANCE, 2001
PONT DES ARTS, PARIS, FRANCE, 1999

Group Exhibitions

MUSÉE DES CIVILISATIONS, QUEBEC, CANADA, 2002
PALAIS DES NATIONS-UNIES,
 GENEVA, SWITZERLAND, 1995
VENICE BIENNALE, ITALY, 1995
DOCUMENTA 9, KASSEL, GERMANY, 1992
KANDA OGAWA MACHI CHIYODA KU,
 TOKYO, JAPAN, 1991

Heiner Stadler

Born in 1948, Pilsting, Germany
Lives in Munich, Germany

Film Projects

Eat, Sleep, No Women, 2002
Warshots, 1996
The End of a Journey, 1992
Gold!, 1988
King Kong's Fist, 1984

Screenings

AMERICAN FILM INSTITUTE LOS ANGELES
 INTERNATIONAL FILM FESTIVAL, CALIFORNIA,
 2002
LOCARNO INTERNATIONAL FILM FESTIVAL,
 SWITZERLAND, 2002
BERLIN INTERNATIONAL FILM FESTIVAL,
 GERMANY, 1997
VENICE BIENNALE, ITALY, 1996
MUSEUM OF MODERN ART, NEW YORK, 1996

JT Orinne Takagi

Born in San Francisco, California, 1959
Lives in New York

Film Projects

Echando Raices/Taking Root, 2002
 (DIRECTOR)
Homeland Insecurity, 2001
 (DIRECTOR, EDITOR)
The #7 Train: An Immigrant Journey, 1999
 (CO-DIRECTOR AND CO-PRODUCER)
The Women Outside, 1995
 (CO-DIRECTOR AND CO-PRODUCER)
Homes Apart: Korea, 1991
 (DIRECTOR AND ASSOCIATE PRODUCER)

Screenings

ASIAN AMERICAN INTERNATIONAL FILM FESTIVAL,
 NEW YORK, 2002
NEW ASIAN FILMMAKERS SERIES,
 ANTHOLOGY FILM ARCHIVE, NEW YORK, 2000
MUSEUM OF MODERN ART, NEW YORK, 1998
CHICAGO ASIAN AMERICAN FILM FESTIVAL,
 ILLINOIS, 1996
SAN FRANCISCO INTERNATIONAL FILM FESTIVAL,
 CALIFORNIA, 1992

Hisashi Tenmyouya

Born in Tokyo, Japan, 1966
Lives in Saitama, Japan

One-Artist Exhibitions

DEPOT, TOKYO, JAPAN,
 "NEO Japanese Paintings," 2002
PROGETTO, TOKYO, JAPAN, 2001
HARAJUKU GALLERY, TOKYO, JAPAN,
 "Japanese Spirit," 2000

Group Exhibitions

KAWANABE KYOSAI MEMORIAL MUSEUM,
 SAITAMA, JAPAN,
 "Kyosai plus one: Kawanabe Kyosai and
 Tenmyouya Hisashi," 2002
BRONX MUSEUM OF THE ARTS, NEW YORK,
 "One Planet under a Groove: Hip Hop
 and Contemporary Art," 2001
 (TRAVELED TO: WALKER ART CENTER,
 MINNEAPOLIS, MINNESOTA, 2002;
 SPELMAN COLLEGE MUSEUM OF FINE ART,
 ATLANTA, GEORGIA, 2003;
 MUSEUM VILLA STUCK, MUNICH, GERMANY,
 2003)
AOYAMA SPIRAL GALLERY, TOKYO, JAPAN,
 "8th Lichtex Biennale," 2000
SHIBUYA PARCO, TOKYO, JAPAN,
 "URBANART#8," 1999
FUJITA MUSEUM, TOKYO, JAPAN,
 "JACA '98," 1998

Zhou Tiehai

Born in Shanghai, China, 1966
Lives in Shanghai, China

One-Artist Exhibitions

SHANGHART GALLERY, SHANGHAI, CHINA,
 "the artist isn't here," 2001
ISE FOUNDATION, NEW YORK,
 "Placebo and Tonic," 2001
HARA MUSEUM OF CONTEMPORARY ART,
 TOKYO, JAPAN,
 "Zhou Tiehai: Placebo," 2000–01
GALLERY QUADRUM, LISBON, PORTUGAL,
 "Will," 2000
KUNSTHAL ROTTERDAM, THE NETHERLANDS,
 "Zhou Tiehai: Jonge kunst uit Shanghai,"
 1998

Group Exhibitions

GOEDHUIS CONTEMPORARY, NEW YORK,
 "On the Edge of the Millennium:
 New Art from China," 2002
 (TRAVELED TO GOEDHUIS CONTEMPORARY,
 LONDON, UNITED KINGDOM)
GWANGJU BIENNIAL, SOUTH KOREA, 2002
PUSAN INTERNATIONAL CONTEMPORARY ART
 FESTIVAL, SOUTH KOREA, 2000
VENICE BIENNALE, ITALY, 1999
SECESSION, VIENNA, AUSTRIA,
 "Cities on the Move: Contemporary
 Asian Art on the Turn of the 21st
 Century," 1997–98
 (TRAVELED TO CAPC MUSÉE D'ART CONTEM-
 PORAIN DE BORDEAUX, FRANCE, 1998;
 P.S.1 CONTEMPORARY ART CENTER,
 LONG ISLAND CITY, NEW YORK, 1998;
 LOUISIANA MUSEUM OF MODERN ART,
 COPENHAGEN, DENMARK, 1999;
 HAYWARD GALLERY, LONDON, UNITED
 KINGDOM, 1999;
 MUSEUM OF MODERN ART,
 HELSINKI, FINLAND, 2000)

José Angel Toirac

Born in Guantanamo, Cuba, 1966
Lives in Havana, Cuba

One-Artist Exhibitions

ART IN GENERAL, NEW YORK,
 "Think Different," 2002
 (WITH MEIRA MARRERO DÍAZ)
GALERIA HABANA, HAVANA, CUBA,
 "Mediaciones II," 2002
CENTRO DE DESARROLLO DE LAS ARTES
 VISUALES, HAVANA, CUBA,
 "En Rojo y Negro," 2001
 (WITH MEIRA MARRERO DÍAZ)
N.O.M.A.D.E. GALLERY, PARIS, FRANCE,
 "Death and Representation
 (Exhumaciones)," 1998
INSTITUTE FOR STUDIES IN THE ARTS,
 ARIZONA STATE UNIVERSITY, TEMPE,
 "Rosca Izquierda," 1998

Group Exhibitions

MUSEUM OF MODERN ART, NEW YORK,
 "New to the Modern: Recent
 Acquisitions from the Department of
 Drawings," 2001–02
CONTEMPORARY ARTS CENTER, CINCINNATI, OHIO,
 "En cada Barrio Revolución," 2001
CENTRO DE DESARROLLO DE LAS ARTES
 VISUALES, HAVANA, CUBA,
 "III Salón Nacional de Arte Cubano
 Contemporáneo," 2001
GWANGJU BIENNIAL, SOUTH KOREA, 2000
YERBA BUENA CENTER FOR THE ARTS,
 SAN FRANCISCO, CALIFORNIA,
 "Art from Cuba: Irony and Survival on
 the Utopian Island," 1999
 (TRAVELED TO CRANBROOK ART MUSEUM,
 BLOOMFIELD HILLS, MICHIGAN, 1999;
 AUSTIN MUSEUM OF ART, TEXAS, 1999;
 MUSEUM OF LATIN AMERICAN ART,
 LONG BEACH, CALIFORNIA, 1999)

Saira Wasim

Born in Lahore, Pakistan, 1975
Lives in Lahore, Pakistan

Group Exhibitions

ART SHART GALLERY, LAHORE, PAKISTAN, 2001
IIC GALLERY, NEW DELHI, INDIA,
 "Manoeuvering Miniatures:
 Contemporary Art from Pakistan," 2001
 (TRAVELED TO SAKSHI GALLERY,
 MUMBAI, INDIA, 2001)
JAY GRIMM GALLERY, NEW YORK,
 "Six Artists from Pakistan," 2000
ROHTAS GALLERY, ISLAMABAD, PAKISTAN, 2000

Danwen Xing

Born in Xi'an, China, 1967
Lives in Queens, New York, and
Beijing, China

One-Artist Exhibitions

PINGYAO INTERNATIONAL PHOTO FESTIVAL, CHINA,
 "Dislocation," 2002
LEE, KA-SING GALLERY, TORONTO, CANADA,
 "China Avant-Garde," 2002
GALERIE DU CHÂTEAU, NICE, FRANCE,
 "Xing Danwen's Work," 2001
GALLERY GRAUWERT, HAMBURG, GERMANY,
 "With Chinese Eyes," 1994

Group Exhibitions

DAMASQUINE CONTEMPORARY ART GALLERY,
 BRUSSELS, BELGIUM,
 "Dolores Marat–Danwen Xing,"
 2002–03
GUANGZHOU TRIENNIAL, CHINA,
 "Reinterpretation: A Decade of
 Experimental Chinese Art (1990–2000),"
 2002–03
QUEENS MUSEUM OF ART, NEW YORK,
 "Queens International," 2002
YOKOHAMA TRIENNIAL, JAPAN, 2001
INSTITUTE OF CONTEMPORARY ARTS,
 LONDON, UNITED KINGDOM,
 "Beijing—The Revolutionary Capital,"
 1999

Miwa Yanagi

Born in Kobe City, Japan, 1967
Lives in Kyoto, Japan

One-Artist Exhibitions

GALERIE ALMINE RECH, PARIS, FRANCE,
 "My Grandmothers," 2002
SHISEIDO GALLERY, TOKYO, JAPAN, 2002
KODAMA GALLERY, OSAKA, JAPAN,
 "Midnight Dream Awakening," 2001
GALERIE ALMINE RECH, PARIS, FRANCE, 2000
CRITERIUM CONTEMPORARY ART CENTER,
 ART TOWER MITO, IBARAKI-KEN, JAPAN,
 1997

Group Exhibitions

BIENNIAL D'ART CONTEMPORAIN DE LYON,
 FRANCE, 2001
YOKOHAMA TRIENNIAL, JAPAN, 2001
CENTRE GEORGES POMPIDOU, PARIS, FRANCE,
 "Elysian Fields: Une Proposition du
 Purple Institute," 2000
SITE SANTA FE, NEW MEXICO,
 "Looking for a Place: Third International
 Biennial," 1999
NATIONAL MUSEUM OF MODERN ART,
 KYOTO, JAPAN,
 "Visions of the Body: Fashion or
 Invisible Corset," 1999

YOUNG-HAE CHANG
HEAVY INDUSTRIES

(Young-Hae Chang and Marc Voge)
Formed in 1999, Seoul, South Korea
www.yhchang.com

New Media Projects and Exhibitions

COMPUTERFINEARTS.COM, NEW YORK, 2002
NATIONAL MUSEUM OF ART, OSAKA, JAPAN,
 "A Second Talk: Contemporary Art from
 Korea and Japan," 2002
MULTIMEDIA ART ASIA PACIFIC, BEIJING, CHINA,
 2002
MEDIAMATIC, AMSTERDAM, THE NETHERLANDS,
 "Mediamatic Supermarkt," 2002
TOTAL MUSEUM OF CONTEMPORARY ART,
 SEOUL, SOUTH KOREA,
 "Project 8: The Gravity of the
 Immaterial," 2002
ZKM CENTER FOR ART AND MEDIA,
 KARLSRUHE, GERMANY,
 "Future Cinema: The Cinematic
 Imaginary after Film," 2002–03
P.S.1 CONTEMPORARY ART CENTER,
 LONG ISLAND CITY, NEW YORK,
 "Animations," 2001–02

Acknowledgments

Lawrence Rinder

ANNE & JOEL EHRENKRANZ CURATOR
OF CONTEMPORARY ART

I would like to begin by thanking former assistant curator Glenn Phillips, who first suggested the idea of organizing an exhibition on this theme. My heartfelt thanks go to curatorial assistant Tina Kukielski, exhibition coordinator Kirstin Bach, research assistant Yasufumi Nakamori, and interns Elizabeth Armistead, Barbara Choit, Apsara DiQuinzio, Bethany Pappalardo, Aaron Timlin, and Lisa Ugaya. Their contribution has been immeasurable. I would also like to thank in addition the following students in my Columbia University/ Whitney Museum seminar who provided crucial research and feedback at a critical moment in the development of the exhibition: Amanda Bowker, Heather Duggan, Holly Greenfield, Elizabeth Hallock, Lila Kanner, Jinyoung Kim, Camila Marambio, Melissa Pomerantz, Christina Rosenberger, Erin Scime, and Dana Simpson.

I am extremely grateful to the catalogue authors Tariq Ali, Ian Buruma, Caryl Phillips, Elena Poniatowska, Sean Rocha, Nawal El Saadawi, Edward Said, Luc Sante, Pramoedya Ananta Toer, and Aleksandar Zograf, whose texts offer such a rich range of views on America's role in the world. The exhibition consultant, Sean Rocha, provided intelligent and informed guidance throughout the course of the project. I am grateful to Joel Sanders for his generous and thoughtful guidance on the exhibition

design. Most of all, I would like to thank Maxwell L. Anderson, director of the Whitney Museum, for believing in the project and supporting it enthusiastically from the beginning to the end.

In addition, I am indebted to the following individuals around the world who leant their support and guidance: Margrethe Aanestad, Sergei Bugaev Afrika, Leeza Ahmady, Atteqa Ali, Ghada Amer, Patrick Amsellem, Knut Andersson, Nathalie Anglès, Anthony Arnove, Hamdi Attia, Dr. Ali Reza Sami Azar, Rina Banerjee, Aleksandar Battista Ilic, Koan-Jeff Baysa, Ron Bechet, Celia S. de Birbragher and ArtNexus, Ivan Bojar, Fritzie Brown, Tania Bruguera, Cheryl Brutvan, Michael Brynntrup, Lorea Canales, Chaos Chen Yeng, Melissa Chiu, Motoko Cho, Eunju Choi, Mark Coetzee, Phil Collins, Charles Cosac, Fereshteh Daftari, Vesna Danilovic, Sue de Beer, Vidha Denis, Dr. Vishaka Desai, Ana Devic, Dominica Diez, Branislav Dimitrijevic, Peter Doroshenko, Huang Du, David Elliott, Michèle Faguet, Jane Farver, Daniel Faust, Heather Felty Kouris, Lauri Firstenberg, Amanda Fortini, Hengameh Fouladvand, Branko Franceschi, Gridthiya Gaweewong, Andrea Geyer, Kathleen Goncharov, Wang Gongxin, Ewa Gorzadek, Ruth Ellen Gruber, Marina Grzinic, Lynn Gumpert, Cai Guo-Qiang, Fredericke Hansen, Eleanor Hartney, Yuko Hasegawa, Salima Hashmi, Pierre Haski, Peter Herrmann, Mark Hertsgaard, Betti-Sue Hertz, Erik Hesby, Katherine Hinds, Mami Asano Hirose, Christopher Ho, Lejla Hodzic,

ACKNOWLEDGMENTS

Heidrun Holzfeind, Laura Hoptman, Ranjit Hoskote, Natasa Ilic, Mariá Iovino, Carol Irving, Rose Issa, Anna Jagiello, Amrita Jhaveri, Inés Katzenstein, Taka Kawachi, Breda Kennedy, Rachel Kent, Anna Kharkina, Yu Yeon Kim, Feodor Kleyev, Robert Kloos, Marilu Knode, Moukhtar Kocache, Shinji Kohmoto, Raiji Kuroda, Suzanne Lecht, Mark Lewis, Pi Li, Malgorzata Lisiewicz, Julia Liu, Lillian Llanes, Tran Luong, Roger MacDonald, André Magnin, Raimundas Malasauskas, Natalia Manzhali, Rosa Martinez, Cuauhtémoc Medina, Susan Meiselas, Bjørn Melhus, Vesna Milic, Gao Minglu, Manijeh Mir-'Emadi, Sinisa Mitrovic, Fumio Nanjo, Shirin Neshat, Victoria Noorthoorn, Inhwan Oh, Tobias Ostrander, Meredith Palmer, Ilho Park, Antonia Perez, Virginia Pérez Rattón, Steve Rand, Lisa Reeve, Sajid Rizvi, José Roca, Sebastian Romo, Rena Rosenwasser, Sabina Sabolovic, Leanne Sacramone, Ralf Sausmikat, Marie-Laure Sauty de Chalon, Reza Sheikh, Yoshiko Shimada, Dario Solman, Sarah and Emmanuel Solomon, Béatrice Soulé, John Spiak, Dejan Sretenovic, Matthew Stadler, Wojciech Stefanik, Fumihiko Sumitomo, Andras Szántó, Aneta Szylak, Suenne Megan Tan, Akira Tatehata, C. David Thomas, Milanka Todic, Kayo Tokuda, Anica Tucakov, Yumi Umemura, Naomi Urabe, Gilbert Vicario, Antoine Vigne, Saira Wasim, Marianne Weems, Sue Williamson, Jessica Winegar, Stephen Wright, Hanna Wróblewska, Danwen Xing, Lydia Yee, Soo-jung Yi, Marilyn Zeitlin, and Rachael Zur.

None of this, of course, would have been possible without the extraordinary contributions of the artists themselves.

Authors' Biographies

Tariq Ali, born in Lahore, Pakistan, is a historian, novelist, and filmmaker. He has written more than a dozen books on world history and politics, including *The Clash of Fundamentalisms: Crusades, Jihads and Modernity,* and five novels. He lives in London.

Ian Buruma, currently Luce Professor at Bard College, was born in the Netherlands and has written *God's Dust: A Modern Asian Journey; Behind the Mask, The Wages of Guilt: Memories of War in Germany and Japan,* and the novel *Playing the Game.* He lives in London and is a frequent contributor to *The New York Review of Books.*

Caryl Phillips is the author of seven novels and three works of non-fiction. A Fellow of the Royal Society of Literature, he has received a Guggenheim Fellowship, a Lannan Literary Award, and the James Tait Black Memorial Prize for his work. In 1993 his novel *Crossing the River* was short-listed for the Booker Prize. He lives in New York and teaches at Barnard College, Columbia University.

Elena Poniatowska, born in Paris, France, became a journalist at age 20 and has written more than 50 books including *La Piel del Cielo. The Skin of the Sky* won the Alfaguara Literary Prize 2001, selected from 596 novels from all Spanish-speaking countries. In 2002 Poniatowska was awarded the National Prize for Sciences and Arts, the highest prize given to an intellectual in Mexico.

Lawrence Rinder is Anne & Joel Ehrenkranz Curator of Contemporary Art at the Whitney. Among the exhibitions he has organized are "BitStreams" and the 2002 Biennial Exhibition.

Sean Rocha is a writer and independent producer. He was formerly a director at the international literary and human rights group PEN. Previously, he was a columnist in Egypt for the *Cairo Times* and a political strategist for a Legislative Councilor in Hong Kong following the territory's first democratic elections. He now resides in New York.

Nawal El Saadawi, born in Egypt, is a psychiatrist and writer. She has lectured at universities worldwide and is the author of the acclaimed *The Hidden Face of Eve: Women in the Arab World.*

Edward Said is University Professor of English and Comparative Literature at Columbia University and is a leading Palestinian intellectual and activist. Among his books are *The End of the Peace Process: Oslo and After; Peace and Its Discontents: Essays on Palestine in the Middle East Peace Process, Out of Place: A Memoir;* and *Orientalism.*

Luc Sante is the author of *Low Life: Lures and Snares of Old New York, Evidence,* and *The Factory of Facts* and a frequent contributor to *The New York Review of Books.* He lives in Ulster County, New York and teaches at Bard College.

Pramoedya Ananta Toer is a fiction and nonfiction writer whose most acclaimed work is *Buru Quartet.* He is the recipient of numerous international writing and human rights awards including the 1988 PEN/Barbara Goldsmith Freedom to Write Award and the 1995 Ramon Magsaysay Award. He currently lives in Indonesia.

Aleksander Zograf, pseudonym for Sasa Rakzić, lives in Pancevo, a town on the outskirts of Belgrade, Serbia. Zograf became known to American alternative-comics readers in the early nineties through Robert Crumb's anthology *Weirdo.* His comics have appeared in many international books and magazines. His solo titles include *Life Under Sanctions, Bulletins from Serbia,* and *Dream Watcher.*

Colophon

This publication was produced by the Publications and New Media Department at the Whitney Museum of American Art

HEAD OF PUBLICATIONS
Rachel de W. Wixom

EDITORIAL
Thea Hetzner, Associate Editor
Libby Hruska, Associate Editor

DESIGN
Makiko Ushiba, Design Manager
Christine Knorr, Senior Graphic Designer

PRODUCTION
Vickie Leung, Production Manager

RIGHTS AND REPRODUCTIONS
Anita Duquette, Manager, Rights and
 Reproductions
Jennifer Belt, Photographs and
 Permissions Manager

COORDINATOR
Carolyn Ramo

CATALOGUE DESIGN
Martin Venezky/Appetite Engineers

EDITOR
Deidre Stein Greben

PRINTING AND BINDING
Blanchette Press

PRINTED AND BOUND IN CANADA

Whitney Museum of American Art

Four of the six **South African** policemen who admitted to setting dogs on three black men in a videotaped attack were convicted of assault after pleading guilty on the first day of their trial. The two other defendants denied guilt on all charges. . . . Former **South African** president Nelson Mandela defended the use of violence to achieve political aims, just minutes after being made an honorary **Canadian** citizen for his role in bringing down apartheid. Mandela, who led the African National Congress's armed wing and spent 27 years in prison on charges of sabotage and conspiracy, told reporters that violent struggle was justified against what he called oppressive ruling regimes. . . .